The Art and Craft of TV Directing

The Art and Craft of TV Directing offers a broad and in-depth view of the craft of TV Directing in the form of detailed interviews with dozens of the industry's most accomplished episodic television directors.

Author Jim Hemphill provides students with essential information on the complexities of working in episodic TV, highlighting the artistic, technical, and interpersonal skills required, and exploring a variety of entry points and approaches to provide a comprehensive overview of how to begin and sustain a career as a television director. The book discusses how to merge one's personal style with the established visual language of any given show, while also adhering to tight budgets and schedules and navigating the complicated politics of working with showrunners, networks, and producers. The book also features interviews with a range of directors, from feature directors who have moved into episodic TV (Kimberly Peirce, Mark Pellington) to directors who have made the transition from other disciplines such as acting (Andrew McCarthy, Lea Thompson), hair and makeup (Stacey K. Black), and stunts (David M. Barrett).

This book provides unprecedented access to the experiences and advice of contemporary working episodic television directors, and is an ideal resource for students studying television directing, early career professionals looking for advice, and working directors looking to make the transition from feature directing to episodic TV directing.

Jim Hemphill is an award-winning screenwriter and director whose films have screened at the Sundance Film Festival, American Cinematheque, and other prestigious international art houses and festivals. He has written about movies and television for numerous publications including *American Cinematographer*, *Film Comment*, *Filmmaker Magazine*, and *Film Quarterly*. He is a programming consultant at the Egyptian and Aero theatres in Los Angeles and works as a visual historian at the Academy of Motion Picture Arts and Sciences.

The Art and Craft of TV Directing

Conversations with Episodic
Television Directors

Jim Hemphill

Routledge
Taylor & Francis Group

LONDON AND NEW YORK

First published 2020
by Routledge
2 Park Square, Milton Park, Abingdon, Oxon OX14 4RN

and by Routledge
52 Vanderbilt Avenue, New York, NY 10017

Routledge is an imprint of the Taylor & Francis Group, an informa business

© 2020 Jim Hemphill

British Library Cataloguing-in-Publication Data
A catalogue record for this book is available from the British Library

Library of Congress Cataloging-in-Publication Data
A catalog record has been requested for this book

ISBN: 978-0-367-15243-7 (hbk)
ISBN: 978-0-367-15245-1 (pbk)
ISBN: 978-0-429-05586-7 (ebk)

Typeset in Bembo
by codeMantra

MIX
Paper from
responsible sources
FSC
www.fsc.org FSC™ C013985

Printed in the United Kingdom
by Henry Ling Limited

Dedication

For Kelly Goodner, who reminds me that there are things in life even better than movies and TV.

Contents

Preface

A few years ago, when a feature film I had written and directed had been released on DVD and the work on it was more or less over, I thought back on the experience and had a minor epiphany. I calculated that the entire process of making my independent movie – from writing it and putting together the financing to finding a cast and crew and shooting it, and *then* going through the arduous process of editing and taking the film around to festivals and finding distribution – had taken a total of around six years. The epiphany came with the realization that in that six years of more or less constant pressure and stress, the only part of the process I truly enjoyed without reservation was the 12 days I spent on set shooting the movie. This led to a minor existential crisis, as I tried to figure out what I wanted to do with my life and career. Was this really any way to live, scrounging for years at a time for a few weeks of fulfillment?

My partner Kelly, who's also a filmmaker, saw me flailing and pointed out the obvious: there was a world perfectly suited to my interests and talents, and it wasn't independent films. It was episodic television, where so many of the things I hated about filmmaking were non-existent. The desperate, years-long attempts to get my movies seen, for example (which resulted in only the briefest theatrical runs before the films disappeared into obscurity as tiles on Amazon Video), wouldn't be a problem in television, where networks already have their own massive marketing and distribution apparatus. The need to carry the burden of the entire production on my shoulders would also vanish, thanks to the fact that in television so much of the responsibility lies with showrunners, producing directors, and other members of the regular staff. (I realize that this lack of authorship for the guest director is one thing that makes TV unappealing to many of my colleagues, but I find giving up some of the control – and the headaches that come with it – liberating.)

Best of all, television moves *fast*. For an hour-long show, you might get six or seven days of prep, seven or eight days of shooting, and a few days of editing, and the program is on the air within months. The job of the guest director in this medium is relatively simple, and focused entirely on the part of directing I enjoy the most: working with the actors and crew to tell a story. Once Kelly pointed all of this out, I decided to shift my emphasis from the

world of movies to the world of television, and began the way I usually do: by plunging into research and reading everything I could find on the subject. What I discovered was that the unique characteristics of the art and craft of television directing were weirdly underexplored in film magazines and books; I found one excellent volume, Mary Lou Belli and Bethany Rooney's *Directors Tell the Story*, but not much else. This book, therefore, grew out of my desire to read it as much as my desire to write it. I wanted to speak with as many episodic directors as I could to learn about their process, how they got started, what they felt the pitfalls were for others hoping to pursue directing as a career, and what they looked for when, as producers, they were in a position to hire other directors.

I began contacting directors I admired (including Belli and Rooney) and asked everything I could think of about their work, learning along the way the extremely delicate balance that goes into episodic directing, a world in which you step onto a set filled with people who know their show better than you ever will and yet you're expected to take command. The directors in this book come from a variety of backgrounds; there are actors, editors, indie feature directors – David Barrett even began as a stunt man – and some of them have very different approaches to the same problems. (There may be some repetition in my questions from interview to interview, but the answers are remarkably varied.) The idea here is to present a wide variety of methods and philosophies, so that the reader can take whatever makes the most sense and assimilate it into his or her game plan. The idea is also to demystify the process, since a filmmaker who ignores the possibility of directing episodic television is closing him or herself off to some significant opportunities. There were over 400 scripted series on the air last year if you include streaming services – that's a lot of hours of television that need directors. Even given those numbers, episodic TV is an extremely tough business to break into, but hopefully the insights shared by the directors in this book will save the reader a little bit of time and pain along the way – and make that first job a little easier once it's been procured.

Acknowledgments

First and foremost I have to thank all of the directors who were generous enough to sit down and share their processes with me, with a special shout-out to Mary Lou Belli, who first suggested that I write this book and tolerated my presence for three weeks while I shadowed her on *NCIS: New Orleans*. I also owe thanks to my editor Sheni Kruger and editorial assistant Sarah Pickles for their guidance throughout this adventure. I doubt I would be here without Scott Macaulay and Vadim Rizov at *Filmmaker Magazine*, where I write the Focal Point column that got me started interviewing episodic directors, and I *definitely* wouldn't be here without my parents Jim and Nancy, who have encouraged and supported my obsession with moving images unwaveringly since I was three years old.

1 Bethany Rooney
(*Arrow, Bull, The Originals*)

I first became aware of director Bethany Rooney's work via her episodes of two of the most visually arresting series on network television, *Arrow* and *The Originals*. On each of these series – specifically, the "State vs Queen" episode of *Arrow* and the "When the Levee Breaks" episode of *The Originals* – Rooney exhibited a sophisticated sense of composition, lighting, and color surpassed only by her deft hand with actors. As I dug further into Rooney's oeuvre, I learned that those two shows were the rule, not the exception – performers regularly give their finest performances under Rooney's direction. This goes not only for youth-oriented genre programs such as *Arrow* and *The Originals* but dramas (*Nashville, Scandal, The Fosters*), action series (*NCIS*), and character-driven mysteries that blend comedy, adventure, and romance (*Castle*). Over the course of her 30-year career, there's virtually no genre Rooney hasn't mastered and no subject she's incapable of putting her own spin on; indeed, one of her most impressive gifts is her ability to seamlessly merge her personal aesthetic with the larger demands of whatever show she happens to be directing at any given moment. The more of Rooney's output I watched and admired, the more I wanted to talk with her and ask about balancing the disparate aesthetic, logistical, and commercial demands of television directing. Not surprisingly, given the fact that Rooney is the co-author (with Mary Lou Belli) of a superb directing textbook, *Directors Tell the Story*, she proved to be a passionate, articulate commentator on her own process.

JIM HEMPHILL: One of the things I admire about your career is the range of genres and styles. I'm curious what your starting point is when you get a piece of material. Do you approach comedy differently from drama, for example, or action different from romance, or are you coming at all of it from a similar place?

BETHANY ROONEY: The starting point for everything is, "What is the story?" I can easily adapt my work to the story I'm telling, both stylistically and in terms of intent – that's my job, to embrace that 1000 percent. So if I come into a show thinking, "This is not such a great show, I don't know if I can do a good job here," by the time I'm done shooting I love the show – I think it's the greatest show ever made. Maybe that's naïve

on my part, or maybe I'm not making enough critical judgments, but on the other hand that's my job as a freelance director: to tell the best version of the story that show wants me to tell. I really go into it with an open mind and an open heart, and a great respect for everyone from the showrunner to the writer of my particular episode to the line producer and everybody else who's there week after week trying to do good work, because nobody is trying to make something bad.

HEMPHILL: That speaks to something that strikes me as very challenging, which is that on a typical TV show you're working with a crew that has been together for weeks or months or even years, and you're the newcomer but you're also the person in charge. How do you form re-lationships with people in that situation, where you need to instantly command their respect and trust?

ROONEY: It's very tricky. Being the person with seven days of prep who is then expected to be in charge by day one of shooting requires great psychologist skills. What I've learned is to not come crashing in making a lot of pronouncements; instead, I sit back and I listen. I see who has opinions and who doesn't, and how the show runs. Who really has the power vs. whose title says they have the power. Once I've taken all that in, by day two or three of prep I can start expressing my opinions and mold everything toward the way I feel the story should be told.

HEMPHILL: How often are you offered a show that you've never seen, and when that happens how do you familiarize yourself with it?

ROONEY: Obviously I watch some episodes, but what I really prefer is to read scripts, because then the story lives in my imagination. So let's say I'm coming in to direct episode nine, and they have four episodes com-plete and the rest are in script form. I'll watch the four, and I'll read the scripts leading up to mine, and then I'm ready to go. If I'm coming in during season five of a show, I'll probably just watch a couple of episodes and then read the three scripts that come before mine.

HEMPHILL: What's your role as far as the script is concerned? If you see prob-lems in the writing, how do you deal with that?

ROONEY: By the time I come on board, I'm not there to make major changes because we're seven days away from shooting and this is a script that's been approved by the studio and the showrunner and the network. If I see difficulties, I can express that with a proposed pitch to solve what I see as the problems, but we can't do a major overhaul. Often it's logistical: asking the question of whether, instead of shooting a scene at a location where we already have a full day of material to shoot, we can move the scene to another location – explaining to everyone involved why that would be a good idea. I can also express if something isn't clear, because I'm a fresh set of eyes and that's a valuable thing; if the intent in a particular piece of action isn't clear, or if I don't understand the motiva-tion for a character's behavior, I can say that, especially if it's something

the writer can fix in an efficient way – and a speedy way, because again, we only have seven days of prep.

HEMPHILL: What are your initial steps when you get a script?

ROONEY: The first read is hugely important, because at that moment I'm a stand-in for the audience, seeing the show for the first time. Everything I do after that is intended to recreate the emotions I felt reading the script for the first time. On day one the department heads and I have a concept meeting, walk sets, and start to look for locations. We talk about how the show will look and how the story will be told in very broad strokes. The process of looking for locations could take a day or many days depending on how complicated they are, and then we start other things like casting and department head meetings in which I'm saying what I like and don't like – "I like red but not black," that kind of thing, always keeping in mind that I'm not there to upset the apple cart. I'm there to make the best possible episode of this particular show.

HEMPHILL: That seems like another tricky balance, in that you're being hired for your specific point of view but have to remain faithful to the visual language that has already been established.

ROONEY: It comes more naturally than you might think, especially when you've been doing it for a while like I have. I'm never going to override what has previously been established, but an episode can't help but become something that's expressed through my point of view, because I'm the one making the decisions. All of those decisions are going through the filter of my brain and my experiences and how I think and what I feel, so the show is going to have my stamp on it no matter what.

HEMPHILL: At what point do you start planning your shots?

ROONEY: Somewhere around day three I start blocking and making a shot list, so that by the time we start shooting on my eighth day I've blocked and shot-listed the entire script. That not only helps me figure out the best way to tell the story I'm telling, but if in blocking I discover that I need a certain prop that isn't in the script, I have time to tell the prop master. The last thing I do in pre-production is create an outline of the script, which you might think would come first, but the priorities in prep are the things that need action – picking locations, casting, all those things I said earlier. So when I get to the end of prep I outline the script, which further helps me understand the story I'm telling and also helps me clearly see the themes and the different threads running throughout the script. It's like the writer had the seed of an idea that blossomed into this big tree, and I'm going back to try to rediscover what the seed was. I have to fight through the layers to answer the question, "Why are we really telling this story?"

HEMPHILL: When you're doing that blocking and shot-listing, do you have access to the actors at all?

ROONEY: No, at that point I'm just relying on my imagination, because they're all off shooting another episode. Once we start shooting, I remain

open to everyone's ideas – if an actor comes up with something that doesn't precisely match my preconceived blocking but it works better, or if the DP [Director of Photography] has a better idea, that's great. I'm all for it. But I can't be open to new ideas if I haven't already built a platform to stand on. The better a psychologist you are and the more experience you have, the more likely it is that the scene will block exactly as you had planned it. But then there's always that 5 percent of the time where a piece of magic will happen that I did not plan or foresee, and that's actually one of the big joys.

HEMPHILL: As far as the actors go, I would think that on television you're working with a huge variety of backgrounds and approaches and levels of experience. How do you approach performance as an episodic television director?

ROONEY: The essential thing is always the same – once again, it's about asking what story we're all telling. Then it's about asking what each character hopes to achieve in a scene, and what's their obstacle to achieving that. I have to know those things, but the way I convey them varies depending on my relationship with the actor. It could be straightforward, or it could be in a more jokey way. I'm a big hugger, so sometimes there are a lot of hugs and laughs, but sometimes actors aren't interested in that and I have to adapt to who they are. I always want them to know that my approach comes from kindness and support for them – actors are so vulnerable, and I love and cherish them for that, so I'm never going to be mean. I'm not even going to be critical, really. I'm just going to work with them to get the most out of every scene. At this point I've gotten pretty good at quickly figuring out what an actor needs, because I come into contact with so many people. If you think about it, I do ten episodes of television a year, so that's hundreds and hundreds of actors and crew people I'm working with. Your ability to understand people and work with them can't help but get better the more you do that.

HEMPHILL: What happens when different actors have different, incompatible approaches?

ROONEY: One is always hopeful that if one actor likes to shoot their coverage first the other one doesn't and that kind of thing, but when that isn't the case there are overriding factors you have to consider. Who's number one on the call sheet, and who generally carries scenes more strongly? They should be accommodated. Or, if it isn't that kind of scene, the actor who has the bulk of the emotional work should be accommodated. Thirdly, it's all about lighting – which way are we shooting, and let's continue shooting that direction. But at the end of the day, sometimes you just ask – you say to an actor, "Is it okay if we shoot you first?" Sometimes they'll say sure, and sometimes they'll say, "I really need to warm up to this, can you do the other side first?" It's a negotiation, like almost everything.

HEMPHILL: That idea of letting the direction of the lighting dictate the order of your shots leads to something else I wanted to ask you about. It seems

to me that in television you have less money and less time than in studio features, yet you're expected to get the same results. A show like *Arrow*, for example, is competing with studio comic book movies that cost hundreds of millions of dollars, and the viewer doesn't know or care that you had fewer resources than your big studio counterparts.

ROONEY: It's very difficult, especially in this day and age when everybody wants more for less. What you have to do is think about moments, because great moments are what people remember. My job is to identify moments that are iconic or important and make sure I execute those as effectively as possible, whether we're talking about an action sequence or an intimate emotional scene, I want to find the biggest and best possible expression of that particular moment. If you have those moments, people are going to think it's a good episode, and then you can spend a little less time on some of the less consequential scenes. It's about allocating your resources to where they have the greatest emotional and dramatic impact.

HEMPHILL: How important is the director of photography in helping you find those moments? Are you collaborating with him or her extensively in preproduction to discuss those things, or ...?

ROONEY: It depends. There has been a trend toward DPs alternating episodes, in which case you might get some prep time with a director of photography. If you're on a show where one DP is shooting all the episodes, you might not really be working together until the first day of production, because while you're prepping he's shooting. (I say "he" because most of the directors of photography that I've worked with are men.) Ideally you'll have the DP with you while you're location scouting, because then he can talk about where the sun will be at the time of day you're planning to shoot, and give his thoughts on the best way to approach the location or what types of special equipment we might need to order. That doesn't always happen, and if the DP is shooting while I'm prepping I might try to pull him aside during lunch and say, "Can I show you some photographs of the location and talk about them with you?" Thankfully the process does seem to be evolving more toward the alternating DP model, which is always preferable.

HEMPHILL: Leaving aside the issue of a show's preexisting style, what's your preferred way to shoot? Your best shows seem to rely less on quick cutting and more on a refined compositional style.

ROONEY: I do prefer a more elegant way of shooting, where characters are tied together within the frame and it's less about cutting from one close-up to another. The same goes for an insert – I'd rather tag an insert within the shot than cut to it – and it extends to POV shots. I like to establish what the character's going to be looking at with the character still in the frame rather than just cutting to a clean POV. The longer the takes and the more choreography you can do within the frame the better, in my opinion – but then I'll get on a show where the style is cut-cut-cut-cut, and I have to adapt to that.

HEMPHILL: I happen to agree with you. Philosophically, I just prefer a more expressive, elegant frame to what Gordon Willis used to call "dump truck" directing, where you shoot a bunch of close-ups from a bunch of different angles and let it get sorted out in the editing room. Where do you suppose you acquired that taste? Did you always want to be a director?

ROONEY: No, I started in the business as a secretary to Bruce Paltrow and Mark Tinker on a show called *The White Shadow*. When they created *St. Elsewhere* they promoted me to associate producer. That meant I supervised all the post-production, which taught me how to tell a story visually, because I saw every frame of every episode a hundred times. I saw if the director told the story properly or did not. If they didn't, I learned ways of manipulating the film to correct it, and my visual sense evolved out of that without me even realizing it. Bruce was a wonderful mentor who taught me to tell the story first and foremost, but to do it with the time and money allotted − to make choices that are creative while also making your day. To be a great television director you need to know how to tell the story with your performances and your camera, but almost as important is the ability to be a good leader − you can't do it by yourself, so you have to pull people together. In my mind, being a good leader means being inclusive and kind but also firm and decisive − and that's just dealing with the cast and crew on set. You also have to put your psychologist hat on when you're working with the producers and showrunners and the people from the network, which is a whole other side of the process.

HEMPHILL: And I would imagine those people are weighing in when you get to post-production.

ROONEY: I have four days to edit my director's cut, though that can be speeded up if we're up against a tight airdate. Once I turn that in, there are all kinds of factors that can affect the final episode that have nothing to do with me and which I might not even be aware of − the studio might take out a fantastic shot I designed and keep something less wonderful because it sets up a plot development that's coming four episodes down the line. Sometimes shows are written long and therefore delivered long, and then when I watch the episode that airs I'm really surprised by what they cut and what they kept.

HEMPHILL: You're currently working on *Bull* as a producing director, which puts you in a position of greater power and influence. How did you get that job?

ROONEY: I was hired as a freelance director for one episode in season 2. It was a terrific script, the guest actors were perfect, and of course, the series regular actors brought their A-game. It went really well. I had a wonderful time and told my agent that if more opportunities opened up there, I would be interested. Everything worked out for the best! It was quite an adjustment, to move to New York for the season, but I'm proud

to say I take the subway to work every day and feel that I've left my California car behind both geographically and emotionally!

HEMPHILL: What do you see as the pros and cons of being a producing director vs. being a guest director for hire?

ROONEY: When you are a guest director, you come in, do your best work possible, and float above the fray of political relationships and past history. There are clear advantages to that, primarily the fact that the director becomes solely focused on the job, not what is around the job. There's also the fact that a director learns more about the craft on every episode, so if you're directing at multiple places, you're bound to learn more because each show is different from the next. One becomes better at the job in an exponential way because of the diverse experiences. You also get to travel a lot!

When you're the producing director, you are tethered to one place. You get invested, in every way, an opposite emotional experience from that of the guest director. You care about the staff, crew, and actors. You learn the stories that the show tells, and the way they are told. You work hard to see that prep and production flow quickly, easily, and creatively. You begin to take some ownership – just a tiny percentage, since it's such a collaborative experience. But still, essentially, that show becomes your *life*.

HEMPHILL: How do you see your role in relation to the guest directors on *Bull*? What kinds of conversations do you have with them in prep, and what do you do to help facilitate their best work during production?

ROONEY: I see my role as being similar to the manager of a small boutique hotel. I've been here for a while, I know the patterns, the ebb and flow, the personalities. My guest (director) will be arriving, and staying for a short time. I want him or her to be comfortable and taken care of. I will communicate how things generally work, but be open to the guest's choices and creativity. I will support those choices and endeavor to assist without imposing. I'm a facilitator helping to make that guest's episode be the best one we ever made!

HEMPHILL: What do you look for in the directors you hire?

ROONEY: I look for a leader: someone who can creatively interpret the script and communicate that vision to everyone else. I want someone who is calm and quiet; secure in their view of themselves and the world they inhabit. And it helps if they have a sense of humor!

2 Kurt Kuenne (*The Blacklist*)

I first became aware of Kurt Kuenne's work when I saw his 2011 feature *Shuffle* on the festival circuit; that film, an audacious psychological thriller about a man who finds himself waking up each morning at a different stage of his life, was an extraordinary fiction debut for a director who, I later discovered, had also made one of the most powerful documentaries of recent years. *Dear Zachary* (2008) begins as Kuenne's tribute to a murdered friend and develops into an excruciating portrait of a legal system gone horribly wrong; it's touching, enraging, devastating, and inspiring in equal measures. *Batkid Begins*, which Kuenne co-wrote (with director Dana Nachman) and edited, was another deeply moving documentary, albeit one considerably more uplifting and less wrenching than *Zachary*.

In addition to these films, Kuenne has also directed several award-winning shorts and worked as a composer, sound designer, and cinematographer. In the fall of 2016 he took on a new challenge: directing episodic television. When I heard that Kuenne was helming an episode of *The Blacklist*, I contacted him to ask if he would share his thoughts on making the complicated transition from independent filmmaking to network TV. We spoke just days after Kuenne completed editing his episode, "The Lindquist Concern," and then reconvened two years later to follow up after Kuenne had been asked back to direct several more episodes.

JIM HEMPHILL: Let's start by talking a little about the shadowing process, where you spend an episode – not your own – at a director's side to get the lay of the land. Did you do any preparation before shadowing – studying episodes of the show, etc.?

KURT KUENNE: I didn't need to do much preparation for shadowing on *The Blacklist* because the creator, Jon Bokenkamp, is one of my closest friends, so I've been intimately familiar with the show from its inception. I believe I was one of the first people ever to read the pilot script and give him notes on it, I gave notes on the edit of the pilot, and he's frequently sent me cuts of episodes over the years to get my feedback, or to see what I think about how various songs are playing against the picture – so I've seen every episode of the show (many of them multiple times) and am

intimately familiar with its characters and mythology, so further study wasn't really necessary.

I scored Jon's first feature as a director back in the late '90s, and he discussed the possibility of my becoming the composer for *The Blacklist* when the pilot was going into production, but scoring a TV show is a 24/7 life and a very different proposition than scoring a feature – which is a process that begins and ends – so I elected not to push for the gig so that I could continue pursuing the creation of my own films. I would never have been able to make *Batkid Begins*, for example, if I was scoring his show, though he did use some of my music last season.

I've always enjoyed my position as "fly on the wall" for *The Blacklist*, being someone uninvolved that Jon could come to for impartial feedback, so when he called me last December and asked if I wanted to direct an episode, I hesitated before saying yes. I like being the guy he can vent to; I didn't want to be the guy he was venting *about*. We've been friends for 23 years and when you go to work for your friends, you have the potential to jeopardize that relationship, and his friendship is one of the most important things in the world to me. But he's been a fan of my movies for years, had total confidence it would work out, it was a big honor to be asked, I thought it would be a great challenge and a new adventure, so I jumped in with both feet, determined to make him happy if I was going to do this.

HEMPHILL: How many episodes did you shadow on, and what was the purpose of shadowing – both from your perspective and from the point of the view of those who were going to hire you?

KUENNE: When he first asked me about directing the show, my initial response was that if I was going to do that, I wanted to go out and watch for a week to see how they did things, and he agreed that was a good idea; I had never done television before, so I wanted to see what their process was, how this particular company functioned, and become familiar with their way of operating, as well as meet and become comfortable with the principal folks running production with whom I would be working. They shoot in New York and I'm based in Los Angeles, so I went out there for a week on my own dime to watch – and because the last two days of each outgoing episode overlap with the first two days of each incoming episode (they call them "tandem days"), I was able to shadow two different directors during that one week, Michael Watkins and Andrew McCarthy, both of whom were very gracious. In addition to directing about a third of the episodes, Michael Watkins is also the executive producer who runs the production unit along with co-EP Laura Benson. He's kind of the patriarch of the New York operations, so it was paramount that I get to know him and develop a good relationship with him. Michael was incredibly welcoming and helpful, he's done decades of television and is just a fountain of wisdom. He also has an endless supply of quotable sayings pouring out of his mouth every day, I wish I could

remember all of them; he's just extremely funny and insightful, and he's 100 percent devoted to the show.

HEMPHILL: Take me through the actual process of shadowing – did you shadow on the episodes during prep as well as production? What were your typical days like?

KUENNE: I shadowed on two days of prep and four days of shooting. Shadowing is kind of a weird and lonely process, because you're the only person on set with no actual function other than to watch, so while I was constantly positioning myself to be close enough to the action that I could see and hear the important stuff, I always felt like I was in the way of the people doing the actual work. And despite the fact that you're not performing any useful function, it was actually mentally exhausting, because I had read the scripts for the episodes I was shadowing, had developed a plan in my own mind of how I would have shot scenes on that day's call sheet, I'd go over that in my own head at home before coming to the set as if I was actually going to be directing that day – and then I'd see how Andrew or Michael decided to shoot those same scenes and contrast it with what I had been planning in my own head. So, I took on the mental stress of the director position during the shadowing process without actually being the one doing the job yet. I never spoke to the cast during my shadowing process, but I did chat up several of the crew members and get to know them, which ended up being wonderful for when I returned to direct later in the year, as a level of familiarity had already been established.

My typical day would be that I would get there right at call time, stay as close to the director as possible without being annoying, float around so that I could hear any important conversations whose content would be valuable, ask questions when it felt appropriate, mentally work out how I would handle a given situation, then see what they did – and I stayed right to the bitter end every day, as if I was doing the job myself.

HEMPHILL: What did you get out of the shadowing experience, both in terms of what you learned, and how it helped make you a more viable directorial candidate to the powers that be?

KUENNE: *The Blacklist* shoots almost every scene with three cameras in order to minimize set-ups and maximize shoot time. It's a system Michael Watkins developed as a way to pound through all that material in the limited time that they have. That was a style of shooting I wasn't used to, as I'm used to composing one image at a time, so it was really valuable to see how they used the three cameras to capture all that material so quickly. It makes the cinematographer's job much harder, as he has to light in such a way that it will look good from multiple directions at once – but Mike Caracciolo, the DP who shot my episode, is absolutely brilliant at it. I could also see why the show has a style of using long lenses most of the time, as it's a necessity if you're going to keep the other two cameras out of your shot. I also came into the process wondering how

one directs actors who've been playing the same parts already for three years – and I quickly saw that what you're mostly doing is giving small adjustments. It's about getting moments right, but you don't need to have conversations with them about their character, as they know their character far better than you do.

The shadowing process also drove home for me how quickly the whole process moves in TV, how little time you have, and how you don't have the opportunity to fix something if you don't get it right the first time. I was also a little stunned by the page counts I saw at the bottom of each day's call sheet, which are far higher than they are on a feature – but their process and speed makes them accomplishable.

In addition to shadowing on *The Blacklist*, my buddy TJ Thyne, who starred in my feature *Shuffle* and my short *Validation*, invited me to shadow Jeannot Szwarc (who was also very gracious) on the set of TJ's show *Bones* for a day when he heard I was going to be doing this, so that I could contrast the working styles of the two shows, which was also very valuable. *Bones* has a lot of standing sets that are used week in, week out, making the process a little simpler, whereas *The Blacklist* only has one standing set – everything else is either location shoots or quick builds and teardowns on their two empty stages. The *Bones* set felt very relaxed during my time there, whereas *The Blacklist* felt like a mad dash to the finish line every day. But they always make it.

HEMPHILL: How long after you shadowed did you direct an episode? Did you know you had the job when you started shadowing, or was it contingent on that going well?

KUENNE: I shadowed in late March/early April of this year. There was not a 100 percent guarantee of my being officially offered an episode at the time I shadowed, so I was in a sense risking my money on the trip if the network didn't approve me for whatever reason, but I figured it would be a great experience either way, so I wasn't concerned about that. After the trip, I went back to work on my own projects, and then they offered me episode five of the fall season in June.

HEMPHILL: How many days of preproduction did you have, and what did those consist of?

KUENNE: My prep period was seven days, from 8/24–9/1, and we shot for nine days, from 9/2–9/15 with weekends off. Pre-production begins with location scouting, as the first thing we need to do is find all the places we're going to be shooting because, as I mentioned above, *The Blacklist* only has one standing set and the star of the show is almost never on that set. So we began the first day by looking at photographs of potential locations, then hopping in the van and going to see them, see if they work, and if so, figure out quickly how we're going to utilize them so that the art department can start preparing to dress the location. Tom Scutro, the location manager, has an encyclopedic knowledge of New York City and came up with fantastic places at great speed. Nicholas Lundy, the

production designer, is just brilliant at coming up with wonderful, au-
thentic sets at lightning speed; he and his team blew me away with what
they were able to accomplish in that small amount of time while simul-
taneously working on other episodes. The second day of prep, we began
with a "concept meeting," in which all of the department heads assemble
around a speakerphone (to loop in the folks in L.A.) to go through the
script beat by beat so that everyone understands what we're going to be
shooting, what the intention is and what's needed. The different depart-
ments asked me questions about how I wanted certain things to look,
etc. after which we continued location scouting in the afternoon. On the
third day, I had individual meetings with each of the departments – art,
props, stunts, special effects, costumes, extras, hair and make-up – then a
casting session in which actors auditioning for the guest roles of the epi-
sode were brought in to read for me. I would be sent links to tapes/reels
of other actors at night to save time. The fourth and fifth days consisted
of more location scouting in which all the locations are finalized. All the
while, the different departments were sending me emails with examples
of things they were preparing for my approval or feedback. The sixth day
was a "tech scout" in which all the department heads come to the loca-
tions we've chosen. I showed them where the action was going to take
place, how we're going to shoot it, what I want it to look like and what
we're going to be seeing, so that they could all get on with the necessary
preparations to make the shoot days go smoothly. On the seventh day, we
had a final production meeting with all the department heads to go over
further details about the coming shoot. In the afternoon, we got on the
phone with Jon Bokenkamp and had a "tone meeting" where we talked
through the script to make sure we were all on the same page regarding
the emotional arcs of the characters, what the intention of the scenes are
and how everything is supposed to feel. Then I got a good night's sleep
and started shooting the following morning.

In addition to the speed of the aforementioned process, another added
layer of challenge that one doesn't have in features is that you only get
the script shortly before you start, and it's constantly being rewritten
during that week of prep, so when you wake up each morning, there's
usually a new draft that you need to sit and read before you come into the
office for the day. This is particularly challenging for the AD [Assistant
Director] – and Adam Weisinger, the first AD, is such a hard worker and
brilliant at this – because he has to break down and analyze the script
early each morning before any of us come in for meetings in order to
lead us all through the coming work and adjustments. It makes it more
challenging to have total authorial knowledge of the story you're tell-
ing because you don't have a lot of time to ingest it, and it's constantly
changing, so you have the danger that five different versions of a scene
will be in your head and remembering which one is the most recent can
sometimes be a challenge.

HEMPHILL: What was your relationship like with the producing director, and how did he guide you?

KUENNE: Michael Watkins, the production showrunner, was wonderful with me. He said to me many times during prep week that this show is one of the more difficult shows to direct on network television, given the locations, the set pieces, the action, the pace, etc. and that it's not the place to do your cool, choreographed shots as there simply is no time for it with the amount of material that has to be covered; you'll die on the floor if you do. "Keep it simple, use the three cameras wisely and give good notes to the actors." After taking a good look at the shooting schedule and Adam Weisinger's timing notes, I saw that he was absolutely right; if you try to get any more than what you absolutely need, you simply won't make your days. (And given the speed at which the show is cut, only what's essential will end up in the episode anyway.) So I took his advice and it worked.

HEMPHILL: What were the differences between your relationships with the cast and crew here and the kinds of relationships you had on your independent features?

KUENNE: My relationship with the cast and crew felt quite different from the relationships I've had on my indie features for the simple reason that on my own films, everyone has come to the project because of me – they've liked my script, my previous films, my music, etc. On *The Blacklist*, however, I was an outsider coming into a production family that's been working together very successfully for over three years now, and I don't believe anyone in the New York unit was really familiar with my work – so I'm guessing that folks were therefore probably a little nervous about me during prep, particularly knowing I hadn't done television before and that it's a very different animal from features (and certainly from documentaries, for which I seem to be better known presently). But once I finished our first day of shooting an hour earlier than anticipated and got the crew out early for their Labor Day weekend while getting everything we needed, the tone was set for what turned out to be a great shoot. On the third day of shooting, Adam Weisinger turned to me and said, "You're really hitting your stride as a TV director," which was extremely kind of him to say. In a way, I felt a stronger kinship with the day players and guest actors that were cast in the episode because, like me, they were coming into this environment for the first time too. Working with Adam Godley (who played my episode's Blacklister and was just brilliant) was the closest relationship I had to the ones I've had with the cast on my own films. We had in-depth discussions about who his character was, what his motivations were and really worked out his arc together. There's no need for that with the series regulars, as all of those choices have been made long ago.

HEMPHILL: How do you work with actors who have been playing these roles for years? Is it difficult to figure out your place in terms of shaping performances, and if so how did you find your working method?

KUENNE: In working with the series regulars, I saw my job as mainly to make sure the intention of the scene was coming across and was playing authentically. I'd show them what I thought the blocking could be, they'd try it out, and then I'd just watch and see where they naturally went with it in rehearsal, and often I'd be surprised where we ended up – and all the while, I'd make sure they were hitting all the emotional moments the script and story needed. So the direction per se usually manifests itself in making small adjustments. Sometimes it's just noticing that they walked through a door clearly knowing who was on the other side of it, rather than taking the time to stop, look and process that someone they didn't expect to see is in the room. Or it's reminding them to take the time to make a tough decision when they're asked a hard question. Or it can simply be telling them to pick up the pace because the scene is playing like molasses and needs to fly. And sometimes they're just cooking and the best thing you can do is shut up, stay out of their way and just make sure your cameras are in the right place to catch what they're doing.

HEMPHILL: How did the casting of guest actors work?

KUENNE: I had one live casting session where numerous actors came in to read for me, and I was also sent links to watch auditions of several people that I didn't have time to see in person. I'd narrow each role down to my top two or three picks, which would then be shared with Jon Bokenkamp and Michael Watkins, and Jon would make the final call – but our top picks were unanimous in almost every case, which made it easy. I was thrilled with the guest actors that ended up in the episode. Bonnie Finnegan, the casting director, brought us wonderful people to choose from.

HEMPHILL: How many pages per day were you expected to shoot? How did you prioritize what shots to get under such a tight schedule?

KUENNE: I had nine days for my episode; I understand that ten days is more common for this show. The number of pages per day varied depending on what was being shot. The highest number of pages I had to shoot in one day was nine pages, though that was mostly dialogue on the principal "War Room" set; the cast is really good with it, and the crew knows how to work that room quickly, so that material flies a lot faster than that number would tend to indicate. The lowest number of pages I had to shoot in one day was four pages, but that was on a day where we had a major stunt which took hours to rig, so it filled the entire day. There was never an easy day. I prioritized by looking for the simplest way to cover a scene that also maximized its potential and gave me everything I was going to need, then adding in a special shot or two if time permitted ... but if it didn't, so be it. Michael Watkins is fond of saying, "All I do all day long is make compromises. If I didn't have to compromise, I'd do this job for free. I get paid to compromise." And it's true, you simply don't have time to shoot it the way you dreamed it upon reading the script for the first time – but you do your best to get as close as you can get.

HEMPHILL: You touched on this before, but can your elaborate on the advantages and disadvantages of always shooting with multiple cameras?

KUENNE: *The Blacklist* shoots almost every scene with three cameras to save time on multiple set-ups by getting numerous angles at once. The advantages are that it does save time, allowing you in certain cases to get a scene in one set-up with multiple lens sizes on subsequent takes, which can be essential with the amount of material you have to capture in a day. And it's nice for the actors too, because they can just go with the flow of the scene, rather than starting and stopping so much. One of the disadvantages, at least for me, is that only one camera can get a true eyeline on the actor – and if you're shooting both sides simultaneously for time reasons, you can't get a true eyeline on either angle, because if you did, the cameras would be in each other's shot. So it's a challenging thing to navigate, because you're fighting to use the three cameras in the most advantageous way, but also to keep them out of each other's shot. It also can create issues with the 180-degree line, which I tried to observe as best I could under the circumstances, depending on where they're placed and where the actors are moving. Multiple cameras also create enormous challenges for Mike Caracciolo, who somehow manages to make it look gorgeous from multiple directions at once while moving at high speed. He's truly brilliant. And the camera operators are magnificent and really help you out, finding pieces, incorporating moves that are signature to the show, which they know well having done it for so long; when you have a guy like Derek Walker operating the A camera, he makes your life so much easier by just instinctively finding the move you wanted and executing it beautifully without your even having to say anything.

HEMPHILL: How much moving around did you do, and what kinds of challenges did location shooting create?

KUENNE: We shot three and a half days on the stages, the rest on location. We only had one day where we did a company move during the middle of the day from the stages to a nearby location. That does slow things down enormously, but it had to be done. Since we had control of the locations, I didn't feel much difference from my point of view shooting on a location versus on the stages, with the exception of the sound problems caused by city noises. I'm certain it was a very different experience for the folks in charge of logistics, who were mobilizing a small army every day to make these locations work for us, but they did such a great job that I felt the freedom to do everything I wanted to do. It was very hot some days and they often had to pipe in air hoses to the rooms in which we were shooting to keep everyone cool, then shut them off while shooting.

HEMPHILL: How did your background as an independent filmmaker inform or help you while shooting *The Blacklist*?

KUENNE: My background in low budget filmmaking was a great help to me in TV because I'm accustomed to moving fast. I'm also accustomed to

being told, "You can't do that, we can't afford it," then finding another solution within my means, which is an extremely helpful mindset to have in TV, where your limitations might be more based in time rather than finances, but the same principle applies.

HEMPHILL: Let's talk a little about editing. How many days did you have to edit?

KUENNE: I had four days to work with Dave Post, the editor, in shaping my cut. Dave's first assembly was about ten minutes over broadcast time, but was very good overall; we'd never worked together before so there were some scenes where he didn't realize what I'd intended right off, so we reworked those, and there were others where his approach was right in line with what I'd had in mind from the start. Michael Watkins asked me to deliver a cut that was a few minutes over broadcast length, as they like to be able to make the final determination as to what will ultimately come out to get the episode down to time. So, over the course of three days, Dave and I chopped a little over seven minutes out, getting the episode down to 2:56 over broadcast length, then we spent the bulk of the final day shaping the temp score, which greatly affects the way the episode plays. Four days is not much time to finesse a 43-minute piece of material, as I'm used to spending more time, having test screenings, getting feedback, doing further cuts, testing more, etc. But here, there simply isn't time for that, so you do the best you can in the four days that you have. So when I say I turned in my "director's cut" after four days, that moniker doesn't mean the same thing that it does in film; it's not the definitive "this is my masterpiece" label that is generally ascribed to that term. It was my best attempt in four days to get it down to the running time they asked for while preserving the essence of my creative intent. It was also a new experience for me not to be at the controls, because I've edited every film I've ever made, and I'm used to just seeing a sequence in my head and cutting it that way – so it was a new challenge to verbalize the sequence in my head and describe what I wanted to Dave so that he could execute it. But it was a great experience, and Dave really made it feel like *The Blacklist*, as he's internalized its rhythms, having cut the show for so long now. He's a marvelous editor.

HEMPHILL: Once you've turned in your director's cut, what happens then? How many more hands does the episode pass through, and do you have any more involvement at that point?

KUENNE: Next, Jon gets his pass, then the studio gets their say. Jon called me as soon as he watched my cut and said he was really pleased with it, so I considered that "mission accomplished," as my whole goal was to get through this experience giving him what he wanted and to keep our friendship intact. It is weird for me, particularly as a composer, not to be the one sculpting the sound design and the music for something I've shot, which I've done on every film I've ever made, but that's the process in TV. I will be at the mix, so I get one last chance to comment before

it's locked for broadcast. But whatever happens, it's Jon's show and it's his invented world that we're playing in here, so if he's happy, I'm happy.

HEMPHILL: What lessons did you take away from the experience that might be helpful in your own, more personal work?

KUENNE: The experience certainly gave me a renewed appreciation for the time one has on a feature to stage and shoot things the way you intend to, and will make my next feature feel time-luxuriant by comparison, but it also gave me a renewed sense of how fast it is possible to move if your team is prepared to. It also gave me an idea of what the limits and parameters will be if I'm fortunate enough to get some of my own TV projects off the ground in the future, which helps tremendously as I move forward writing them. But mostly I just feel grateful to have had the experience of this magical month working in New York and the opportunity to explore a new style of working surrounded by such brilliant craftspeople and artists. And I hope the fans of the show like the episode.

The next section of the interview took place two years later, in November 2018, after Kuenne had returned to direct several more episodes of The Blacklist.

HEMPHILL: How long after your first episode of *The Blacklist* were you asked back? What kind of feedback did you get from people on the show and/ or at the network about your initial episode after it aired?

KUENNE: During the shooting of my first episode, Jon Bokenkamp gave me regular feedback that he was really pleased with the dailies, so that was encouraging to hear. When I turned in my director's cut, I waited on pins and needles to see what he thought; he called me a couple of days later to say he thought it had turned out great, though he jokingly added the caveat, "You're probably going to be insulted when I add more music to it." He said that because a) I'm a composer, I've scored for Jon in the past, so he knows I have strong opinions about music; and b) the temp score I'd laid in was much more sparse than the show's usual scoring palette, as it's often scored wall-to-wall, which isn't my style when I score films. I'd left certain areas without music because I didn't feel they needed it, and I felt proper sound design would do precisely the job that was needed in those spots. But when you're watching a "workprint," those spots are just silent, and they feel very empty to anyone who isn't hearing what I'm hearing in my head when I watch those scenes, so the general impulse is to fill the silence with music ... and since the director in TV is not involved in that part of post to direct the sound design, it's not an area over which I had any control. So I tried to suggest where I think music should go with my temp score, but I found out when I saw the final mix that I only have so much influence in that department.

So, I knew Jon was pleased with it, and some people I knew in the music supervision department wrote to tell me what a great job they thought I'd done when they were working on the episode, but I didn't

hear anything from anyone else in an official capacity at that time. I "live-tweeted" the show from the writer's room the night that it was broadcast, which is a process where you engage with the show's viewers on Twitter in real time during the broadcast, answering questions, and in effect doing a text version of a commentary track for them, sharing fun facts and secrets ... which seems like a weird thing to do the first time someone's watching your work, but that's becoming more common in TV now. (That's one aspect of TV that's totally different from movies: you never get to watch your work in a theatre with an audience, which is one of my favorite parts of the process. Social media feedback is the closest experience you get.) Anyway, the viewers who engaged with me on Twitter were thrilled with the episode, and have been very welcoming when I've returned to do more episodes, so it's been nice to get positive feedback from the fans as well.

That episode aired October 20, 2016, and I didn't hear another peep about being brought back to the show until the following May. (They tend to hire all 22 directors for the season in one fell swoop in late May/ early June, so there weren't any openings for the rest of the season anyway.) So I was pleasantly surprised to learn that I was on the director's list for the next season that May, and they hired me once again for episode five of the new season (season five). Shortly after getting that call, I finally went in to meet with some of the execs at NBC and Sony, who congratulated me on doing a great job the first time out, and said they were happy to have me back. I remember one of them saying, "Congrats, you bought yourself another episode!" But I'd had no idea what they'd thought for the previous nine months. I was subsequently hired back for two more episodes in season six.

HEMPHILL: How was directing as someone who had already been on the show different from what it was like the first time you did it?

KUENNE: Coming back to the show the second time was a much more comfortable experience than my first time simply because everyone knew me and was happy to see me again; no one was nervous about me because I was no longer an unknown, so I felt an immediate trust and camaraderie upon returning, which is a wonderful place to be working from. The episode I had the second time out, however, was more logistically challenging, so the shoot was more difficult, but that was because of the demands of the script combined with the time frame in which we had to execute it. At that time, *The Blacklist* normally shot ten days per episode, though on my first episode, I ended up with a nine-day schedule because they'd overspent on the season premiere and had to make that up somehow; I drew the short straw and therefore got a shorter shooting schedule, but I'd made it work. The same thing then happened on my second episode: I ended up with nine days to do what should have been a ten-day episode. It had a shoot-out, a car chase, a foot chase, two explosions, ash raining on a suburban neighborhood, dogs, children,

babies, entire scenes spoken in Arabic with English subtitles … it had a multitude of hurdles I didn't have the first time out. I was a bit nervous about finishing in the time allotted, but was emboldened when Laura Benson, the producer, said to me, "You don't have an easy day on this entire shoot, this should be a ten day show – but you did it in nine days last year, so I know you can do it, I'm not worried about you." And I have to say, knowing that everyone believes in you and is on your side goes a long way to finding a way to make unmakeable days.

It was also easier working with the cast the second time out because they knew me from the previous year, so we also had a comfortability with each other, which just makes everything go smoother. I became particularly friendly with Amir Arison, who plays Aram Mojtabai on the show; we'd gotten along great on the first episode, and during the intervening year, he'd stumbled across *Dear Zachary* on Netflix without realizing it was my movie until he heard my voice narrating it, so coming into my second episode, he was gushing with praise for the movie, started watching my other work, and is now talking to me about possibly being involved with the editing of a documentary project he's working on. So this level of comfortability and mutual respect makes the process much more enjoyable.

HEMPHILL: How do you feel your relationship to the cast and crew has evolved over the course of the episodes you've done?

KUENNE: Again, I feel an ease with everyone now just by virtue of having worked with everyone several times; while each episode presents unique challenges depending on what the script calls for, the personalities are all known, so I've learned how best to communicate with everyone. For this show, I'm now a different director than I was the first time out in that I think I now have my hands comfortably around the machinery of the show, if you will; I know the capabilities of the resources we have at our disposal, the limitations, the workflow and its associated time factors, as well as how the show will be cut and scored, so I know what to focus on and what to ignore. I know that some actors will happily accommodate the blocking you give them, and others will want to challenge it and explore it, so you learn to be loose with your plan, less rigid, and adapt on the spot. Now that I've done it several times, there's no longer an authority figure looking over my shoulder on the set; in fact, the third time I did the show, Laura Benson said to me at the end of my last day, "You'll notice I paid you the silent compliment of almost never being on your set, because I know I don't have to worry about you." So I feel more relaxed and free to shoot a scene the way I want to, whereas the first time out, I was nervous, I knew they were nervous about the fact that I was new to the show, and I constantly felt like I was asking permission to shoot things the way I wanted to. On my first episode, I'd say that I got 25 percent of what I saw in my head upon reading the script for the first time on the screen. On my second episode, I got closer to

45–50 percent. On my third and fourth outings this year, I'd say it was closer to 70 percent. And I think the increase in getting more of what I'd envisioned on the screen is due to having a knowledge of how their organism works; it's like being more comfortable with a car after having driven it for a while. You know where all the controls are, and your hand just automatically finds the buttons without your brain having to think about it, so everything happens smoothly and you don't have to take your mind off the road in front of you. That doesn't mean there won't be bumps in the road, but you know the instrument you're using to navigate it.

HEMPHILL: Have you learned anything directing for episodic television that has informed your other work as a director and composer since the last time we talked?

KUENNE: I've certainly learned techniques for working quickly that can come in handy when one is in a time crunch, and I've become more comfortable with shooting multiple cameras in order to get multiple set-ups in one pass and not wear the actors out, though one has to be careful, as it has the potential to limit how you can light the scene. And I've learned so much just watching all the marvelous craftspeople in each department execute their assignments, it's been dazzling to see what people who are truly at the top of their game can achieve in what I would have assumed was not enough time; it inspires me to think about what else it's possible to accomplish if these people are given the time and opportunity. I don't know that any of this experience has informed how I approach my own original work from a creative perspective; in fact, I think it's important to get your mind in a different place for your own work, because directing to execute someone else's vision and stay within their style can train your mind to "ask permission" to do what you want to do creatively, even when you're back doing your own work – it can keep you from making daring, risky leaps at a time when you're free to do whatever you want. So it's important to leave that part of it behind, as you want your mind to be free to create with total freedom; that's the only shot you have at doing unique, interesting work. But the craft lessons learned along the way in TV can only help in executing one's original ideas later, as your mind has been exposed to another's way of doing things that might not have occurred to you.

3 Stacey K. Black (*The Closer, Macgyver, Midnight, Texas*)

As is probably already becoming obvious, directing episodic television can be one of the most challenging forms of filmmaking. A tricky balancing act is required by having to simultaneously meet the expectations of the audience, the demands of the network and showrunner, and the desires and opinions of actors and crew, who have been on the show for years – and all while providing a distinctive enough point of view so as to make one's self essential to the process (and thus get asked back to direct more episodes). Few directors have managed to navigate the intersection between personal expression and mass entertainment as well as Stacey K. Black, who in the past few years has evolved into one of the finest filmmakers in any medium. A supreme visual stylist whose work is distinguished by an expressive use of color, dynamic yet unobtrusive camera movement and framing, and a deft sense of realism and humor in terms of her direction of actors, Black has an unerring sense of how to integrate her voice with the preexisting styles in which she works. She's particularly strong when it comes to action, which she stages with precision and energy – her work on shows such as *NCIS: New Orleans* and *MacGyver* feels both spontaneous and purposeful, delivering the kinds of kinetic thrills one used to find on the big screen in the work of Richard Donner and John Badham. I sat down with Black (who is also a composer, musician, and award-winning web series director) to find out how she approaches action, where the real power resides on a TV set, and why a background in the hair department is great preparation for directing actors.

JIM HEMPHILL: One of the reasons I wanted to talk with you is that I think you've really mastered the key task in TV directing, which is to assimilate the voice of each show without sacrificing your own directorial personality. When you get a job on a show, what are your first steps in terms of coming up with a visual approach?

STACEY K. BLACK: Well, the first step is to watch every available episode (if it's not a first year show), twice, sometimes three times, to study the shooting style already established on the series, and to learn the relationships between characters. For instance, on *NCIS: New Orleans* the camera is almost always in motion. There's not much in the way of a

static camera on that show, but of course using that at a precise moment is powerful. So when I do my blocking and shot-listing, I think of how to move the actors and the camera to fit the behavior of the characters, the story that is being told, and the visual style already in place by those who designed the show. Then I look for certain spots in the script where I can push the envelope a bit, and add in something a little different. But not too different. It's a balancing act, for sure. I like to think of it as "Sprinkling a Little Stacey on It."

HEMPHILL: I imagine that some shows match your own sensibility better than others. What's your method of finding your way into a series that, either in terms of content or the way it's shot, is a significant departure from what you're interested in or how you would do things?

BLACK: As a director hired to translate an episode of a series from script to screen which has been created by someone else, how I would do things on say, my own show, isn't a consideration. I have to fit myself into the showrunner's vision. And again, find spots in the script where I can sprinkle on a little something of my own, that doesn't veer too far off from his or her initial vision. When it comes to content, the goal for me is to direct as many different types of stories and genres as possible, so my toolbox will be full, and I'll end up a well-rounded filmmaker. In each script I'm hired to direct, I always find things I love. Sometimes I have to excavate to find those lovable nuggets ... but they're always there.

HEMPHILL: Do you find that there's a lot of variety in the way different shows are set up? In other words, does the balance of power between the show runner, the star, the producing director, etc., shift from series to series?

BLACK: Fantastic question, and YES! Each show is different and has its own set of built-in rules. But one thing remains the same from series to series, the showrunner is the boss. Ultimately, you must please the showrunner. And the producing director. And the actors. Oh, and the studio and network. Who am I forgetting? Oh yeah – me! I have to make sure that I love the episode I direct as well! I can't let all of that other responsibility muddy up the waters, otherwise the episode loses point of view, and that is a career killer. It takes a deft hand, but, being respectful of the script, the professionals and craftspersons on set, the process, and contributing everything I can to deliver the best possible episode is the only way to survive and deliver the goods.

Many shows have a producing director who is there to guide and support the guest directors, and the person who holds that position is invaluable. James Hayman on *NCIS: New Orleans* is an immense source of support, great ideas, and guidance. He has earned the respect of cast and crew alike, and he runs that show like one big happy family. So there's really not a struggle there. We're happy to follow his lead. He's a true leader, in the best sense of the word. I've been fortunate in that I have so far been hired on mostly kind, supportive shows. Michael Robin and

James Duff set the bar high for me on *The Closer* and *Major Crimes*, which kept a significant amount of people together for 13 years. If you think about it, that's like going from kindergarten through graduation together. It's a family. And like in any family, you have to please Mom and Dad. And again, it's a pleasure to do so when they are so damn cool.

HEMPHILL: What are your first steps when you come on to a show you haven't directed before? How do you gain the trust and camaraderie of a cast and crew that's been working together for months or even years when you're the guest director?

BLACK: I do my homework. And then I do it again. And again. I know the show, I know the characters, the shooting style, everything that has happened with the characters up to the jumping off point of my script. I immerse myself in the world before I even arrive for day one of prep. And then I prep my ass off, and then shoot every day with a definite plan.

I worked on crews for many years, and I witnessed a lot of directors who would show up NOT having done the homework. Not knowing the characters. Not having a plan. It was so disrespectful of everyone's time, skills, and talents, I couldn't understand how those people had careers. Fortunately, I think the day of that type of director is close to being over. And now that I'm in this rarified position, where I get to contribute my own specific talents to a creation where people give their all, every day, I show up ready, and I don't waste the cast or crew's time. They all show up and give 120 percent every day, so if the director doesn't, well that's a big problem. Again, respect.

HEMPHILL: How extensively do you predesign your shots in prep? Do you shot-list or storyboard, or do you remain open and make those choices on the day with the cinematographer?

BLACK: It's a combo platter. I have specific blocking and shot lists for every scene, which I usually go over with the cinematographer during prep. But as a rule, I don't share my shot lists, because production is fluid, and I need the freedom to change my mind on the day if I see something that's going to work better. Or if the cinematographer has a brilliant idea, or an actor. Or anyone. I'll listen to great ideas from anyone who has them. It's a collaboration, and the sought-after result is a fantastic episode. Storyboards are good for big action sequences, but I usually use them to lock my own vision into my brain during prep, and rarely look at them again while we're shooting. It would be very easy to get stuck in shooting the storyboards and totally miss something amazing due to being rigid. So many things happen while shooting, and you want to be open and receptive to take full advantage of those magic moments!

HEMPHILL: How is directing actors on a series different from a movie? Does the fact that they have owned these characters for so long alter the way that you have to direct them?

BLACK: I think regular actors on long-running series have a wonderful grasp of who their characters are, and don't need as much direction in that

regard. But each episode's story is different, and as in real life, characters have relationships with other characters, and those relationships have ups and downs. So if I can help the actors navigate those bumpy roads, then yay! I find communicating with actors to be the best part of directing. And as long as my ideas aren't completely wonky, I find that most are receptive. Sometimes they'll have a different idea for how something should be played, and if it's better for the show, then great. If it's not, then I need to quickly figure out how to convince them that they will be happier with the performance if they do it my way. It's tricky! There's no set "way." You need to be genuine and communicate with each actor and not try to manipulate them. Dude, they will smell that a mile away and you'll be done before you start.

HEMPHILL: Do you ever run into conflicts between what different key people – the showrunner, star, and/or producing director – want, and if so how do you deal with that?

BLACK: If there is a power struggle between say a showrunner and an actor, that's a tricky spot for a director to be in. I'm a guest in their home. But, I also have a tight schedule to keep. The production train keeps chugging along. So ... if I sense danger coming, I will pre-empt as best I can and hope like hell the train isn't derailed.

HEMPHILL: I want to get into specifics in terms of your action direction. On the last *NCIS: New Orleans* you directed there were some extremely elaborate stunts and chases. How do you design those?

BLACK: Like I design any scene. I have to watch the movie in my head, and then figure out what shots I need to create that scene. Then make sure they are going to flow well from one scene to the next. And yeah, wow, did we have some amazing stunt pieces on "The Last Mile" episode of *NCIS: New Orleans*. The opening car chase and jump was the most fun I've had directing to date. Gordon Lonsdale is the cinematographer on that show, and he is spectacular. Working on these big stunt pieces with him and stunt coordinator Johnny Arthur was a blast.

HEMPHILL: Do you ever run into a case where something like that doesn't go as planned, and how do you adapt?

BLACK: Yes, things do go wrong sometimes, and you have to quickly edit in your head and figure out what you need to shoot to get everything you need to make the scene work. On "The Last Mile," we had a problem with the last big stunt piece, when Driscoll's Cadillac gets T-boned by the truck. Something didn't go as planned in the first take, and we didn't get the crash the way we wanted it. So Gordon and I edited in our heads, and realized we could shoot the moment of impact separately, and it would cut. And it did. Like butter.

The biggest challenge is always schedule, schedule, schedule. We shot that episode in New Orleans in the winter, so we only had ten hours of daylight each day, and a major portion of that script was daylight exteriors. We shot the big highway shootout, and the T-bone of Driscoll's caddy, on the same

day. Within ten hours of daylight! Again, singing the praises of Gordon, by the time we got to the last shot of Pride, Sebastian, Isler and Percy witnessing that Driscoll was dead in the car, it was pretty much dark. But you'd never know by looking at the episode. Gordon and gaffer Paulie Olinde performed some camera voodoo with exposure and stops, and voila! Daylight.

HEMPHILL: With *Midnight, Texas* you moved into supernatural material. What were some of the challenges and pleasures of working in that genre?

BLACK: I'll admit, I was a little nervous going in. I was already a fan of *Midnight, Texas* when I booked the gig for an episode in season two, and the visual effects were massive in season one. So I knew I'd be treading in unfamiliar waters. But, being on sets for over 20 years, I knew the basics. I'd need to shoot all the elements that the visual effects artists would need to stitch together. Luckily, visual effects supervisor Kevin Rafferty was always on hand to answer my many questions and made the process enjoyable and a real learning experience.

 The biggest challenge of directing any show is the schedule. The pace in television is break-neck. And for visual effects shots, you need to shoot each piece many times. The initial shot, the plate, the ball pass, the HDRI and if the scene calls for a stunt *and* VFX (which many of the scenes in *Midnight, Texas* do), that adds another element – and more shots – to the scene. The pressure to shoot amazing footage, correctly, in a visually interesting way, that tells the story, and to do it on time … I mean … it's stressful. But when everyone is on their A-Game, and the episode cuts like butter, there's no better feeling than that sense of accomplishment. I so hope to do that show again. I loved everyone involved.

HEMPHILL: Tell me a little about your episode of *The Fix*. Was Marcia Clark directly involved with you and your episode, and if so what was that like?

BLACK: I am still in awe that I was able to direct an episode of this show. I was lucky enough to get a sneak peek at the first few episodes, and it is AMAZING! I can't wait for it to air. And, yes Marcia Clark! It was fantastic to spend time with her, picking her brain, and helping to bring her vision to life. Sarah Fain and Liz Craft created the show with Marcia, and I got a good glimpse at how they run their team. Democratic, balanced, and they have wild respect for each other. It was a real pleasure.

HEMPHILL: Then on *Bull* you went to work with one of your mentors, Bethany Rooney. Tell me about the experience of coming to work as an equal alongside a director with whom you formerly had more of a teacher–student relationship?

BLACK: Bethany is one of the greats! And she really wants to see people succeed. And let me be perfectly clear, I don't think of myself as an equal to Bethany Rooney. She's directed around 240 excellent episodes of television, and I'm just about to hit 20. I have quite a way to go, and I feel like I will always be a student to her teacher. Which is great, because while working on *Bull*, just knowing she was near, really helped me stay calm and focused. You know, I just kept thinking to myself, "WWBD?"

I am SO fortunate. I have many people who have mentored me, and who still mentor me on this amazing path. Bethany, Michael M. Robin, Mary Lou Belli, Rick Wallace, James Duff, Kyra Sedgwick, Mary McDonnell ... they have all nurtured my growth, put tools in my toolbox, taught me their tricks, and shared stories of how they learned from their own "ouches." Michael Robin gave me the initial idea to shoot my documentary feature film, *Send My Mail to Nashville*, and was Executive Producer on the project. He literally put his name on me. Finding people who saw something in me, who cared enough to teach me, and who still speak up and make phone calls on my behalf ... they are the real reason I'm in the middle of this exciting, life-changing career shift. I work 200 percent harder, every single time, because I never want to let them down.

HEMPHILL: What kind of advice would you give to students or filmmakers who want to work in episodic television? Would that advice be different for a woman vs. a man?

BLACK: I have been asked this question many times, mostly because of my unconventional path from hairstylist to director. And I think my advice goes for anything you want to go after in life. Not just this business. You have to show that you have what it takes. If you want to be a director, then direct something. Writer? Write something. Then show your work to those who have the ability to give you opportunities, and ASK FOR WHAT YOU WANT. I can't stress that enough. You have to open your mouth, and state your case. And have the goods to back it up. That goes for women and men, but I think asking for what you want is generally much easier for men. I think my generation of women is the last to have trouble with self-promotion. I'm seeing strong women in the next generation and hopefully they won't have the same trouble. It is very hard for me to do, but I push through it anyway. Because I have a lot to accomplish in my lifetime.

HEMPHILL: So you mentioned that your background is in hair and makeup, and you're also a musician. How do those skills influence your approach to directing?

BLACK: It's all storytelling, if you think about it. Even hairstyling. My approach was to always style the hair, as if the character was styling the hair. So how did that character wake up this morning? What are her plans for the day? Is she planning on getting a visit from the big boss who intimidates her? No? Okay then, let's do her hair in a way that resembles a little girl. Vulnerable. It would add to the character's discomfort. I love making characters uncomfortable. I think that is delicious for the audience. And making music – storytelling. Writing songs – stories set to music. Directing – storytelling. I love stories. I love to read, watch, sing, write, and absorb stories as many ways as I can.

HEMPHILL: How much did you learn while doing hair and makeup that you apply to your job now?

BLACK: I spent many many years talking to actors about their characters. Their wants, desires, likes, dislikes. I listened when actors would talk about directors, and what they loved about them – and what they didn't love. I soaked it up. I use it all. All the time.

HEMPHILL: What are the greatest pleasures of being an episodic director? What are the frustrations and limitations?

BLACK: I am playing in a giant sandbox, with incredibly talented professionals. We get to build intricate sandcastles together. Then smash them apart, and build again. We get to tell stories together. I could not be happier.

Frustrations and limitations? Hmmm ... I get frustrated with myself, usually. At the end of a shoot, I look back and think of things I missed – which we all do, but still – and I can't help but feel I could have done a better job, so I guess that's a good thing. I should keep that edge, so I never become complacent.

4 Norman Buckley
(Gossip Girl, Pretty Little Liars, The Perfectionists)

When it comes to finding visual corollaries for his characters' psychologies, few filmmakers can top editor turned director Norman Buckley. A devoted Hitchcock disciple, Buckley skillfully applies the master's lessons when it comes to shifting points of view and finding cinematic corollaries for the characters' anxieties and guilt; utilizing sophisticated interplay between foreground and background elements, frames within frames and a kinetic mobile camera that continually probes the action for new perspectives, Buckley unerringly finds compositions that both ratchet up the suspense and express emotion and psychology. On shows such as *Gossip Girl* and *Pretty Little Liars*, he alternates between placing the viewer in the characters' shoes and providing an ironic distance, giving equal weight to the cinema's tendencies toward voyeurism and identification. The result on both shows is a unique form of empathetic satire, in which our deep feeling for the characters sneaks up on us amidst morally questionable – at times even appalling – behavior. While he has largely carved out a niche for himself in the world of teen drama, Buckley has also done wonderful work on adult melodramas like the reboot of *Dynasty*, where he strikes just the right note between sly irony and heightened soap opera, all the while using architecture beautifully to convey the internal tensions at work. I spoke with Buckley as he was in the middle of his first season on *The Perfectionists*, a *Pretty Little Liars* spinoff on which he is now in charge as the producing director.

JIM HEMPHILL: Before we get into your directing work, I'm curious to hear your origin story. How did you break into the film business as an editor?
NORMAN BUCKLEY: I graduated from the USC film school in 1980, where I specialized in editing. I had no idea how to get into the film business at that point, so I went back to Texas and began working in industrial films. My sister Betty Buckley is an actress and had a starring role in the film *Tender Mercies*, which was shot in Waxahachie, Texas, near my hometown of Fort Worth. Upon her arrival she happened to hear that the editor William Anderson, who edited for both Bruce Beresford and Peter Weir, was looking for a local assistant for the six weeks of shooting. My sister told him, "My brother could do it." I went to meet with him

and he said he would only need someone for the six-week location shoot. I said, "If I quit my full-time job to do this, then I'd like for you to take me to New York with you to finish the film." He told me, "If you do a good job then I will." And he did. I ended up working on the film for a total of ten months. I will always be grateful to both my sister and to Bill Anderson for giving me such a great opportunity.

From there I was able to parlay that job into assistant editing jobs on *Silkwood* and *Places in the Heart* over the next two years. Both films were also shot in Texas, where I was able to work as a local, and were finished in New York. So I was very fortunate to work with some of the best editors in the business right away: Sam O'Steen and Carol Littleton. What I learned on those first three films I've carried with me always.

HEMPHILL: You worked with some pretty major auteurs at both the independent and studio level: Bruce Beresford, Mike Nichols, Don Coscarelli, Rob Reiner ... what kinds of things did you learn from those filmmakers that informed your own work when you moved into the director's chair?

BUCKLEY: Bruce Beresford was extremely kind to me and essentially gave me a master's course in film appreciation. At the time, the early '80s in New York, there were many repertory theatres that showed classic films. He would invite me to join him and his family for screenings. He would talk to me about why certain filmmakers were great, and encourage me to see films that wouldn't necessarily have been on my radar. I learned a lot about performance from watching Mike Nichols and Rob Reiner work, and I learned a lot about editing from cutting horror with Don Coscarelli. In horror films the fright factor is all in the editorial sleight of hand. I was very lucky in that I learned from ALL of the directors I worked with over the years. I probably had the closest relationship with Robert M. Young, with whom I worked on four films as an editor. He taught me that the camera should always be where the story is. He has been a great mentor to me and I credit him with teaching me the most.

HEMPHILL: Had you always been a fan of movies and television growing up? Did you always want to direct, or is that a desire that emerged later, once you started working in the film industry?

BUCKLEY: I always loved movies and had a very rich fantasy life as a child. I don't think I ever really thought a career in film was even possible, so I never thought about it as a career goal. I was a little lost my first couple of years in college because I had no idea what I wanted to do. I was majoring in history but had no career plan at all. I had lunch one day with my mom and she asked me, "If you could do absolutely anything you wanted to do, what would that be?" And I replied that I would work in movies. And she said, "Then maybe you should go to film school." It was an epiphany. She essentially made me realize, you can do anything you want to do, so what is it that you want? So that is what I did. As I said above, I started working in editing and I was happy in my career as an

editor. The directing emerged later and happened naturally as a result of my editing work. I never set out to be a director. It happened organically, like a fruit that drops off a tree when it's ripe.

HEMPHILL: At what point did you start to seriously think about directing, and how did you make that transition? Where was your editing career at the time?

BUCKLEY: I was quite happy with my editing career – I was editing a lot of independent films which were frequently in film festivals, and I saw myself remaining in features. But in 2000 I began editing television pilots, and every pilot I edited was picked up to series – which gave me a certain amount of clout as an editor at Warner Brothers. I worked on a pilot called *Fastlane* with McG, and I stayed on to edit the series. (I found it difficult work – I think that television editors are under-appreciated. What they do is very, very hard – essentially cutting half a feature film every three weeks.) Originally, McG had planned to direct the pilot of *The O.C.* (later replaced by Doug Liman because of McG's prior commitments) and he asked me to edit it. I said that I would and would remain on the series if they would let me pick the editorial staff, and IF they would let me direct. I wanted a voice at the table. McG and Stephanie Savage were very supportive of this and introduced me to Josh Schwartz, with whom I had a long and gratifying collaboration. I began directing in the second season of *The O.C.* while I was still editing, and by the fourth season I was only directing. I directed six episodes of the show, and then I went from that to two other Josh Schwartz shows, *Gossip Girl* and *Chuck*.

HEMPHILL: What were the advantages of coming in to *The O.C.* as a director who had been on that same show in the editing room? What were some of the challenges?

BUCKLEY: Having edited the show from the very beginning I was intimately involved with all aspects of the show and I knew the cast very well. So it was a very safe environment for me. AND YET – I broke into a flop sweat my first day directing. I was so nervous you could have taken my shirt, wrung it out and had half a bucket of water. I remember thinking, "You can run in the bathroom and hide, or you can just power through this humiliating incident and keep going," so I kept going. Humiliation is good for the soul.

HEMPHILL: At what point did you decide to officially quit editing and focus solely on directing? Was it a risk, or did you feel your directing prospects were pretty secure?

BUCKLEY: I quit editing at the end of the third season of *The O.C.*, and only directed during the fourth. It was a risk, and a cut in pay, but I quickly started filling my schedule when it became clear to people that I intended to pursue a directing career seriously. However, I went back to edit two pilots after that, *The Middleman* and *Chuck*, negotiating episodes to direct as part of my deal on both shows. It was a bit of a jump to start working for people outside of the Josh Schwartz/Stephanie Savage orbit, but

I knew a lot of people and I also got an agent while I was still on *The O.C.* and he helped a great deal in terms of breaking me out of the network of people I already knew.

HEMPHILL: How strategic were you about your career as you worked on shows like *90210* and *Chuck* and *Melrose Place*? Were you trying to build any kind of brand, or just taking whatever came your way?

BUCKLEY: Quite frankly I was grateful to get work and didn't really think about how to strategize about a career. My career has always somewhat revealed itself. I have been ready for the opportunities that have come my way and I never condescend to any material. I am grateful that I've kind of landed in the teen genre, and I don't turn up my nose at it. I think I understand it. I am a teenaged girl at heart.

HEMPHILL: Tell me a little about your experience directing *Gossip Girl*. At the time it had one of the best young ensembles on television, and some of the most gorgeous cinematography. What were the most important things for you to keep in mind directing that series?

BUCKLEY: The years I worked on *Gossip Girl* were some of the happiest years of my life. My late husband Davyd Whaley was an artist. He would travel to New York with me and he took classes at the Art Students League while I was working on the show. It was a very satisfying time creatively for both of us. It worked out that we were in New York for about four months out of each year from 2008 through 2012. I always thought of *Gossip Girl* as updated Edith Wharton and I thought it was a particularly strong show in the first two seasons. I always tried to think about creating beautiful and dramatic tableaus for that show, so that the viewer had an experience akin to turning the pages of *Town and Country* or *Vogue*.

HEMPHILL: You've worked on a lot of series at Freeform, formerly ABC Family. How did you get into that world, and why do you think you've been so successful there?

BUCKLEY: I initially worked at ABC Family editing the pilot of a show called *The Middleman*, and then I also directed an episode of the show. Shortly after that I began working on *Greek* and *Make it or Break It*, directing several episodes of both shows. This led to my work on *Pretty Little Liars*, *Switched at Birth*, and *The Fosters*. My success there has been because I understand the teen genre and I've gotten great support from many of the executives at the network.

HEMPHILL: In general how important is it for episodic directors to cultivate relationships with network executives? At the end of the day, who has the real power to hire you, those executives, showrunners, producing directors, or does it vary from show to show and network to network?

BUCKLEY: All of the above. Network executives have to approve the selection of directors and, as I said above, I have been supported by executives at all of the networks I've worked at. Showrunners and producing directors also weigh in and every show is different in terms of who has the power to hire.

HEMPHILL: You're best known for your work on *Pretty Little Liars*, where
I've always sensed a strong Hitchcock influence. Have you in fact been
influenced by Hitchcock, and if so, how? Who are some of your other
influences?

BUCKLEY: Yes, most definitely Hitchcock. I read the Hitchcock/Truffaut
book when it first came out in 1967 and it has shaped my life and ap-
proach to filmmaking. I learned everything from that book, both in
terms of editing theory and how to block and shoot. My favorite film is
Rear Window. I was watching and studying Hitchcock films even before
I knew that I wanted to be a filmmaker. My other great influences are
George Stevens, Fellini, Michael Curtiz, and Billy Wilder. The con-
temporary filmmakers I admire the most are Terrence Malick, Olivier
Assayas, and Jonathan Glazer.

HEMPHILL: As a filmmaker with a strong background in film history and
aesthetics, where is the line for you in terms of imposing your own taste
on material vs. serving the mandate of the showrunner? How do you
merge your own sensibility with the material you're working with?

BUCKLEY: My job is to serve the series that I work on. I do not impose a
visual style upon a show, I find what appeals to me within the visual style
that has been previously set. That being said, I prefer to work on those
shows and with those showrunners who allow a certain freedom in the
approach. The key for me is to embrace the challenge of merging my
taste and style with whatever show I'm working on.

HEMPHILL: How big a part of guest directing on a show is simply figuring
out the politics in terms of where the power lies? How do you approach
figuring that out when you come on board a new series?

BUCKLEY: As a visiting director, you are the guest. It's a strange way for the
business to have evolved, but there it is. I always spend the first couple of
days on any particular show just listening. One quickly senses who really
has the decision-making power, what their values are, what's important
to them and not, and that information varies on every show.

I respect the people who run the show, those that "live" there, and
I try my best to work within the parameters that they lay out for me.

HEMPHILL: Where is the line for you between planning and intuition? Do
you prefer to plan out your shots in detail, respond to what the actors are
doing on the day, or is your approach somewhere in between?

BUCKLEY: I plan everything. I have an A plan, a B plan, and C plan, which
are so much a part of my consciousness by the time I walk onto the floor
that I am able to dispense with them and then just be in the moment.
I think it is important to be prepared but flexible, ready to embrace
what's spontaneously happening with the actors and the crew, but the
more prepped I am, then I am more able to be fluid. I know the story
backwards and forwards. I know why people are doing what they're do-
ing. If I get any resistance from an actor, then I ask them to show me
what they'd like to do. Nine times out of ten an actor who resists just

wants to know that he has permission to do it his own way, but generally has not thought through what they want to do instead. I very rarely have encountered a difficult actor. Most of them want to be directed and they want to be challenged to see the scene in a different way.

HEMPHILL: Having come from the editing room, how did you learn how to communicate with actors?

BUCKLEY: I studied for several years with Judith Weston, who wrote a book called *Directing Actors*. My job is to create a space where the actor feels inspired and comfortable. How one does that is different with every actor. I've watched various directors treat all actors with the same approach. That is not my style. I tailor my notes to an actor based upon my understanding of how they like to be directed. Some actors want to talk about everything and some just want to be told where to stand and then they want to find it themselves. Sometimes all I have to do is remind them to have the thought that gives rise to the next line. Sometimes I need to remind an actor where they are coming from and where they are going to. Sometimes I have to remind an actor to listen attentively to the other actors. It is a very individual process. I try to respect how the actor likes to work rather than trying to bring them to my own process.

HEMPHILL: You've recently moved into the producing director position on the *Pretty Little Liars* follow-up *The Perfectionists*. How did you get that job?

BUCKLEY: I had directed 23 episodes of *Pretty Little Liars*, several more than any other director, and I'd also supervised several first-time directors on that show. I was ready for a change from LA after the death of my husband in 2014, so when I heard the show would be shooting in Portland I let the producers and network know that I would be interested in the job.

HEMPHILL: What do you find appealing about the producing director job vs. being a journeyman guest director? Is there anything you prefer about the latter?

BUCKLEY: I like both jobs for different reasons. Producing requires a different skill set, but allows me to collaborate with my colleagues in a way that I had not previously. It is rewarding to be building a show from the ground up. Being a guest director is satisfying in that there is always a new territory to be explored and you work hard for a month and then you're off. I enjoy both and am grateful to have seen the process from both sides of the fence.

HEMPHILL: What kinds of conversations do you have with the guest directors on the series? What do you tell them about what you want and what is expected of them? What are the visual principles that characterize the show?

BUCKLEY: My job as a producing director is to advocate for the directors we hire, and to represent the showrunner's vision to them when there is a question. I do not "tell them what I want." They are hired with the

expectation that they know the show and bring their own vision to it. My conversations with the other directors are more about how I can assist them in getting a script and a production schedule that allows them to do their best work. I provide a context for them if needed, talk to them about the strengths of various actors, and provide a second pair of eyes when asked. My job is to support and encourage, not to dictate. I am a great believer in the director's primacy on set. I want to support that idea as I see many people in the industry trying to diminish the episodic director's contribution.

HEMPHILL: What do you look for in the directors you hire? What gets someone asked back?

BUCKLEY: This is a new position for me so that question is probably premature, but I can say with certainty that someone would be asked back who makes their days, who does it on time, who does a wonderful episode, and is popular with the cast and crew.

HEMPHILL: How do you feel the job of episodic director has changed since you started?

BUCKLEY: When I started there was less interface with writers on the set. I think a writer on the set can be a good thing or a bad thing, depending on the writer and depending on the show. Sometimes I have been on shows where I am taking notes from an inexperienced writer who doesn't understand editing and is expecting every take to be an entire perfect performance and exactly the way they envisioned it, and they often will constantly ask me to note the actor with line readings and unimportant details that can squash a performance. It slows things down immeasurably. It's very unpleasant and counterproductive. However, I've also been on set with writers who collaborate, who understand the director's role, and allow me to do my work to the best of my ability. They make the entire experience an expanded one. It can be a very exciting collaboration when I am working with an inspired writer, who is flexible and open. As a visiting director it's often the luck of the draw.

HEMPHILL: What advice would you give film students or independent filmmakers looking to pursue a career directing episodic TV?

BUCKLEY: Episodic directing is NOT auteur filmmaking. As a director on a television show you are there to serve the greater endeavor, not your own stylistic impulses. To be a good television director you need to understand acting, editing, and time management. Not every scene needs to be a four-course meal – some scenes are just baloney sandwiches. Otherwise you will never make your day. I've seen directors crash and burn by trying to do too much, by getting too precious, by shooting too much coverage, by taking too long with rehearsals. It's math. Five minutes an hour is a full hour of shooting on a 12-hour day, so inasmuch as a visiting director understands this simple fact, then he will be ahead of the game.

5 Anthony Hemingway
(*American Crime Story,*
Underground)

Two of the best television series ever to tackle America's endlessly compli-
cated relationship with race premiered almost simultaneously in the first
half of 2016. First up was the FX series *American Crime Story: The People v.
O.J. Simpson*, in which two of the greatest living American screenwrit-
ers, Larry Karaszewski and Scott Alexander, found their greatest subject
in the tragicomic bouillabaisse of race, class, sex, and violence that was the
O.J. Simpson trial. A darker and more unsettling – though no less entertain-
ing and riveting – examination of the same issues could be found just a matter
of weeks later on WGN's *Underground*. That show, which tells the story of the
men and women involved in the Underground Railroad, is set over a hun-
dred years before *Simpson* but feels every bit as urgent and alive – both series
are period pieces that resonate with the way we live now in provocative,
challenging, and insightful ways.

Though the two series are quite different in approach and sensibility, they
share a key creative figure, Anthony Hemingway. A director and executive
producer on both shows, Hemingway has long been one of the most profi-
cient visual stylists and social anthropologists in television; before taking on
Underground and *O.J.*, he helmed essential episodes of *The Wire*, *The News-
room*, *Empire*, *Treme*, and *Battlestar Galactica*, among many others. His dynamic
and original episodes of *Underground* and *American Crime Story* rank with his
finest work, and I spoke with him about them as the first season of *Under-
ground* was about to be released on DVD.

JIM HEMPHILL: I want to start by talking about *Underground*, which I think
 is one of the most visually dynamic and dramatically intense series on
 television right now. The two go hand in hand – the material is inher-
 ently riveting, which motivates some really powerful framing choices on
 your part, which in turn further intensify the drama. I'm thinking, for
 example, of the way you open the series with the runaway slave fleeing
 through the woods; you employ a number of visual devices to ratchet
 up the tension very, very quickly. Could you talk about what kinds of
 choices you're making in a scene like that?

ANTHONY HEMINGWAY: It was a mutual feeling and decision among the creative team to be bold at every turn. The story's narrative runs the course of extremes, so it was important for me to play in the dichotomy of extremes visually. My inspiration always starts from the page, and writers Misha Green and Joe Pokaski very dynamically set a high bar that challenged me to step up to the plate and swing for a home run. We wanted a visual experience that was relevant, cutting edge, energetic, and urgent, which would give viewers a different entry point into a period and narrative that was entertaining and compelling. I'm not a fan of possessiveness, but *my* DP (laughs) Kevin McKnight and I have so much synchronicity when it comes to the cinematography and how it supports story themes and character arcs. Ultimately, I wanted the visceral "edge of your seat" viewing experience that would prevent anyone from changing the channel until the last credit rolled.

HEMPHILL: That opening to the series introduces another aspect that I think *Underground* handles more creatively than just about any other show on television, which is sound design. You've got a number of interesting things going here, not the least of which is the bold but very effective choice of music – you've got an anachronistic Kanye song playing under the chase, which bleeds into breathing that we hear in the same rhythm as the song and a number of other aural elements.

HEMINGWAY: Kanye's song "Black Skinhead" was scripted. It was actually one of the first clues to inform me that Misha and Joe's approach to this was defying every preconceived notion I had.

HEMPHILL: There's a nice balance on the show between frenetic handheld camerawork and elegant, classical camera moves as well as more formal compositions. What factors come into play when you're making your decisions about how to cover a scene?

HEMINGWAY: The visual approach to any scene for me is based on the psychology of it and how best to let the camera become the heartbeat or reactor rather than a dictator. The camera choices should add to the storytelling, not distract from it.

HEMPHILL: Speaking of coverage, do you generally shoot with more than one camera?

HEMINGWAY: I'm a fan of efficiency. Whether it takes one camera or 12 (which I've used) to get the work done efficiently, that's what we'll use. Depending on your shot, you can achieve better compositions with fewer cameras, but there are also times when certain performances (based on the emotion, comedy, matching, long speeches, action, a lot of coverage) benefit from multiple cameras. I'm very attentive to the needs of the set and what can help serve everyone's needs best.

HEMPHILL: When you're directing the pilot and first several episodes of a series, you're making an enormous number of important, to a certain degree irrevocable choices in terms of casting, tone, and visual style – these are things the show will be stuck with forever. How much outside pressure do you receive, and where does it come from?

HEMINGWAY: TV is a collaborative medium. Establishing a new show is fun, at times rewarding and fulfilling, but always stressful. There's so much riding on the success of it. Mind you, it's a rigorous process of proving that you are the best person to be at the helm. It takes a lot of patience and grace to do it because there are so many hands involved. I think of it like parents raising children. You conceive the child, birth them, and as they grow up, the parents try to make the best decisions for that child that will afford them the best life possible. As the director, I'm that teacher or influencer that the parent chooses to provide the best education or whatever factor of elevation for your child. The challenge is gaining the trust needed to collaborate, which then allows me to create the show's foundation and language. The best experiences are when there is collaboration with trust and support.

HEMPHILL: Let's shift gears and talk about working with actors. You're dealing with a lot of unsettling material on *Underground*. What kind of environment do you try to create for the performers to bring the utmost level of reality to their performances, and how do you create it? What are the challenges of executing such emotionally complex effects on a television budget and schedule?

HEMINGWAY: Most scripts these days are more and more ambitious than what the budget, studio, network or airtime will allow for. It's definitely a challenge because normally the scripts are amazing and you want it all, but the reality is you can't always have it all. Hard decisions have to be made when finding solutions. In creating the space, I believe in fostering a fun, creative set. I frequently play music during lighting setups to break the monotony and lower stress levels. In my experience, I've found that being mindful and aware of everyone's needs helps to create a safe atmosphere for the actors and crew and allows them to do their jobs. On *Underground* we filmed in real elements, which added extreme amounts of production value as well as raised everyone's sense of connection and responsibility.

HEMPHILL: There's obviously a huge tradition of movies and television series that focus on this subject matter. Did any of them influence you?

HEMINGWAY: *Underground* was different from page one. First off, it's a story that's rarely known and has never been depicted fully on screen. That alone was a first, so I didn't want too many influences. I was already familiar with what's been done in this period and narrative, so I didn't need to do much research. All I needed to know is that we wanted *Underground* to defy the traditional approaches. That allowed me to fly free.

HEMPHILL: You directed a period piece of a very different sort – though another one dealing with race and class in America – when you came on board *The People v. O.J. Simpson* to direct five episodes. How did you become involved with that project?

HEMINGWAY: Ryan Murphy's partner at the time, Dante DiLoreto, approached me while I was working on an episode of *Glee*. He simply told me that Ryan wanted me to come on board as the producing director. There wasn't ever really a question. (laughs)

HEMPHILL: What were your feelings about the trial at the time it occurred, and how did they change or deepen, if at all, while working on the series?

HEMINGWAY: I was as affected by this trial as everyone else. Having heard and read many stories of inequality, privilege, and racism, this was the first time I got to see it for myself and with my own eyes. Working on the show deepened my charge to help find mechanisms of change and to help us heal and grow.

HEMPHILL: What are the differences between your role on a show like *Underground*, where you're responsible for the pilot, and a show like *O.J.*, where to a certain degree the style and tone are pre-established?

HEMINGWAY: The difference in doing pilots and coming onto a show that has its voice and visual style established is in how you find a way to be helpful and still contribute something. It's a challenge because not everyone truly wants what you can bring to the table. It's tricky and certainly not every experience is enjoyable. The pleasure with *American Crime Story* was that they respected me and allowed me to contribute my talent, voice, and perspective.

HEMPHILL: Whereas to a certain degree your visual references for something like *Underground* are a bit limited, the events you're depicting in *The People v. O.J. Simpson* were covered extensively – to an almost insane level – by the media at the time they occurred. How did that influence your approach?

HEMINGWAY: The challenge was more so in the writers' room, in figuring out what story to tell, because it was certainly a lot more than ten hours' worth. The visual style needed to feel grounded and able to integrate some of the old news footage. Thankfully a lot of that stress was decided on prior to me starting, since Ryan Murphy directed the pilot. Ryan encouraged everyone to be mindful of how much contemporary or present influence we encountered because we were telling a specific story during a specific time.

HEMPHILL: And how differently did you work with the actors on *O.J.*? The styles are, in a way, very different. In *Underground* you have people performing in dialects and surroundings very removed from our own. *O.J.* takes place in a more recognizable, familiar environment, yet one that is still slightly stylized and satirical thanks to Karaszewski and Alexander's take on the subject. Also, while the actors on *Underground* are great, in *O.J.* you're dealing with several huge stars – do they require a different sort of handling from less powerful or experienced actors?

HEMINGWAY: Most actors, regardless of their experience or success, love to be directed. I love working with actors and had the greatest year between working on *Underground* and *American Crime Story*. Both shows have actors that are beasts!

HEMPHILL: Obviously, with these two shows airing at the same time you're building a body of work that examines race in America through a historical prism to comment on the present. What was your primary goal

taking on these two subjects, and did that goal change or evolve by the time the shows aired?

HEMINGWAY: My involvement with both *Underground* and *American Crime Story*, in the same year, was divine order. I couldn't have planned it. I'm blessed to have these opportunities and experiences. These stories are important. We need more of them. They work toward the healing mechanisms we need to educate us for change. The reality we create today determines the outcome or success of tomorrow. Everyone can't be a hero, but everyone can be excellent. That is my goal, to be excellent!

6 Lauren Wolkstein
(*Queen Sugar*)

While many of the directors in this book found their way into the job via other positions on the set, Lauren Wolkstein took a path that is becoming increasingly common in the television industry: she transitioned from the independent film world into episodic directing. Wolkstein first garnered acclaim for her 2009 short *Cigarette Candy*, which won the Grand Jury Prize at the South by Southwest film festival. Her subsequent shorts traveled the world, screening at Sundance and other prestigious film fests, and in 2017 she expanded her 2011 short film *The Strange Ones* into a haunting feature starring Alex Pettyfer (the film was codirected with Christopher Radcliff). Wolkstein's talent caught the eye of Ava DuVernay, who had decided to staff her *Queen Sugar* television series exclusively with women directors. Wolkstein's first episode, season three's "Your Distant Destiny," contained the same exquisite imagery and attention to psychological nuance that marked *The Strange Ones*, and led to subsequent assignments on the series. It's also a terrific case study in how to incorporate one's own visual signature into a preexisting framework; Wolkstein's episode is consistent with her own preoccupations as an artist while still fitting in nicely within the context of the overall series. I interviewed Wolkstein about her television debut while she was deep in prep on a new episode of *Queen Sugar* for season four.

JIM HEMPHILL: How did you get the job on *Queen Sugar*?

LAUREN WOLKSTEIN: One of the show's producers, Kat Candler, had seen my films and informed Ava DuVernay about my work when Ava was looking to hire female filmmakers for her show. Kat and I both had short films premiere at Sundance back to back and we really admired each other's work; I made another short film around the same time that Kat's incredible feature film *Hellion* premiered at Sundance, and we continued to remain in touch about our projects. Kat directed several episodes of the first season of *Queen Sugar*, and I started watching it and fell in love with the show. When Kat was promoted to producing director for the second season, she said that I should contact Ava about directing an episode, but I hadn't directed a feature film yet. Once *The Strange Ones* premiered at South by Southwest in 2017, I got back in touch with Kat

to let her know that I'd love to be involved somehow and was interested in directing an episode for the third season. Not long after that she was promoted to showrunner and I was announced as a Women at Sundance fellow; I was on my way to the 2018 Sundance Film Festival as a fellow when I received the call from Kat that she and Ava wanted me to direct an episode of season three.

HEMPHILL: What kind of preparation did you do?

WOLKSTEIN: The main preparation was to know the show inside and out, including all the actors and characters' arcs as well as the aesthetic look and feel of the show. Once I was hired, I re-watched the show and studied the craft of every episode. I'm an obsessive visual learner; I analyze every shot and scene until I know it by heart. Also, DeMane Davis, season three's producing director, sent me a visual look book – the visual bible for *Queen Sugar*, which included screen grabs from the two prior seasons as well as all the shots and angles used for the set locations. This look book encouraged the hired directors of the show to find new cinematic shots, as well as familiarize ourselves with the *Queen Sugar* framing and composition of shots that were unique and original to the show.

HEMPHILL: How far in advance of your shoot days did you get a script? Was there any leeway in terms of you having input into the content, or was the mandate to shoot the script as it was?

WOLKSTEIN: I received the script several days in advance of my initial prep date for the episode, which is rare, and definitely not the case for other television shows. I feel lucky and grateful that I had so much time to prepare for my episode with the script in hand, and I worked incredibly closely with the writer, Erika Johnson. We had a tone meeting on the first day of prep, in which we went over the intent of every scene and the emotional arc of the characters based on prior circumstances. If there was anything that I felt should be modified in the script, we would discuss, and I would let Erika know ahead of time how I planned on shooting the scene. Erika was with me the entire duration of production, which was great because there were last minute changes that needed to be made to some scenes, usually to account for location changes, production logistics, and actor availabilities. But for the most part, the script didn't change much from when it was locked and sent to me to start my prep.

HEMPHILL: What were some of the visual principles you were told to adhere to in your initial discussions with the showrunner and producing director?

WOLKSTEIN: DeMane Davis was directing the first episode of season three, so I traveled to New Orleans for a couple of days prior to the start of my official prep in order to shadow her and learn about all the visual principles of the show as well as its rhythm and execution. For example, the show doesn't move the camera much besides the master shot. *Queen Sugar* has wide masters and then close coverage of characters' faces. It's an incredibly cinematic show and learning about the framing of the show

was one of my main goals as a guest director. There were some things that I was told that the show never does, and I had to make sure to avoid switching up the tone by using these tools, such as zooming or handheld camera movement. The camera has an aesthetic and feel that directors need to adhere to, in order to keep the tone and visual style of the show consistent from episode to episode.

HEMPHILL: How did you assimilate your own style into those visual principles?

WOLKSTEIN: That was the really fun part, because your job as a director of someone else's show is to adhere to their style first and foremost, but also to interpret your episode via its own style within the larger framework of the series. My episode had a central theme of new beginnings and early transformations for all the characters, and I saw each of these moments as a rejuvenation in their lives. In order to do this, I established a visual motif for my episode that involved circular camera movement and a burst of new energy into each characters' new beginning. This meant that I used Steadicam for Micah's first day at his new school, and I used a circular track for Hollywood's reunion, in which he was showing a new face to his old friends. I also looked at the shift in character dynamics from the beginning of the episode to the end, and I wanted to make sure that I was staging the camera and blocking the characters in such a way that would show these changes.

HEMPHILL: How many days of prep did you get, and what did those days consist of?

WOLKSTEIN: I had seven days of prep, but I arrived two days earlier so that I could shadow DeMane while she was directing. The first few days of prep consisted of a lot of meetings in order to get acquainted with the department heads and to determine what they would need from me for their prep. The most important early meetings are the tone and concept meetings. In the tone meetings, you go through the script scene by scene and talk about how the episode fits into the larger context of the show. The concept meeting is for all the department heads to meet you for the first time and talk through questions that they have for you about specific details in the script that relate to their department needs. Your 1st AD is your right-hand person during this time, scheduling your days and giving you a tour of the sets as well as going on location scouts with you and the director of photography and production designer. This is different from my previous experiences in independent film, because with feature filmmaking you spend at least a month prepping and gathering your crew. In television, the crew and infrastructure are already in place and you're coming on board with little prep so that you can go right into the trenches with the crew and execute your episode. Most prep days are spent going location scouting and then talking through scenes with your DP and production designer. The last few days of prep are spent going on a tech scout with as many crew members as possible and having one final production meeting that answers any final questions for the crew before you start production.

HEMPHILL: How do you make others comfortable with you, and how do you become comfortable, when you're coming into a situation where most of the cast and crew have worked together for months, if not years, and you're the guest yet are also the person in charge?

WOLKSTEIN: It's definitely a balance of being in control while also listening to your crew. Television directing is the most collaborative form of directing that I know of in this industry. The crew is very tight knit and you as the director of an episode are a guest on their show. Therefore, most of the prep days, your job as a new director is to get to know the cast and crew. Watch their rhythms, see how they work, figure out what they want and need from their director. And what do you want and need from them so you feel the most comfortable and prepared when you're ready to shoot? Once production starts, it moves so fast that you have to keep up with the speed and rhythm of your particular show. You have to do your homework and understand the internal mechanics of the show before you get on set to take on the role of director. I like to memorize the call sheet and meet and greet all crewmembers before my first day of shooting. I think the most important thing with this collaboration is to be open and kind and know that your crew is there to help you and you're there to help them and invigorate the show with new energy. Most productions will be really happy to have renewed vitality on their set, especially since they already know each other so well. I think it's important to lean into that new energy you're bringing to a show that's already in session and functioning every day, without fail.

HEMPHILL: Describe your collaboration with the director of photography. How was it different, if at all, from the way you had worked with cinematographers on your own films?

WOLKSTEIN: My collaboration with the director of photography, Antonio Calvache, was wonderful. Antonio is so talented; he's been there since the beginning of the show and created the original visual aesthetic of *Queen Sugar*. For every film that I've directed, I've always chosen my collaborators and worked closely with my cinematographer to create the look of the film together. For television, the look is already established and you have to fit your directing style and approach into that look. As a television director, you're always learning new dialects for your own visual lexicon and storing new tools in your directing toolbox. The same goes for working with my production designer on the show, Ina Mayhew; she had already designed the entire show before I walked on to direct my particular episode. So I'm learning from her what is possible and not possible for my direction based on the sets, locations, and art that she has already created and is creating.

HEMPHILL: In general, what are the advantages of directing episodic television compared to directing independent shorts and features? What are the compromises and challenges?

WOLKSTEIN: The big advantage is that the infrastructure is already in place and the show is already functioning daily for one or several seasons.

Basically, the train is already moving and your job as the guest director is to jump on the train before it leaves the next station. When I make my own shorts or features I start from scratch, hiring my crew and collaborators. As an independent filmmaker, I'm usually the engine driving the film to be made and executed every step of the way. As a TV director, you enter a machine that is already well oiled, which is a huge advantage in terms of resources and budget. You usually have all the resources that you need to execute your vision on episodic television. With independent filmmaking you're always making compromises and changing your plans based on the budget and the money you've already raised. The finances are not always in place and budgets are constantly in flux at different stages of the filmmaking process.

I'd say the major challenge for directing television is that you have to work within someone else's framework or vision for a show – but I find this incredibly stimulating and invigorating. Being a TV director has really elevated my filmmaking abilities to shoot and execute in several different styles and techniques that normally wouldn't be organic or inherent in my own work. Also, with television, you are a constant student to the craft of directing. You're learning from all of your collaborators all the time, who are masters on the show you're directing. You're entering their world and learning from them. And as a new guest director, you are bringing a fresh perspective to your particular episode.

HEMPHILL: How many days did you get to shoot?

WOLKSTEIN: I shot my episode in seven days, and it's my job to make sure we shoot everything we need within 12-hour days every day. I was able to maximize my resources by limiting the number of setups for any given scene. I would also shoot the most challenging scenes earlier in production so we could spend more time on them. Usually the last few days of the shoot are left for locations that have built-in sets. Therefore, we were guaranteed locations on those days whereas sometimes locations and weather make it more difficult for shooting in the time you're allotted; there's always something that comes up, whether it be with the owner of a particular location or crowd control in a big scene. For these situations, it's always best to come as prepared as possible to cut down shots that aren't needed. Also, it is incredibly important to *prioritize the meat*. That is a phrase that I learned from producing director DeMane Davis. Always make sure you are covering the important part of the scene first and then getting additional coverage if you have extra time.

HEMPHILL: How was your role with the actors different on a show where they have known and owned these characters for several seasons compared to when you're making films that are one-offs?

WOLKSTEIN: The actors on TV shows know their characters so well (inside and out) that they usually already have the answers to their questions based on motivations and intentions that have been embedded in their DNA since the beginning. I found that my job with the actors was really

to talk about their trajectory and circumstances for my episode and discuss where they are in the story of their lives. This information was given to me during the tone meeting, and I would articulate this knowledge to my actors based on the conversations I had with the showrunner and my writer. My job as a director is to talk through blocking and staging with my actors so that it's a collaboration between them, me, and my DP to best show the dynamic shifts in the scenes according to who the actors are and what they want and need in every scene. Some actors want more from their directors and some want less, and it's always my job to figure out what each actor needs. This isn't different from my own independent filmmaking work. It's harder to get one-on-one time with actors on television shows because they're shooting while you're prepping, so you need to make sure you plan your time accordingly to meet with them before you start shooting if you want that individual time with them.

HEMPHILL: How long did you have to turn in your cut, and what was your collaboration with the editor like?

WOLKSTEIN: I had four days to deliver my director's cut. During this time, no one but the editor and I are allowed to look at the cut according to DGA [Directors Guild of America] rules; everyone else is only able to watch the episode once I deliver my cut. After these allotted four days, my work is done and the cut is no longer mine. From then on, the next time I see the cut is when it airs on television. My collaboration with my editor was extraordinary. I worked with Shannon Baker Davis, and she was so incredible and used every single shot that we ended up shooting. I came to the edit without having to change much because she had done such a wonderful job already. So, the four days I was given were already more than enough because I was only tweaking what Shannon had already made so great.

HEMPHILL: *Queen Sugar* is famously one of the few major shows (as of this writing) to be run and directed exclusively by women. How do you think that affects the show, both aesthetically and in terms of the set politics and the way it's run?

WOLKSTEIN: I think having a series exclusively directed by women has made working on the show that much more enjoyable. Everyone on *Queen Sugar* knows that they're a part of something really special, and it's a real family of artists. Also, there's a feeling that you are helping to create an environment that is compassionate and empathetic, and I know this can be a rare feeling on television shows. I've directed some more TV since, and I strive to bring that same ethos of sensitivity, kindness, and compassion to all my work. Luckily the very next directing job that I had after *Queen Sugar* happened to also be in New Orleans with a lot of the same crew members, so that ethos was already embedded within the set politics. The close-knit family feeling from *Queen Sugar* translated well into my next job and I hope it will be there for all my jobs in the future.

7 James Hayman
(*The Sopranos,*
NCIS: New Orleans)

James Hayman went to film school at New York University as part of a legendary group that included Jim Jarmusch and Spike Lee; in fact, his first credit on IMDB is as an assistant cameraman on Jarmusch's seminal independent film *Stranger Than Paradise.* Unlike his classmates, however, Hayman wasn't interested in directing – an ironic fact, given that he went on to become one of the top directors in episodic television on shows such as *Desperate Housewives, Ugly Betty, Law and Order,* and many others. Hayman is currently the producing director on *NCIS: New Orleans* and therefore responsible for that series' incredibly kinetic visual style – he has collaborated with several of the other directors included in this book and, in many cases, facilitated their best work. His talent as a producer is surpassed only by his gifts as a director; his own episodes, such as the season three opener "Aftershocks," or part one of the season four finale ("Checkmate"), exhibit a mastery of blocking with a mobile camera that invites and earns comparison to the work of Jean Renoir – with a bit of Hitchcock and De Palma's control over tension and suspense thrown in for good measure. I wanted to hear about Hayman's philosophies regarding both directing and encouraging good work by other directors, so I spoke with him by phone while he was midway through season five of *NCIS: New Orleans.*

JIM HEMPHILL: You have a pretty interesting filmography long before we get to your directing – you were in the camera department on Jim Jarmusch's *Stranger Than Paradise,* you worked as a cinematographer ... how did you get started, and what were your initial aspirations in the film industry?

JAMES HAYMAN: Well, I worked on *Stranger than Paradise* because Jim and I went to NYU grad school together. Tom DiCillo was the DP and I was a camera assistant on it, but it was film school style filmmaking, so everybody kind of did everything. It was a great communal event. It was really lovely.

I then went on to DP a Talking Heads video for Jim, again because we had this academic connection. I didn't originally want to be a director. I started off as a still photographer in a photojournalism program at American University, and a couple of years into that found movies.

After I worked for a news service in DC for the summer and photographed Nixon near the rose garden, doing that sort of shark tank of news photography, I realized I didn't want to do that, and I also realized I function better in a group than by myself. It's interesting, because now I've gone back to still photography as an adjunct to what I do.

So I transferred up to Santa Barbara and helped start an interdisciplinary film department there. I wasn't really ready to commit to UCLA or USC, that kind of commercial film program, and I sort of danced around it during my undergraduate travels through Central America shooting stills and working for the UN. That got me into NYU Film School. That's where I met Jim and Spike Lee and that whole Lower East Side indie film crowd that was really burgeoning around 1980. The NYU program was very much a director's program, but I didn't warm to that. Coming from the world of stills, I started getting interested in cinematography, which allowed me out of the rat race of trying to direct, and I was able to photograph a ton of movies. I was a teaching assistant for the cinematography professor, and I came out of NYU with an M.F.A. with an emphasis on cinematography and then proceeded to push a broom as a P.A. on commercials in New York.

That led me to video playback, and then I was a camera assistant for years working with a lot of documentary filmmakers out of New York. All the while I was shooting indie projects for no money, and eventually I stopped assisting and just started to get some work as a cinematographer. I did that for about 10 or 12 years and, strangely enough, got a lot of work in the Far East. I shot a movie for two friends of mine in New York who were from Hong Kong, a little romantic comedy with Chow Yun Fat as the lead called *An Autumn's Tale*. Because of that, I became known in the independent film world as the guy that could shoot in the Far East. Now, understand, we never left New York. We shot in Chinatown, but somehow that translated to this idea that I could work in the Far East, so I proceeded to do a number of movies in Japan and mainland China.

Around 1989 I came back from a film in China and the indie movie business had kind of dried up in New York, so I moved to Los Angeles. I worked as a cinematographer there for a couple of years, met my wife on a movie, and eventually landed a job as the cinematographer on *Northern Exposure*. I did around two years there as the cinematographer, and the second year they gave me the opportunity to direct.

That's when I transferred from shooting to directing. You know, it's interesting; the first directing gig is very easy to get if you come up through the family, through a show. The second one is the one that's really hard because nobody knows you. I was lucky enough to get a job for Bob Singer on a show called *Reasonable Doubts*. But the big move for me was I landed a *Law and Order*. The producer on it was a guy named Joe Stern, and he really became my mentor as a director. A very interesting guy, ran a theater company in LA called The Matrix Theater. He didn't

direct, but he taught me a lot about acting and he taught me about directing and producing.

After I knocked around as an episodic director for a while I started landing some pilots. At that time it was very easy for episodic directors to move into directing pilots. These days feature directors have realized the benefit of doing TV pilots, so that employment world has shifted, but at the time I directed a bunch of pilots and I had a pretty good track record. Eventually I directed a pilot for the TV version of the movie *Dangerous Minds*. It was picked up and I became the director/producer on that show because I'd done the pilot. Also because Annie Potts, my wife, was starring in it. I think that probably helped.

So then I moved into the directing/producing world. I did that on and off for a while in between episodic directing, and eventually got into the TV movie business because I got tired of the episodic world. Then I came back to the producer/directing gig. It's a very long-winded way to say, "Here I am".

HEMPHILL: Let's stop on that TV movie topic for a second, because it's kind of an interesting world that isn't exactly like episodic directing. How did you get into that arena and what did you like about it?

HAYMAN: I came to TV movies late to the game because I had a pretty successful career as a director/producer, and then the directing/producing position sort of went away for a while. They were few and far between and I couldn't get those jobs so I went back to episodic directing and I got tired of it. So my agent at the time got me into a movie that I did with a producer named Beth Miller who is the greatest thing since sliced bread. She's just a great creative partner, a really, really good producer. I ended up working for Lifetime doing all these female driven rom-coms. Now, I had a history of episodic directing on shows like *Joan of Arcadia* and *Desperate Housewives,* so I could fit into that world. I remember we were doing a scene in the first movie and it wasn't quite working and I said to Beth, "Well, what shall we do here?" and she said, "Well, what do you want them to say?" I never had that as an episodic director. You don't get to change dialogue. You don't get to really be the boss. It's the writer's prerogative. It's a writer's world. But in TV movies, although you work with the writer, you really have more control over the process. So I finished that first movie and I called my agent and said, "These are great! Let's do TV movies!" and he said, "You're 20 years late." But I was very lucky, for a year or a little bit more than a year, maybe two, I went from TV movie to mini series to TV movie, and had some success there.

HEMPHILL: I'm curious about the differences between all those different kinds of directing and the, sort of, advantages and disadvantages. For instance, as far as being a producer/director versus being a guest director, what do you feel are the advantages and disadvantages of both roles?

HAYMAN: First and foremost for me, as a director/producer I am involved in the creation of the show, whether that be the visual aspect of it or the

tonal aspect of it or the production aspect of it. I'm more connected to that particular world as a producer than as a visiting director who comes in and has to suss out and acclimate their style to the existing style of the show. I find that creatively more fulfilling. The flip side is that it's a huge commitment in time and effort and there is a certain level of repetition in that you're working within the same creative parameters of a show, and as a visiting director you get to go from show to show and flex your directorial muscles in a new way every three weeks, or for the three weeks you're there. Also, as a director/producer, you are part of the political structure of that show whereas, as a visiting producer, the first part of your prep is to try to figure out that political structure and fit into it.

Episodic directing is an interesting position in that episodic television is really a writer's medium first and foremost. As a director, you need to set your boundaries so that you're not just a traffic cop but really are going to bring in a perspective, whether it's adhering to the established visual and storytelling style or adding to it, and I think the biggest hurdle is gaining the actors' trust. I'm talking about the regulars, because they've established a work process, they've established a group of characters, and you're coming in and you're observing them and, hopefully, guiding them to continue to create truthful performances, but they don't know who you are. It's a toss-up whether you're gonna come in and take them down another road or distract them from what their process is. So gaining their trust is important.

HEMPHILL: How do you interact with your visiting directors on *NCIS: New Orleans* and how much leeway do you give them?

HAYMAN: My basic style as a director/producer on *NCIS: New Orleans* is to be as involved as possible in the visiting director's prep and then let them fly and direct their episode. I don't like to be the guy that's sitting behind them second guessing what they're doing. I like to think that I can sit behind them and be supportive of them, but there are a hundred ways to direct a scene, you know what I mean? Part of my role as a director/producer is to support whatever that perspective is. If the director is starting to drift away from telling the story of that scene or from the parameters of the way we shoot I will suggest things, but I feel the prep is much more effective as far as guiding and directing the visiting directors.

We have a very specific style to our show that has grown and expanded over the course of five seasons. So I talk to them about that when we do our tone meeting. I used to take the directors and show them a visual notebook I had created pulling scenes from previous episodes that we liked as far as the visual style of those scenes. I would show the visiting directors those scenes and talk about how we got there, how we used the camera, how we used lighting, how we used performance. At this point our directors are pretty much returning directors, so I don't feel I need to do that anymore. With the new directors I will show them a couple of the more recent episodes; the original visual notebook is no longer

applicable because it was done early in the first two seasons and our style has shifted a little bit.

I talk generally about energy and pace, about how we like to have our moving camera. This season we're tending to get into coverage a little bit more, so I talk about making sure you get multiple sizes and coverage so you're not forced to go from our big sweeping moving masters into very tight close-ups. I find that jarring, so I talk to them about the coverage also having movement to it, and I talk to them a lot about getting a variety of angles. If you have a take where you feel like you've got the majority of lines correct, change it up because the thing about television is that it's a constant battle between creativity and time. I like to say that when you're directing episodic and your alarm goes off in the morning, you're already an hour behind.

And so what I've found is that a greater variety of coverage is better for our show than getting each piece of coverage complete. As long as you know that somewhere in your variety of shots, you have a performance on a particular line, move on. Find another angle.

That's how I approach it visually. We do a lot of meetings for all our departments. I'm very involved in the music and the costumes and the props, and we spend a lot of time location scouting and that's where we all come to understand the particular episode and story that needs to be told in that episode. We spend a lot of time in the van together. It's a show that does a ton of location work compared to other shows. So that's where we bond and find what we need for that particular episode.

HEMPHILL: This season you've introduced a new character and moved Scott Bakula's character into a different position within *NCIS*. Were you concerned about how to strike a balance between introducing enough new elements to keep the audience from being bored and, yet, also remaining faithful to what made them fall in love with the show in the first place?

HAYMAN: I think any time you introduce a new character you need to support that introduction by placing them in an existing world that our audience has grown to be comfortable with. So, yes, we've brought in the character, Hannah, and we set Pride to work in another aspect of *NCIS*. But we still have the interpersonal relationships of our other agents. We still have Pride's familial interactions, we still have his personal story and turmoil. I think the one thing that we've done that's really been different and creative, is this whole journey of Pride and his, sort of, visitations by the angel and his more spiritual journey. There have been a lot of conversations about how to do that. I think we found a happy medium where we have this larger than life storytelling but it's placed in a very grounded world.

HEMPHILL: Speaking of conversations about things like that, how do you interact with the showrunner? What's the division of labor there?

HAYMAN: Chris Silber is our showrunner this year. He was the number two guy last year and when he took over he had a different work style than

the previous showrunner, who was very involved in the writing and the storytelling but left the production aspects like costumes, music, visual style, to me. Chris is much more hands on, so we've developed a more collaborative work effort. While we don't always agree, we have an open dialogue about it and, you know, it's a give and take. He's a great guy. He's very easy to work with. Ultimately as a director/producer, you have a point of view about an aspect of an episode or the show and you voice it, but the showrunner, at the end of the day, is the boss. So if he agrees with it, great. If not … generally, my practice is to say what I think twice, and if the note's not taken the second time, I move on. You have so many decisions to make every day about an episode that there aren't a lot of swords to fall on. There's no wrong answer in producing television. It's just another perspective. And the joy of producing episodic television is that if the direction of a certain character or storytelling aspect isn't working, you can take it in another direction, as opposed to a movie where it's finite. That decision is finite.

HEMPHILL: The show has incredibly complicated action sequences. How precisely do you plan those out?

HAYMAN: I am a planner and I am planner of everything, not just the action sequences. I shot-list every scene. Eight times out of ten I never even look at the shot list, but by doing the shot list it helps me focus in on what's the storytelling in this scene, what are the important points of this scene, what kind of visual energy can I give to the scene. In very complicated action sequences, I will storyboard, but coming from cine-matography, I can type out a description of a very intricate moving shot and I see it in my head. And then I give my shot list to the AD, to the cinematographer, to the script supervisor and that gives them an idea of what I will be doing in that scene or for that day. We also, for the action sequences, particularly the fights, do a pre-vis. The stunt coordinator, Jonathan Arthur, takes the stunt people and films them performing a fight and then we give notes on that. It's very amusing because he always adds action movie music to it. It's hilarious. But a picture's worth a thou-sand words, so by having the pre-vis, by having storyboards in a more complicated scene, people can now start to visualize what's in my head. I cannot draw, so I do stick figures and screen directions by the way their noses point. But we've got Warren Drummond to do the storyboards for us. He's very good at it and, more importantly, he can decipher what a director is describing into a storyboard – and normally it's over the phone, sometimes it's FaceTime, so that's a real talent.

HEMPHILL: At the other end of the spectrum from the action scenes are the expository scenes in the headquarters where you've got multiple charac-ters just giving information. How do you approach those scenes?

HAYMAN: Any procedural scene in the squad room where you have four, five, or six characters is going to live or die on the blocking. The trick in those scenes where you're basically laying a lot of pipe, giving information

about the crime or what have you, is to get it up and moving. In the squad room we have two areas of video screens, and we rely very heavily on those screens to help tell the story. We do circular masters and that adds an energy to it, and that came out of the problem that our show doesn't have a lot of background. We've got a very small group of agents, so how do we keep up an energy? If you look at the mother ship *NCIS*, one of the things that adds to the show is that there are always people moving in the background. That gives you a subliminal sense that things are getting done, that there's an urgency. We don't have that, so by moving the camera we try to amplify that in our world.

HEMPHILL: On a show like this that has been on for a while, how do you help keep your actors connected to the material?

HAYMAN: I just talk to them about pace and energy. I think that's the first thing you will notice begin to flag. I find with actors the best thing to do is to be truthful and direct, because if we go back to what I said about one of the difficulties of visiting directors being that they have to gain the trust of the actors, it's no different for me as a director. I don't care that I'm on the show 24/7. Actors are vulnerable. They're the ones there on the screen. Now, certainly I have a leg up with them than the visiting directors because they've seen in the past that what I've asked them to do has worked out okay. But there's no bank. Every moment, every episode is new.

HEMPHILL: And how do you put the guest actors at ease when they're coming into a show where everyone else has been working together for months or years and has a pre-existing way of relating that they're on the outside of?

HAYMAN: I think the most important thing that a director or director/producer can do to make a guest actor comfortable is to make them part of the family. I like to immediately talk to them about what sparked in their audition, and why they got the part. I think that immediately says, "I like you and I like your work," and that is the first step. We cast out of New York City, so we get a lot of really seasoned stage actors on our show, and they come in knowing that they just have to come in and do their work. In fact, in a lot of ways, they're way more connected to the material than our regulars because our regulars are doing it day in and day out, you know? But it's sort of giving them the rehearsal process and paying attention to what they're doing. I think paying attention to what a guest actor is doing early on in the rehearsal process and giving them an adjustment helps to make them feel that they are, not only in good hands, but being paid attention to.

HEMPHILL: What are the most important characteristics you look for when you're hiring your visiting directors? What kinds of directors tend to get asked back?

HAYMAN: A visiting director needs to be a team player and if a director comes in and has the wrong attitude about how the show works and

doesn't mesh with everyone else, then I'm very protective of my family, whether it's the actors or the crew. So that director probably would not be asked back. We haven't had a lot of that, but a couple.

I think that the directors that get asked back have to fulfill a laundry list of things. One: their episode has to be good; two: they have to be able to work with the actors; three: they have to be able to work with the crew; four: I like a director who comes in and sees the parameters and the structure of our show but will be working to bring something new to it and maybe make me a better producer by showing me a way to do something or a way to tell a story that I hadn't thought of before that adds to our show. I think that's great. That'll be the number one thing for me.

A director that comes in and is going to change the script or not shoot what's on the page, they won't have a long life on our show because, at the end of the day, the director's job must serve the material. So, as I said earlier, if something in the scene isn't working I go to the writer or the producer and I say, "Well, this isn't working," and they say, "No. I think it'll work." Then your job as a director is to make that work, and directors that struggle with that don't really work on our show. And also, they have to gain the trust of our actors because if they don't, first and foremost, that's gonna create a tense set and we're not gonna do that.

HEMPHILL: I can't let you go without asking about what it was like to direct on *The Sopranos*, which many people – myself included – consider to be one of the greatest shows in the history of television.

HAYMAN: David Chase's vision of that show was so specific and so carved in stone that I had to work very hard to leave my visual bag of tricks at the door. I came in used to a moving camera and a more frenetic visual style, and David's style was the antithesis of that. His frames were very set, the scenes were more staid, quieter, things unfolded at a slower pace, and I had to really work to adjust myself to that process, work to that style. And there were a lot of non-actors acting on that show, and I had not had a lot of experience with that. It required me to step up as an acting director to get performances out of those actors. An interesting process for me. David cast by who people were and their look and vibe as real people, and our job as directors was to make sure that they brought that to the screen, because if someone is less versed in acting, as soon as you say, "Action!" they become something else. They become the character they were rehearsing in the mirror for two weeks before. You have to break them of that and, relax them to be who they really are.

HEMPHILL: Since you mentioned that you had a more moving camera, frenetic style, I'm curious: who would you say are your greatest influences?

HAYMAN: I'm in awe of a lot of directors and their style: Martin Scorsese, Steve Soderbergh, Bertolucci certainly. I spent my undergraduate time watching a lot of French and Italian and German movies and American movies from the '30s … I'm overwhelmed by someone like Preston Sturges and his uncanny ability to do like a three-minute oner, walking

through a town with comedy. Among action directors Paul Greengrass is amazing. But I'm also a huge fan of guys like Truffaut and Mike Nichols and their ability to humanize stories. When Mike Nichols passed away there were many, many quotes on the internet and in the newspaper about his creative process, and he had a quote about directing. He said, "Directing is like being in a car in winter on a road that is completely iced over and you basically have zero control and you're in a huge slide and you just have to give it up and, if you're lucky, then the car will make its way down this ice covered road". And I thought, "Yeah, that's about right. That's about right."

8 Julie Plec (*The Vampire Diaries, Riverdale, Roswell*)

Julie Plec got some of the best training imaginable by working at the side of master horror director Wes Craven early in her career, yet never saw directing as a viable career for reasons she discusses in this interview. It's highly ironic, given that with just a few episodes of *The Vampire Diaries* followed by episodes of *Time After Time* and *Riverdale*, Plec quickly established herself as one of the most visually dynamic directors in episodic television. She came to directing as a highly successful writer/producer, having created *The Vampire Diaries* as well as its spinoffs, *The Originals* and *Legacies*. All three of these series are marked by an impressive combination of action, comedy, teen angst, romance, and poignancy that Plec keeps in impeccable balance episode after episode. Her strengths as a writer – her fearless willingness to yield to overwhelming emotions, her concision and ability to pack as much story as possible into each episode – are mirrored in her gifts as a director. Her work tends to be as compact and economical as it is overflowing with moving dramatic moments, and I wanted to find out how she achieved her graceful and stylish effects. We spoke in her office as she was preparing to direct the final episode of *Legacies*' first season.

JIM HEMPHILL: I want to start off by asking about the origins of your directing career. Was directing a goal you had always had in mind?

JULIE PLEC: Directing was the opposite of a goal, it was the thing I was certain I would never do. I had two things happen in film school that made me realize it was not my calling. The first one came my freshman year, when we were assigned a still photography project where we were basically just creating storyboards made out of still photographs for a scene between two people. I shot my stills and put my storyboards up to present, and the teacher said, "Can anybody point out what she did here that she should do differently?" Somebody said, "She never broke the proscenium line," and I realized that I had never gotten over the shoulder shots or coverage; I had just shot flat, like a single dimension plane, because that's all my brain could really see. It didn't even occur to me that there was a three-dimensional space there, so I always took that as a flaw of my brain. And then the second thing that happened was I directed a musical,

and I was terrible at it. So by the time I left college, I was certain I would never write – that's a whole other story – and never direct. I still felt that way when I started showrunning and producing television, because the deeper I got into it the more I continued to recognize that I really only see things instinctively on a flat plane, as though you're watching it on TV or in a theater.

I assumed that because my brain doesn't move things into a three-dimensional space, I could never be a director. I would sit in on the cuts and I would edit, and I would give editorial notes, and I would then do tone meetings, and I would tell the director exactly what I wanted them to do. I would talk about shots that I wanted, and I would talk about mood and emotion and songs, and I would pick songs. I would sit on set and I would know exactly what we needed to do and how to fix it, but have to sit on my hands and try not to give too many notes. I would eventually stay away from set completely, because when I was on set it was disruptive – it's hard to be on set with an opinion and then not want to get in somebody's way.

People kept asking me, "Aren't you going to direct, why don't you just direct?" I kept saying, "No, I don't know enough." I was certain I did not know enough to direct. And then a woman said to me, "Do you think a man would deny himself an opportunity to be a filmmaker for that same reason?" I said, "No, actually I don't think they would," and I thought, I have a very rarefied opportunity. I'm six years into a series that I'm the showrunner of, if I want to direct, I can just direct. Nobody would say no to me, and that is a situation that most people, and certainly most women, never find themselves in. So if I wasn't going to take advantage of that opportunity, on behalf of the sisterhood I guess, then I was failing myself a little bit.

HEMPHILL: So if you felt like you didn't know enough, how did you prepare to direct your first episode of *The Vampire Diaries*, "Let Her Go?"

PLEC: I had been on sets for 15 years – I was an assistant to Wes Craven, I worked with Kevin Williamson when he was making movies … I had been on set for a lot of hours of television, and so much of episodic directing is what happens in prep, which I was intimately familiar with. I can't remember what book I read, but I did do a quick "Directing 101" brush up. Then, before I went to do *Riverdale*, where I was directing a show that wasn't mine, I read Bethany Rooney and Mary Lou Belli's book, which was great. It was nice reading that book to brush up on the things that I have a difficult time remembering episode to episode. Directing is a muscle that you have to continue to build, and when I do it once a year I forget a lot of it – even just the language you use.

Before I directed, a lot of people said to me, "Everybody's there to protect you, everyone's there to help." My DP would say that: "We're here to help, that's our job, that's what we want to do." And I said, "But

all you guys ever do is bitch about how you basically directed the episode and you're upset about it all the time!" [laughs] He said, "What's annoying is when people don't know what they know. When they come in, and you end up picking up all the slack, and they have absolutely no self-awareness about what it is that you're doing. That's frustrating. But for someone doing it for the first time, it would be a thrill, it would be an honor."

HEMPHILL: Well, "Let Her Go" seems like a very ambitious episode to take on as your debut. There's a lot of heavy emotional material, you're directing child actors in it, there are multiple time frames and flashbacks, all kinds of stuff. When you were writing it for yourself to direct did you do anything differently than you might have otherwise?

PLEC: One of the ways I protected myself was writing the episode to my strengths. I wrote it to emotion, I wrote a lot of scenes of two people talking. I did not write any big six-people conversations. I wrote an episode that could have lots of great framing and composition, but that didn't necessarily need a lot of big stunts or moves or anything like that.

HEMPHILL: Well, like you say, there are some very interesting things in terms of framing. I loved the overhead shots, for example. Where did that idea come from, and what were you trying to convey?

PLEC: There were two elements that I wanted to run through the entire episode: one was the sun flares and the other was the overhead shots. *The Vampire Diaries* was a no-flare show for most of its run; in the last couple of years, we let the DPs have a lot more fun and a lot more freedom, and we would use flares very strategically for flashback transitions and stuff. We used them very judiciously, and with purpose – they weren't part of the general setting like you see in a lot of TV. This is going to sound cheesy, but I wanted them to represent a combo of who's watching you, who's looking down on you, and what is heaven. In our show, we talk about peace, and the whole show is built around the idea of grief and loss. So the flares were meant to represent a sense of spirituality, and the overheads represented the idea that when you lose someone, the thing that's always on your mind is, "Are they still with me?" So the overhead was just a little way of answering that question.

HEMPHILL: Speaking of grief, one of my favorite scenes in the episode is the funeral scene, where you've got many, many characters whose reactions you're catching as they mourn. How do you approach something like that? Is it preplanned or is it more intuitive on the day, catching whoever you can catch?

PLEC: The way that I planned for it was to have a very clear understanding of who needed to be captured on camera, specifically in what size for what piece. So I knew I needed a look from Elena to Damon, I knew I needed a closeup of Matt Donovan reacting to the loss of the sheriff and being inspired by the community of police because at the end of the episode

he decides he wants to apply to the academy. You know what beats you need, so I lined everybody up so I could just pop through, and know on one take, once I had one of them I could just zoom in and run it again and get the next thing I needed in the same setup.

It's all about the consolidation of setups. Our DPs really like to work on prime lenses, and in a situation like that you just need to insist on a zoom, because if you had to change the lens every time you needed to size up on a character you'd be adding endless amounts of minutes. I made sure everybody was teed up so that as I was running along what I called the fishing line, which is a dolly track that moves from the front of the pews all the way to the back, then back again – you're catching audience, B-roll, that kind of thing – I could also capture a lot of those looks during that run. It's funny, I had planned a fishing expedition shot with the operator just going in and grabbing pieces, getting cool moments, picking out cool extras. We had a substitute cameraman working because our cameraman had been out sick, and I was getting frustrated. And [director of photography] Darren Genet said, "He's not a fisherman, Julie. He's not a fisherman." So then you have to stop, and you have to point out, get this and that. But a cameraman who's intuitively connected to the story can do that for you, and you don't have to pay attention. It could be the most happy accident that you find in the dailies and then the cut, something beautiful the B-cameraman has captured without you paying attention.

The greatest happy accident on that funeral day – and this is where ADs don't get enough credit – is that we had scripted the police salute to Sheriff Forbes, and we researched what it would look like and what they would have to do. It was really just meant to be a five-second bit, but when the AD staged it he had them all rise in unison, he had them all walk and march in unison, and then do that whole beautiful salute. I started to cry at the rehearsal because it was so special, and just decided, we're shooting it all, we're covering it all. It ended up in the show, and turned what was meant to be a quick little moment into a beautiful way to honor the sheriff. And that was just the AD doing his job staging the background, but finding a gorgeous story moment.

HEMPHILL: Well, shooting something like that longer than you intended leads me to the question of editing. How do you feel having spent a lot of time in editing rooms prepared you for directing, and then once you directed did that teach you anything new about editing?

PLEC: Having seen dozens and dozens of terrible cuts, I have a very clear sense of how I want a scene to begin and end editorially. I might know that the master won't come alive until about three shots in, that I'll be starting a scene on a close-up, coming off of another beat prior. Or I've designed the transition, or whatever – I know in my head what the in and out points of the scene are. But when you're shooting, if it's a beautiful master, and they're doing a nice big pull-back at the end,

you just don't yell, "Cut," right away, because you want to see where it goes. It's nice, it's rhythmic, and you just like the feeling of it, so you don't yell, "Cut."

When it comes to performance, even though you know you're going to end on a certain line, sometimes you'll find something in the way they react *after* that line, where you can feel a tear about to fall, or you can feel that they're going to nod or close their eyes. I'm always looking for the editorial cutting point, so I'll wait and not cut until I see a physical shift. Now, an editor believes that their fundamental responsibility is to assemble the footage you shot and honor it, so if you let your beautiful master go on six extra seconds, or if you let that performance play while you waited for the tear, they are identifying that as your intention. So when you watch your editor's assembly it's 18, 20 minutes over what the episode should be, and you have to go through and fall back out of love with the happy accidents that you discovered along the way and prune out all the extra padding. I've had beautiful happy accidents that have stayed in the cut, and sometimes a scene has been cut completely differently than what I designed because of a happy accident.

I've found that it's helpful to have a clear understanding of when you want to use your master. We go all the way to the tightest size in our shows, because we live a lot in the eyes and the face, so the master and the closeups are the two most important shots. If you know you're starting an intimate conversation close and are going to get three lines in before you pop out, then if the crane doesn't work or moves wrong at the beginning you don't care, because you know you're not going to use that part of the shot. You can save yourself a lot of time and grief, and you can also dissuade a DP from wanting to do a big move at the top, because you know you're not going to use it.

HEMPHILL: It's funny to me that you felt directing didn't come naturally to you in film school, because clearly you're comfortable with it now. How quickly did that comfort and confidence come?

PLEC: I had a director tell me once that on the first day of every episode he gets up in the morning and pukes because he's so nervous, and I kept waiting for that feeling. I still have it when I'm writing – every day I think, "I'm a fraud, I'm terrible, I'm a hack, I will never get good at this. It's just a matter of time before I'm discovered." As a director I kept waiting to have a breakdown or think I was going to be a disaster, and then I got on set and called action for that first shot, and I just knew I was supposed to be there. I loved it from minute one, and even with everything I didn't know – with everything I *still* don't know – I just knew I was supposed to be doing it. And it was alarming, because usually I'm a self-saboteur, and I kept waiting for the other shoe to drop. It hasn't dropped yet; it dropped a little bit when I was editing the pilot for *Roswell* and hated it for ten solid days. I thought, "Well, here it is. Here's where everyone finds out that I can't do this," but we fixed it, and it's fine.

HEMPHILL: I'm definitely curious about *Roswell*, but first I want to ask about the other shows you directed that were not your own, *Time After Time* and *Riverdale*. How did those come about?

PLEC: *Time After Time* was Kevin Williamson's show, and he came to me and said, "It's a beautiful time right now to be a woman, and even if you're still gathering experience there are a lot of people who want to take shots on you." He knows what I do, which is attach to the emotional beats and capture them – I always tell directors at our tone meetings, "If you capture the beats that are on the page, you cannot fail. If you photograph the beats, you will be fine. If you are *not* paying attention to the beats, it will be a disaster." Kevin and I share that philosophy, so he knew I would be able to get the emotions and that everything else could be supported. I went in feeling very protected, because Kevin was the boss, and Marcos Siega, who had directed the *Vampire Diaries* pilot, was the producer/director. I knew that neither of them were going to let me fail, so I had confidence – but I also really wanted to succeed and show them they were right to take a shot on me. I struggled with the director of photography, who I've been told was basically carrying episode after episode and was exhausted and angry. I think he made some assumptions about who I was and what it would be like, and he was just not a partner. It was an important and valuable lesson, because I know people on my own shows experienced similar things with DPs in the early years. One of the reasons I started rotating DPs on my shows was to combat the God complex of the single DP. Because they're first in, there all day, it's their crew, it's their team, it's their show. They see you as the intruder – even the showrunner. All the producers, the line producers, the writers, are all intruders on their show. The directors are just visitors; they are not to be respected, they are to be tolerated. It makes for a really toxic environment. But when you rotate a DP, the DP preps with the director and they become a team; they have a relationship and a rapport and go into the episode together. That has made all the difference in the world, not just in the harmony on set, but in the quality of the cuts. Once I started rotating DPs, I started getting director's cuts that were good, because there was a point of view that came from the director and DP working in tandem. The guy on *Time After Time* was not rotating and he was not happy and not nice, which made for a difficult first couple days. We kissed and made up in the middle and got through the episode, but initially I had to combat that energy.

Then there was a huge stunt sequence where I got the pages the night before, meaning it was a big set piece that we were essentially going to wing on the day. I called Marcos, and I said, "I need you to come stage this for me, there is no way I can do this." He came out and asked me what I wanted, and I said, "I generally want this," and he made it work – he set the shots for me, and then he walked away. That's what I mean

about protection from two people who I had grown up in the business with, but I would hope that any production would give that kind of protection to a younger director, as long as that director is okay asking for that kind of help.

HEMPHILL: That leads to another question I have before we get back to your guest directing. What are the qualities that you look for as a producer in other directors that you hire, and what gets someone asked back after you've worked with them?

PLEC: The singular thing that will get a director asked back is a great cut. A director's cut that you love the first time you see it, and that you love all the way through the process. Even if you hear the actors didn't like him or the crew didn't like him, you say, "Too bad. That cut just took a solid two weeks of work off of my plate, they're coming back." If the cut is terrible and everybody liked the director, thought they were a good team player and were prepared and did everything right and were great with actors, then I usually wait to see if the end result of the episode is good. Because as Marcos once said to me, "If the episode is good, that means the footage was there. If the footage was there, the director did a good job." There are a million things that can make a cut go bad along the way, but if at the end of the day the episode is there without reshoots, then the director is good and I will ask that director back. There were some very unpopular directors on *Vampire Diaries* who never missed a beat, and I would say to the cast, "I'm so sorry, I know, but too bad."

HEMPHILL: Let's jump back to your *Riverdale* episode. Was that a different experience in that it wasn't your show, and it wasn't with people like Kevin and Marcos with whom you'd been working for years?

PLEC: *Riverdale* is a Greg Berlanti show, and he's one of my oldest friends. He's never there, but he hired me. It had just launched its second season as a hit show, and I thought, "Why not go in there and experience a taste of my own medicine?" It was the middle of the season, and middle of the season scripts are always late, always, on every show. So I got a late script, a big script with too much to be able to shoot in the eight-day window I had, and I made a list of all the things I thought we could trim and handed it to the line producer. She said, "Oh no, this isn't going to fly. They don't like to make cuts." I thought it would never get done, but they added three second-unit days to the schedule, and we got everything. Because it was a hit, the show had the freedom to spend that extra money, and to make sure that the showrunner Roberto got everything he wanted. Technocranes, drones, it was just one gift after another. And I got to experience a positive relationship with a DP, who while not rotating was still nice and extremely gifted; anything I did was elevated by his aesthetic and his design.

Riverdale was the first new hit for that network since *The Vampire Diaries*, so I got to go in as the creator of that show and work with kids who

had all grown up on it. They were happy to have me, and among the adults I had worked with Skeet Ulrich on *Scream*, so I walked into a very warm environment.

HEMPHILL: Even so, it must be weird to walk into an environment where everyone knows the show better than you yet you're expected to be the boss. What kind of balance do you have to strike between being assertive and being humble and respectful?

PLEC: Funnily enough, I think you're damned if you do and damned if you don't. I remember on day one of prep for *Riverdale*, I didn't say a word during a concept meeting and felt like I wasn't doing my job. I had to remind myself that when I'm the showrunner, I do all the talking in the concept meeting and rarely hear from the director. And if the director does try to say too much, I'm like, "Buddy, simmer down, you don't know us yet." If you come in like a bull in a china shop, trying to assert your authority or even just your competence, you run the risk of stepping on toes from the jump. Conversely, if you say nothing for the first two days, you run the risk of everybody thinking you're passive and that you're not a leader.

So don't make the rule for yourself that you're not going to speak, but don't go in feeling like you have to mark your territory or impress. Being present, having read the script, already having a clear understanding of the material, knowing that you've researched the show, is all key. When I am most annoyed by directors is when they come in and I feel like they watched two cuts, and have done nothing other than that to prepare. If you're coming in to take an art class in the style of Picasso, and you've never studied Picasso, how are you supposed to paint like Picasso? You've got to study. When I did *Riverdale*, I watched 22 episodes in a row, and read every other script that there was. It took a lot of work, but I was prepared. On the shows that have mythology and serialized character elements, the more you know about the show the better – and if you don't know it, that's a problem. If a director comes in and I'm on season six of *The Vampire Diaries*, and they say, "What does this mean, 'vamp speed?'" I'm thinking, "Oh, my god. I can't believe that we just hired you. Have you done nothing to prepare?"

I just had a female director that we worked with who had obviously come out of a boys' club, and really felt the need to not have her hand held, and to assert that she knew what she was doing. She led with terrific confidence and was very likable, but she created extra work for herself by needing to be the one that says, "No, I need to see that. I need to see that camera move rehearsal again. I need you to show me that." Everything had to be signed off on by her, and the DP and the AD got frustrated, because they were like, "We could save so much time if she would just trust us, trust that we're not trying to show her up or make her think that she doesn't know what she's doing. We do know what we're doing, and this machine is very well oiled. And if she can trust the machine,

without feeling like we're taking her responsibilities away from her, we'd gain half-an-hour a day." Which is valuable, valuable real estate. I think it's about finding the balance of understanding that the team exists to make it work for you, and trusting that the team will make it work for you, but also showing yourself as a leader. Whether it's just in the way you interact, the fact that you know everybody's name by the end of the second day, is a really nice thing.

I still forget names, and it's humiliating. Somebody like Bethany Rooney knows who everyone is; Bethany goes into the cast trailers in the mornings and says good morning to each actor. One of the women I directed, I worked with recently, had a cast meeting with every actor, ten, 15 minutes, just to ask them what their process is like and how they like to be communicated with. You don't have to do that, I don't do that, but the actors appreciated it. To feel like you are coming in because you care, and not because it's a journeyman job for you. When you feel the journeyman attitude, you resent it a little as part of a team, because this is your child and your family. And they're coming in like they don't give a shit about your family, it's very easy to read that in a director.

HEMPHILL: Is it important on a show that's been running for a while to keep everyone's enthusiasm up? For example, do actors who have been playing the same parts for years get stale and need an extra bit of help, or is it the opposite – just stay out of their way?

PLEC: I've noticed that the actors don't particularly want to hear from the guest directors after a few seasons, in terms of character and perfor- mance. That's not true across all actors, it's just more common than you think. In early seasons, which I think is a better thing to look at, the actors learn very early on that they get almost no direction at all, and they are starving for it. They're dying to be able to play, they are curious about what options they can give in performance, they want more than the one take that they usually get. I had heard going into *Time After Time* that the previous directors had been so under the gun, and had so much shooting to do, that they were doing one take, one take and out, and the actors had been expressing frustration about how little acting work they were able to do. So I made it a point to go in and prioritize working with the actors over everything else, and I did the same thing on *Riverdale* for the same reason. The lighting, which is gorgeous, takes extra time, so they had so little time to be directed. I went in and I di- rected them, and they were grateful to be able to act and communicate about character and story. I have a feeling if I went back to *Riverdale* in a year, they'd be like, "Why are you talking to me? Get out of my face." Because ultimately, they just at a certain point want to go home. "Oh, we got it in one take, great."

But I think that if I were to make a list of things from my experience to say about episodic directing, if you are in a show where the actors are

still excited to be there, take the time to really understand their character and to be able to communicate with them. Give them more than the one shot at it, talk to them like actors, don't be screaming from the tent, and don't focus as much on the technical stuff. Get in there, get next to them, communicate with them, and make them feel like actors. Some hate it, but read the room.

HEMPHILL: Let's finish with *Roswell*, which you directed the pilot for. Are you a producer on that series as well?

PLEC: I'm an EP [Executive Producer], yeah. The woman who created it is the writer I've been mentoring for about five years, so I was helping her get the script off the ground. I had always said, "I'm ready to direct a pilot, so when the opportunity arises, if it's the right fit, I'd like to do it," and she said to me, "I'd much rather have you do it than some dude that's gonna try to steamroll all over me and not treat me like a partner." So she was very much in support of it, and right before that I did the *Riverdale* and it got really well received all the way up to Mark Pedowitz and Peter Roth at the network, who thought it was one of the stronger episodes that they'd seen of the show. So they were instantly on board.

I'm not trying to put myself down, I earned it, but if you can have a female director on a pilot in a business that has so few female directors doing pilots, it's good for everybody. So they felt like they could trust me with it. That was a great experience, but I alluded to hating myself in the edit. I made a lot of what I now consider to be rookie mistakes shooting that pilot, which I see when I watch it. Everybody else was really happy with it, but I was not at first – though I've grown to love it. There are just things that you learn as an episodic director that you have to unlearn as a pilot director.

HEMPHILL: Like what?

PLEC: It's world-building. You have to visually build a world. When you walk into a preexisting show, the world has been built for you. There are establishing shots in the can, in the edit. There are pieces that they can steal that sell the space for you. The audience has seen every inch of every set, so you can just shoot a scene smaller, because people know where you are. I didn't shoot the city of Roswell, and the reason I didn't shoot the city of Roswell is because I didn't *have* the city of Roswell. Because we agreed to shoot in Albuquerque under the gun, we had one street that was our Roswell, and on the other side of the street we couldn't get any ITC traffic lockdown, so I had no Roswell to shoot. But it didn't occur to me that I needed more until I was in the edit, thinking, "How do you shoot a show called *Roswell* and not really show Roswell? You need the guy inside the car driving by the alien museum, you need those pieces." It didn't occur to me, because in a series you just gather them. And probably they should have been written into the script, obviously that would have helped. You have to be so far ahead thinking about how

you're going to establish, build, and then show off this world. It is very different than episodic.

You also have no idea what the actors are capable of, zero, and it could go either way. No matter how much rehearsing or planning you've done, they could show up on the day and just collapse. Nerves, cold feet, or just fake talent. And you may think you can get through a scene in three hours because it's really simple setups and it's a really basic scene, and end up spending four-and-a-half, five hours on a single performance, because you can't go back and fix it. You've got to make it work.

You have to pay ten times as much attention to all the beats, there's no insert unit that's gonna come and clean up your stuff. You can't have a thing about turning off an alarm, and not get the shot of the hand hitting the alarm. Even though in episodic, that's the kind of thing where people always say, "Don't worry about that, we'll get that later." You have to do a lot of advance tone work for what your temp score's gonna sound like. On an episodic, they've got seasons' worth of cues, they just drop in, and you don't pay any attention to the music. In a pilot, you're basically the first composer, because you've got to give all the references, you and the showrunner have to give all the references musically of what you want. You have to choose the color palettes, you have to work with the DP to say, "I want this to be a red and orange and yellow show, not a blue and green and brown show." You have to decide, do you want this to be a shallow depth of field or long-lens show, or do you want it to be all wide? There's so much more that goes into mounting a pilot; thankfully there's also so much more time. You actually have time to think about this stuff. But with everything you think you know, you don't know actually how little you know when it comes to building something from scratch.

HEMPHILL: And do you have a responsibility to the future of the show in terms of creating a look that can be replicated by other directors down the line?

PLEC: I personally don't believe in blowing the bank on a pilot in a way that you can never replicate moving forward, less so visually than financially. Big huge set pieces, massive drone and crane work, that kind of thing, it's a sales tool. I probably err too much on the side of an episodic producer, when I should release myself from that and just work on the sales tool. That's probably a big lesson that I learned. I was very concerned about making my days and making the schedule, and I was very open to cutting the script down and not building a set that we should have built. When I got to the end product, the scope of that set that we didn't build could have really helped. The one we used felt so small and narrowed the scope of the entire back third of the script. We had major story problems, because some of the lifts that we'd made for time and for money actually created unforeseen narrative problems. I was trying to be a good soldier and a good team player, and I probably did damage to the end result that I didn't need to do had I just fought a little harder and been less

concerned about that kind of thing. I still believe that the director has a responsibility to the whole piece, but nobody applauds you for delivering a mediocre pilot on time. They applaud you for delivering an excellent pilot, whether it's over-budget or not. They demonize you if you're irresponsible and an asshole about it, but operating under the pretense that you're a decent person, and are respectful, there's room for forgiveness if the end result is good.

9 Michael Dinner
(L.A. Confidential, Justified)

One of the most haunting and atmospheric pieces of filmmaking I've seen in recent years is the pilot for the television adaptation of James Ellroy's *L.A. Confidential*, which, as scripted by Jordan Harper and directed by Michael Dinner, beautifully captures Ellroy's unique blend of acidic humor, weary resignation, and brutal violence as both a destructive and cathartic force. Working with his *Justified* collaborator Walton Goggins – brilliant here in the role of Jack Vincennes – as well as an equally fine Brian J. Smith (playing Ed Exley) and Mark Webber (Bud White), Dinner pays tribute to both Ellroy's novel and Curtis Hanson's 1997 film without being constricted by either. Deftly blending a propulsive modern energy with the film noir tropes established by Robert Siodmak, Anthony Mann, and other masters of the form, Dinner has created a crime series that is as singular in its style as groundbreaking shows such as *Miami Vice, Crime Story*, and *Homicide*. The 45 minutes of Harper's script are densely packed with sharply observed cultural insights, richly conceived and developed characters, and enough plot for a feature three times the length, and Dinner keeps the elements in balance with total command – the show is complicated and unpredictable but clear, concise, and delivers an emotional impact as concentrated and impactful as Ellroy's prose. Whether or not Dinner and Harper would be able to deliver on the promise of their pilot was an open question when I conducted this interview; when I sat down with Dinner to talk about his work on the show the pilot had not been picked up by CBS, the network that developed it, and he was waiting to hear if the series had found another home elsewhere. Sadly, it never did, but I still think this interview is of value for its insights into the process of directing pilots and how it compares to features and weekly episodic work. Dinner seemed like the perfect person to talk with on this topic; as the director of pilots for *Sons of Anarchy, Justified*, and *Early Edition*, among others, he's helped shape the visual language of some of the best TV series of the last 20 years.

JIM HEMPHILL: I want to start by asking how you came to be involved in this show, and what your philosophy was going in – how much did you have the book on your mind, or Curtis Hanson's film?

MICHAEL DINNER: I hadn't seen the movie since it came out, but I'm a fan of the novel and I really liked the script, though it certainly didn't feel like a network show. I've actually done other things that were kind of out of the box for CBS – usually, they don't get picked up. But I figured that if I did my job well they would decide whether they had the nerve to program it, or that maybe they'd shift it over to CBS All Access. That's how I went into it, and I felt good about the pilot because it stayed pretty true to the novel tonally. I went back and looked at the movie before I started, and it's a really good adaptation – but it's only 15 or 20 percent of the book. And I wanted to take a more modern approach – I didn't want to be slavish to noir, though certainly I had to pay homage to what came before.

HEMPHILL: Similar to what you did on *Justified* with Westerns.

DINNER: The same thing. I knew *Justified* was a neo-Western, and I wanted to walk to the edge of the cliff in terms of the clichés, and then be able to pull it back. If you know the pilot, there's a shot where Raylan's facing this character Dewey Crowe, and it looks like a scene on a main street in a Western, like a Sergio Leone movie. Raylan's got his gun out and he's facing off against Dewey, and it's shot and framed the way you would expect with the camera kind of low, looking up at him like he's John Wayne … and over his shoulder is a house with a satellite dish. And that's what the show's about: framed like a Western, but there's a satellite dish over his shoulder. It was the same kind of approach on *Confidential*, in that I paid homage to older films but wanted to be very aggressive in the storytelling in terms of the way we moved the camera, the compositions, the lighting …

HEMPHILL: You've got Bojan Bazelli, an incredible cinematographer who did *Deep Cover* and some of my favorite Abel Ferrara films. What kinds of conversations did you have with him about the look of the show?

DINNER: He was great, and like most of the team he had barely done any television. We were kind of uncompromising in how we decided to shoot it, and we just figured, well, we'll see if CBS is willing to stretch or not. Right now we're waiting to hear if there's a life to the show; it did not get picked up by regular CBS, and quite honestly, if I were the writer I'd be concerned about doing it on network, because it's really a novelistic approach. The conversation with the director of photography began with what I didn't want to do. The cliché in film noir is hard lights coming in through blinds, so we shot everything with soft light. And then there's a conversation about lenses – we shot on wider lenses that had a shallower depth of field. In general I tend to shoot on the two extremes of the lens; I like being aggressive in the storytelling and taking the audience by the neck and saying, "Pay attention to this." There's a scene in the pilot early on where a guy pulls a gun, shoots a cop, gets in his car, speeds away, does a U-turn, and then he's T-boned. My thought was, I'm going to shoot this the same way I would shoot this scene today, it's just that

they're in period outfits in period cars. There would have been a way of shooting that 50 or 60 years ago – even 20 years ago – where the camera wouldn't be as aggressive. I wanted it to be as kinetic as possible, so I turned to the visual effects people and said, "I don't want to be limited." The great thing about Broadway in downtown Los Angeles is that there's architecture to hang shots on, and then you just have to somehow remove the little signs and meters and lines on the street and things like that. I wanted to make sure I could rotate around 360 degrees and clean it up, because that to me makes it less of a museum piece. So that was the approach: how can we tell this story so that there's an emotional pop to it, and it's aggressive in modern terms, but still assimilates noir filmmaking? It was tough, because we don't preserve architecture in Los Angeles. Trying to recreate 1952 LA is like doing a science fiction movie set on the planet Xenon.

HEMPHILL: And you're doing it on a TV schedule.

DINNER: The network pilot season is insane. You get a call saying, "Will you do this?" and you start shooting five weeks later. But look, I've lived in LA off and on my entire adult life, and I both love and hate the city. I love the transient nature of it, and the decadence of it. And it's an interesting time in Ellroy's story; the whole history of how the LA Police Department began and evolved is such a great story about a city that's like the Wild West – it's not like New York or Chicago.

HEMPHILL: I'm kind of amazed that you had so little prep, given how fully realized the world is. I didn't get any sense that you were limited in terms of your resources when it came to evoking the period detail. How much of it is digital trickery and how much is actual production design and art direction?

DINNER: There's not a lot of digital trickery in terms of set extension or things like that – we spent a good deal of visual effects money on taking stuff out, not adding. Giving it scale is more of a storytelling trick than anything; I mean, there are some locations that are very tight but work for the kind of claustrophobia the story needs. I was worried about whether or not we had enough scope in this thing, but I think there is enough, and when it's contrasted with scenes that have the characters in pressure cooker situations there's relief. I try to direct like I'm writing a pop song, where you've got verses and choruses and bridges. You've got to earn the right to be fast. You've got to earn the right to be slow, to be tight, to be wide. So there are a lot of tight spaces, but some spaces that open it up, and that contrast is what gives it a sense of scope.

HEMPHILL: Another tough thing about that tight prep is that you don't have that much time to cast, and casting is everything with a series. How difficult is that process?

DINNER: I've seen network pilots fall apart because you can't cast them; sometimes the cast falls off the truck and sometimes it takes a long time. Right now I can't imagine anybody doing the role in *Justified* other than

Tim Olyphant, but we actually did a dance with Woody Harrelson for five weeks before it worked out with Tim. With this one, I think that CBS gave it a lot of rope because it was out of the box for them. It all happened very quickly; Walton Goggins was the first one to become involved, because he and I had a long relationship after doing *Justified* for six years. Then I got word that Shea Whigham, who Walton shot in the head on an episode of *Justified*, was interested, and he came on, then Brian Smith, who I'd seen in bits and pieces of *Sense8*, then Mark, and they all loved doing it. Usually in network there's a lot of committee decision-making, but on this one they trusted the writer and myself and New Regency, who were producing it, and Lionsgate. Our first choices were the people we cast, whereas often, when you're doing a network pilot, you might not get anybody in your first five choices. The characters here felt complicated and gray, which is what I liked about the characters on the Elmore Leonard shows I did, *Justified* and *Karen Sisco*. But maybe that's why the show didn't get picked up by CBS. And they love it, by the way — it's just not a typical network show.

HEMPHILL: Yeah, I was very surprised by what you got away with in terms of the violence and the darkness of the world.

DINNER: I didn't want to temper it. I've done a lot of violent stuff, and what interests me is when it grows out of character and you don't see it coming — when it's explosive. What I liked about Elmore's stuff is that you didn't see the joke coming and you didn't see the violence coming. Sometimes it came within the same scene. But I don't like to make stuff violent just for the sake of manipulating the audience. It has to be organic somehow.

HEMPHILL: Did you have to take anything out in editing that you didn't want to, either for time or because it went too far in terms of the violence?

DINNER: A little bit. I kind of shot to the bone because we didn't have a lot of money — shooting in LA was hard, not just because we were doing 1952 but because there's no tax credit when you're doing the pilot. Lionsgate's chairman, who I've known for a long time, called me up and said, "Why is this so expensive?" And I said, "Well, you've got 100 people in a scene, it's 1952, they're not going to wear clothes that they got at the Gap. You have cars stretching six blocks up the street." So I gave up a day, which meant cutting some scenes to begin with, and then we lost some scenes editorially. CBS had me pull back a little on the violence, and there were things I took out that I think would let it breathe a little more if I put them back in. Things that gave the characters a little more psychological space. If the show finds a new home on streaming or someplace, I might put three or four minutes back in.

HEMPHILL: Once you turn in your cut, is there a lot of testing that goes on to help the network decide whether or not to pick up the pilot?

DINNER: Well, it varies from network to network. Some places, especially in cable, try to screen it for their target viewers; some places go for a more

general audience. When I started in features, it was terrifying. Over the years I've found that some of the testing gives you good information, but a lot of it's bologna. This one actually tested well, but I've had pilots that have tested through the roof that they didn't pick up because it just didn't fit with what they wanted to do on their network. And sometimes they'll pick up stuff that didn't test well because they had a need for it. I think with this one they were really torn about what to do, because it just doesn't belong on the schedule with their other shows. It's a different thing. But I love it, and I hope that it has a life, because I think that the actors are great and it would be great to see it continue.

10 Joanna Johnson (*The Fosters, Good Trouble*)

Joanna Johnson first garnered attention in the television business as an actress on the CBS soap opera *The Bold and the Beautiful*, but acting was never her primary love. A gifted storyteller on both the page and with the camera, Johnson found her first success as a writer by creating the hit sitcom *Hope and Faith*, and then really hit her stride as a writer, director, and producer on the groundbreaking drama *The Fosters*. *The Fosters* began as an intimate portrait of an unconventional family and expanded and deepened to become a cultural touchstone, an essential reflection of and commentary on the times in which we live. Over the course of its five years *The Fosters* addressed virtually every relevant social change and political issue imaginable, ranging from marriage equality and racial profiling to immigration, the privatization of public services, and the role class plays in our legal system and in society at large, but the show's genius was in its ability to do so with all the nuance and sophistication that our public discourse so often lacks. Angry and passionate yet committed to civility and empathy in a contentious era, it's one of those rare series that started strong and only got better and better − the series finale, written and directed by Johnson, caps everything off with one of the most emotionally resonant and meticulously structured hours of television I've ever seen. Juggling relationships and issues that have grown increasingly complex over the course of five years, Johnson keeps everything in perfect balance, her camera unerringly honoring the right point of view at every given moment and her script striking just the right note of bittersweet resolution. For those of us who followed the series since its beginning, the finale was an almost overwhelmingly affecting experience; standing on its own, it's a flawless hour-long piece of visual storytelling. Johnson began directing on the show in season three after being on board as a writer and executive producer from the beginning, and her episodes are all characterized by a remarkable emotional power in both the performances and the editing and compositional choices. I spoke with her about making the transition to directing while she was on the set of the *Fosters* spinoff *Good Trouble*, on which she also juggles duties as writer, executive producer, and director.

JIM HEMPHILL: I want to start by asking a little about your origin story, because I first became familiar with you as an actress. Had you always wanted to write and produce and direct, or did those desires all come later after you had been in the business for a while?

JOANNA JOHNSON: I never intended to be an actress. I went to USC and wanted to be in the film department, but I was afraid that I wouldn't get in because I knew it was really competitive. I applied to the psychology department, and then transferred over to film. I got my degree in Critical Studies, which was an easier department to get into but still gave me access to the production side of things as well. I went through all my film requirements quickly because I loved those classes, and in my last semester I was kind of bored. I knew people in the theater department, and I realized that the theater department and the film department just didn't interact. They weren't teaching directors how to work with actors. I got into a private acting workshop through another girl I knew in school who was acting and studied with this guy Darryl Hickman for quite a while. It kind of got me hooked on wanting to act. I also took directing workshops, and I was a horrible director. I overcomplicated all my shots, and I just kind of overdid everything. Out of college I was also writing and taking writing workshops, and ultimately I realized that was my real passion. And I wasn't a great actress. I mean, I was fine, but I knew I really wanted to be behind the camera. I wanted to be the one telling the stories, I wanted more control. So I quit the soaps, because I knew that if I was working and making money, I wouldn't be that motivated. I needed to be a little more desperate. I quit and had no money and I just wrote and wrote until I got my break.

HEMPHILL: When did you start seriously thinking about how to begin directing after your writing career started going well?

JOHNSON: I thought about directing when I was doing *Hope and Faith*, which was a sitcom I did in New York. I thought if we went enough years, I might do that, but I was a little intimidated. I learned a lot about cameras, because on a sitcom you're watching the three or four cameras at the same time – which also means you're kind of getting an idea of editing. Editing that show, and also editing *The Fosters*, is where I really learned about directing. If you can spend time in an editor's bay and just watch, it's such a great place to start. That's really how I got the confidence that I could do it. I think editing is a great training ground, and a lot of editors make great directors, as do a lot of cinematographers. The thing about editors is they are crafting performances as well, so they really know how to tell the story.

HEMPHILL: So would your advice to aspiring directors be to spend as much time in the editing room as possible?

JOHNSON: It's definitely important, but you know, my main advice to young people who want to direct would be: don't go to film school. Study liberal

arts – literature, history, something like that – and live life. Don't study film, study life so that you have something to write about or a point of view to express as a director. And then the best training you can get is to get on a set and work as a production assistant. Get on stages and watch, ask questions ... don't go to school for it. I did that, and I think it was limiting.

HEMPHILL: What kinds of things were running through your head when you would watch other directors' cuts on *The Fosters*, and how did your opinion of their work change after you directed yourself?

JOHNSON: Oh, I have much more empathy for directors now that I have directed. I used to ask, "Why didn't they get that shot? Why are they doing this?" Then I realized that when you're directing, you're in a hurry. On TV you only get seven days to shoot, and we're a very ambitious show with a lot to get in a day. You just can't get everything you want to get. Sometimes you miss things. That's just human because you've got so much that you're thinking about. But I did learn from things I didn't think were that well done, and I thought, "Well, I could probably do that better." And I really wanted to take the process all the way through. When you're an actor, you only get to be part of the process. When you're a writer and producer, in television at least, you get to be in the edit, but you're still left out of the part of the process that the director does, the interpretation. Writing teachers tell us all the time, "writing is rewriting," and it's true – and every step of this process is rewriting. You're retelling the story. Once you finish the script, the actors are retelling the story – they're rewriting it. Then the director comes in and rewrites it again with their interpretation. Then there's the production designer and the costume designer and the casting director ... everybody's participating in the creation and every step is a rewrite. Then you go into the edit, and that's the biggest rewrite of all. What's great about directing is that it's that missing piece of interpreting stories that I wasn't able to fully participate in before.

HEMPHILL: Speaking of writing, how has directing informed your writing process? Do you write any differently when you know you're going to direct an episode?

JOHNSON: Directing has really helped me know what's possible and what's going to be really challenging. To know something is going to be very hard to shoot and maybe we should find a better way. Just like having been an actor helps as a writer, because you know certain scenes or certain lines are going to be hard to play. Having directed helps you to write in a more production friendly way, and it also helps you know what the strengths of your cast and crew are so that you write according to their strengths and not put too much pressure and stress where the weaker links may be.

HEMPHILL: What other things did you learn when you directed your first episode?

JOHNSON: I learned to trust my instincts. For example, I knew we didn't have some coverage we needed. The DP assured me that we had it, and I knew we didn't have it. I realized later that he didn't know exactly what I was referring to. A communication issue. I didn't have that shot, and I wanted it. So I learned that you have to speak up and get the coverage that you need, and trust your instincts regardless of what other people are telling you. I also learned that directing is really hard; it's mentally exhausting because there are so many things you're thinking about at once, and you're on your feet for hours and hours. I have such respect for the crew that pulls these long, long hours. They have incredible stamina. I also have a lot of respect for guest directors who go from show to show without much of a break. It's exhausting, and it's even more exhausting when you're green because you're trying to learn. You don't have the experience and the shorthand to go in on the fly and figure something out, and one thing you learn is that you have to be willing to throw your best laid plans out. You have to have a plan, but things change or actors will say, "I don't want to move there or do that," and you've got to be able to think on your feet and change things around quickly.

To me, directing is a lot about math. It's almost like geometry, just knowing the angles you need. Again, spending hours and hours in an editing room is so important because I know the pieces that I need and don't have to have perfect takes in every side that we're shooting. One mistake of first time directors is trying to get a perfect master. The truth is you're not going to be in the master that long. You're wasting your time on the master when you need to get into close-ups, or learn how to turn a master into coverage. You need to learn those really good cinematic tools to make your day.

HEMPHILL: Given those tight schedules, how do you give the time and attention you need to the actors? What kind of environment do you create for them?

JOHNSON: I try to make them feel safe and heard and like they're a partner in what we're doing, but then I let them do their thing and try to stay out of the way, making small adjustments as we go. Sometimes when I'm on set with other directors, I don't think they're sensitive to the fact that an actor is working very hard to stay in an emotional place, and everybody's around them talking and moving around, and not being respectful of the fact that they need to focus. If it's an emotional scene, don't cut a lot … let them stay in it. Because when you yell cut, everything falls apart a little bit.

HEMPHILL: What other things do you notice about your guest directors that would be important for people going into this job to think about?

JOHNSON: As a guest director, you have to be collaborative, and you have to come in and recreate what the show is, not reinvent it. You're there to bring your talent and your point of view, but your primary job is to capture the tone of the show and understand what the writers and

showrunners want out of the scene. We have tone meetings where we go through each scene with the director and talk about what we're looking for; some showrunners have eight-hour or two-day tone meetings, but I don't have time for that. We have a two-hour meeting, and I'm hoping the director is paying attention and getting what we want. It's important to me that the director is a good interpreter, and I appreciate when they say, "I have this in mind. What do you think?" So that I can say, "Yeah, try that," or, "I don't think that's going to be what I'm looking for." Sometimes I'll say, "Please try it, but also give me coverage. Give me the other way we talked about just in case." I think being collaborative and prepared are two really important aspects of being a guest director. The issues I've had have been with directors who don't really want to listen, or are somewhat hostile to having a writer on set. This is a writer's medium, and I want my writers on set. I want them producing because they know the show better than you do and they know where the show is going when you don't know that.

HEMPHILL: Of course, because *The Fosters* and *Good Trouble* are your babies, when you direct you kind of have the best of all worlds. Would you ever guest direct on someone else's show?

JOHNSON: I don't think I would pursue it. I like the luxury of answering to myself when I'm directing. It takes a lot of pressure off when you're directing your own show. On somebody else's show, I think I would be terrified to make a mistake and not get exactly what the showrunner wanted! Maybe when I learn more and get better at it, I'll try it.

11 David M. Barrett
(*Star Trek: Discovery, Blue Bloods*)

A couple years ago, I was in a hotel room flipping channels when I came across an episode of the popular CBS series *Blue Bloods*, an ensemble family drama in the form of a procedural anchored by Tom Selleck. I was struck almost immediately by how stylistically expressive the episode was; it was clear that the director had thought through a precise means of conveying each character's perspective in a distinctive way, assigning specific focal lengths, camera moves, and color and lighting strategies to each protagonist. It was the kind of subtle but dynamic approach to visual design one finds in the classical Hollywood cinema of directors such as Michael Curtiz and Victor Fleming, and I was stunned to find it on TV while casually channel surfing. I made a note of the director, David Barrett, and began looking up his other credits.

I quickly discovered that the *Blue Bloods* episode was not an outlier; Barrett's work on shows as diverse as *Arrow*, *Under the Dome*, and *The Mentalist* were equally impressive, and his contributions to *Blue Bloods* – on which he is an executive producer as well as the primary director – have expanded and deepened that show's visual grammar in a way that is as rare and valuable as it is easily taken for granted. In 2017, while on hiatus from *Blue Bloods*, Barrett directed one of the best hours of sci-fi television I've ever seen, the "Magic to Make the Sanest Man Go Mad" episode of *Star Trek: Discovery*. It's a time loop narrative – a kind of *Groundhog Day* in space – that encompasses major character developments important to the arc of the series as a whole, but races through them in a breathlessly intricate plot expertly constructed by writers Aron Eli Coleite and Jesse Alexander. In Barrett's hands, the pace is swift without ever feeling rushed or chaotic, and the emotionally resonant moments are expertly balanced with the comic and suspenseful ones; his direction of the actors is as sensitive as his action filmmaking is kinetic. I spoke with Barrett while he was taking a break from shooting a new *Blue Bloods* episode and asked him about breaking down a script, working with actors, and the pressures of taking on a beloved franchise – especially when that franchise is being used to launch an entirely new streaming service.

JIM HEMPHILL: It seems to me that one of the challenges with your episode of *Star Trek: Discovery* would be keeping the audience acclimated

throughout the various time jumps ... if the director doesn't have his hands firmly on the controls, the material can come across as chaotic and confusing rather than involving and surprising. What was your initial response to the script?

DAVID BARRETT: Well, my first thought was that it was overwhelming, because it was a new show and a lot was riding on it for CBS. On top of that I've got a time jump episode, which means you have to choreograph every extra, every prop, every light, every actor's gesture. You have to figure out how to make each scene different than the version before, but still the same – when a character comes in with a new piece of information that's different from the previous time we saw that scene, what's the ripple effect? You have to follow that ripple effect down to every background artist. So if you have a hundred extras, that's a hundred people that you have to think about – what are they doing different? In the first draft of the script I think there were eight different time loops, so that's literally eight hundred beats that I had to choreograph and justify for the background artists, crew, and cast. If you go to a new time loop and you're not specific about what's different and why, everybody starts to check out, especially when it's hour twelve in the day. Whenever a question is asked of you in one of these complicated episodes, if you're not able to answer it clearly and decisively you're going to lose everyone. They've all got muscle memory from doing the scene one way, and it's very difficult to break that muscle memory.

HEMPHILL: And you have to make it make sense not just for the crew but for the audience, which means finding multiple ways of directing the same scene that are different yet organic. Every time you go back to the beginning of the time loop, I noticed that you were altering the way you moved the camera to convey that while the story might be repeating, the emotional and psychological underpinnings of the scene were shifting.

BARRETT: Right, in addition to making sure the time loop makes sense for the audience, I also had to keep them from becoming *bored* by the repetition, which they would if I shot it the same way each time. So I had to figure out how the different emotions in each time loop would determine what I was going to do with the camera – I approached each segment differently, depending on whose point of view we were seeing the time loop through and what new information that character now had. We started out in studio mode, then went to Steadicam, then to Steadicam with a remote zoom, then hand-held, then hand-held with a remote zoom – I wanted to get across the increasing sense of desperation. From a production standpoint, I'm sure the thinking was that the episode would be easier than normal because we could just steal pieces from the original time loop rather than shoot fresh material every time, but in order not to be redundant I had to shoot original footage each time so that the audience didn't feel cheated.

HEMPHILL: Well, if a character has new information, then you have a responsibility to cover it differently.

BARRETT: Exactly. If the behavior is different you have to complement that with the camera.

HEMPHILL: What's your process for planning all that out? As you said, there are hundreds — thousands, really — of moving parts you have to keep straight in your head before you ever get to the set. For each character there are dozens of decisions having to do with blocking, camera movement, lens choice, how you choose to light and frame the scene, color, etc. … and it's exponentially increased by the time loop conceit. How do you keep it all straight in your head?

BARRETT: It was the most complicated script I've ever shot in my life. What I had to do was sit on the floor in my hotel, and every time I got a new revision — and that was another challenge, the script kept changing — I had to cut the script up into pieces and lay it out on the ground. I had so many different columns on my floor trying to keep track of the different time loops and what all the characters were doing that I had to move into a bigger hotel room. [laughs]

HEMPHILL: You mentioned the additional pressure of this being a new show, and a show that's essentially launching a streaming service — I know they had *The Good Fight*, but this was the show CBS was really using to try to drive subscriptions to All Access. What was it like coming into that kind of environment as a hired hand, as opposed to working on *Blue Bloods*, which is an established hit where you're the boss?

BARRETT: Well, I'm never the boss — the showrunner and the audience are the boss. In the case of *Blue Bloods*, it's very difficult to be on a show that's been on that long and keep motivating, pushing, and inspiring people — which you have to do, because the minute you start to coast, the numbers go down. To keep pushing the boundaries and remain passionate and inspire the crew on a show that's been on for eight years isn't easy.

Now, *Star Trek: Discovery* was scary as hell, to be honest. The responsibility was almost paralyzing. I was so grateful for the opportunity to come on board something as iconic as the *Star Trek* franchise, and I didn't want to be the guy who underdelivered. The best way I can explain coming in as a guest director is to say … imagine starting a new job every 15 days. Because you usually have around seven days of prep and an eight-day shoot. So imagine going to a brand new job, meeting everybody, and *running it* — you're expected to have all the answers, even though everybody else has been there for months or years and you've just arrived. The tricky thing is that you have writers and showrunners and a network to serve, and you want to deliver the tone that they want — but you have to deliver it in a way that they never imagined. In the case of *Star Trek: Discovery*, nothing had aired yet, so I approached this like I was shooting a pilot — ordinarily when I come on to direct a show, I watch every previous episode and try to honor the style they've set up, but in

this case there wasn't much footage available to watch. One of the first episodes of television that I ever directed was an episode of *Enterprise* [a *Star Trek* series starring Scott Bakula that ran from 2001–2005], so I've always loved *Star Trek*. I loved what J.J. Abrams did with *Star Trek*. I loved the way he complemented the actors' energy with the camera. I wanted to do something similar here; my priority was really drawing the audience into Burnham's experience, so that they would feel what it was like for her to experience love for the first time. In the scene where she's falling in love at the party, every decision from the long lens to the lighting to the actors' gestures – where his hand falls on her back, when her hand touches his shoulder – is designed to make it feel as though those are the only two people in the room. I wanted to put as much detail into her behavior as possible so that the audience would really relate to her and feel those moments when he took her breath away. In terms of directing the actors, it was about giving them permission to fall in love with each other – I told them to let everything else around them fall away, to never break eye contact, to listen to each other intently. The actors had to be fearless, which they were.

HEMPHILL: There's a wonderful intimacy to that scene, yet there's also a great sense of scope. The romantic moment takes place against the backdrop of this huge action story, and the series as a whole does a great job of balancing the intimate and the epic – it's something I've noticed about the series as a whole, not just your episode. The show has the scale and ambition of a great sci-fi feature film, without the kind of straining against the resources that you sometimes find in television. I've noticed that some of the other shows from Secret Hideout [Alex Kurtzman's company, which produces the series] have similarly high production values … what's it like for you as a director to have that kind of canvas?

BARRETT: Well, here's a quick example from that scene we were just talking about: I'm sure they spent a lot of money to get the Al Green song, which I never would have imagined I'd be able to get. But the producers selected it and paid for it, and it added a whole other layer to the scene, which speaks to how important it is to have good producers with high standards and expectations. I can deliver pieces of a good scene, but without smart producers who know how to take full advantage of those pieces in post and a good editor who understands sound, cinematography, and emotion – and the editor on this show, Andrew Coutts was one of the best I've ever worked with – a scene like that can fall totally flat. The great thing about *Star Trek* is that everybody is all in, from the first AD to the producing director to the showrunners to the writers to the line producer. I remember a point on the second day of shooting where I was playing it a little safe and [executive producer] Heather Kadin called me. She said the dailies were looking good and they were happy, and I said, "I'm glad you're happy, but I feel like I'm playing it too safe." She said,

"We hired you to shoot the show the way you see it. Don't play it safe. Shoot it." That was a pivotal moment that had a lot to do with why the episode turned out as well as it did. And everyone was like that. There was another director, Doug Aarniokoski, who did the episode before me and shared what was working and what wasn't – he was very gracious about giving me the lay of the land. The AD, Woody Sidarous, gave me his weekends; [showrunner] Aaron Harberts stayed on the stage after wrap one night and spent hours working on the script, then went right to the airport to get on a flight back to LA – he never even slept. Then another writer, Ted Sullivan, flew in with three hours' notice and spent the whole shoot with me making the script perfect. Then there was the cinematographer, Glen Keenan, and the producing director Olatunde Osunsanmi ... I'm not trying to be political here, this is the truth – these people were all instrumental, and all very generous with their time and knowledge. It truly was a collective effort. And I ask them all a *lot* of questions, because every moment on every page of the script means something to me. I need to know the meaning behind every line so that I can be as specific as possible with the actor – the more I can give them, the more confidence they'll have and the safer they'll feel committing to their own interpretation of the scene.

HEMPHILL: Well, that leads me to what I respond to so strongly in your work, which is that you're clearly an actors' director but you're also very visually oriented, and you pay full attention to both performance and visual style without compromising either. How do you keep that balance? What motivates the decisions that go into blocking the actors and composing the frame?

BARRETT: It's all about character. Whose point of view is it in the scene? I'll shot-list and block from whatever point of view the story is being told. Knowing that point of view and the emotion that's being expressed informs everything, from the blocking and behavior to the color palette of the production. I'm working off of whatever I felt the first time I read the script – everything down to the accents on the wall is driven by that initial emotional response. Every department – camera, wardrobe, production design – has an opportunity to help tell the story, and it's the director's job to inspire each department to put an extra bit of care and purpose into their work. Collectively, that's the difference between an episode that moves an audience and an average episode.

HEMPHILL: I know you have a long relationship with CBS ... was directing something for their streaming service a different experience?

BARRETT: Well, I was very aware of what it meant to the network, so I was thinking about it from both a creative standpoint and a business standpoint. CBS was putting everything they could into this in an effort to launch the app, because it's a whole new revenue stream for them. So in that sense I was conscious of it being a show for the app, but no matter

what platform you're directing for you never want to take shortcuts or cheat the audience. Never. *Star Trek* is one of the biggest franchises in the world, and I was determined not to leverage the name or just rest on the laurels of the franchise but really give the audience a fully dimensional experience. You're only as good as your last job in this business, so you have to put everything you've got into every one – that's the way I approach it.

12 Andrew McCarthy
(*The Family, The Blacklist*)

Two things distinguish director Andrew McCarthy's television work: exceptionally loose, naturalistic performances, and a rigorously elegant sense of framing and blocking. An actor's director in the best sense, in that he treats behavior as one component of a fully integrated, visually expressive whole, McCarthy's episodes of any given series are almost always that program's most emotionally and cinematically layered. Even on a show such as *The Blacklist* that already has a strongly established visual style, McCarthy is able to integrate his own preoccupations with the preexisting framework to both serve the franchise and deepen it. (He also elicits delightful effects from star James Spader, with whom McCarthy worked as an actor in *Pretty in Pink*, *Less Than Zero*, and *Mannequin*.) A diverse craftsman as comfortable with teen comedy and melodrama (*Gossip Girl*, *The Carrie Diaries*) as he is with tragicomic middle-aged malaise (*Happyish*), period intrigue (*Turn*), and political satire (*Alpha House*), McCarthy feels like an old Hollywood studio system pro transplanted to the twenty-first century.

For my money, McCarthy's best work as both director and actor can be found on season one of ABC's *The Family*. Created by *Grey's Anatomy* and *Scandal* writer Jenna Bans, it's a spectacularly absorbing drama about a suburban family thrown into turmoil by the return of a boy who claims to be the presumed dead son who went missing ten years earlier. The series consists of an elaborate network of mysteries that go far beyond the question of the boy's true identity (which, in any case, has already been revealed on the fifth episode of the season); all of the characters have their own secrets, and Bans gets considerable mileage out of the complex moral and philosophical implications of her characters' behavior. This is one of those rare TV mysteries that keeps the audience guessing but plays fair; it promises a lot in its initial episodes, and then not only delivers upon but exceeds that sense of promise with a convoluted yet clear narrative refreshingly absent of red herrings. Every narrative and thematic idea that's raised is thoroughly, thrillingly explored by Bans, her writing staff, and a cast led by Joan Allen, Rupert Graves, and Alison Pill.

In a pitch-perfect ensemble, McCarthy is the high point as Hank Asher, an anguished pedophile who spent ten years in jail for a murder he didn't

commit. It's an uncommonly multifaceted character played to perfection by McCarthy, who provokes a wide array of responses in the viewer – he inspires complete empathy without soft-pedaling Hank's profound (and profoundly disturbing) darkness. For the first time since the beginning of his directing career, McCarthy did double-duty on *The Family*, directed three episodes while also giving the performance of his career. I spoke with McCarthy by phone as he prepared an episode of *Halt and Catch Fire* to get some insights into his process.

JIM HEMPHILL: You don't usually direct shows in which you're also acting, but *The Family* is an exception. Did they approach you as an actor first, or as a director, or was it a package deal?

ANDREW MCCARTHY: I first heard about it when my manager gave me the script and said, "Joan Allen's doing this," which sounded promising. They were originally thinking of me to play the husband role, and I said, "Well, I've played that part before. What about this pariah over here?" Things evolved from there, and I had spoken with Jenna a year earlier about possibly directing a pilot of hers that didn't go forward. So we had already had those kinds of conversations, and when I agreed to do *The Family* as an actor she said she'd like me to direct a couple and I said, "Perfect!" It was interesting, because we shot the pilot, and then started the rest of the series months later; I directed episode three, so I was prepping as soon as we started the series. When I would show up to act in other director's episodes, I was more consciously aware of what they were doing than I might otherwise be as an actor – I was going to school at the same time as I was acting.

HEMPHILL: I would think it would be challenging to lose self-consciousness in the way that you need to as an actor when you're directing yourself, since to direct you have to be hyper-aware of everything.

MCCARTHY: I'd only done it once before, and it was the first time I ever directed episodic. I was on a show called *Lipstick Jungle*, and directing that was a lot more overwhelming – mainly because it was all new to me. It wasn't as hard as you would think on *The Family*, because the guy was so specific and not really me, whereas so often characters are just an extension of yourself. Here it was like putting on a hat, because everything about Hank was so different from me both internally and physically, down to his walk. But it did take a little adjustment, because he's very insular and doesn't speak a lot, and directing is anything but that – you have to really take the floor and communicate well to a large group of people so that they all know what they're supposed to be doing. So it took a few minutes sometimes to make that shift; when I was directing myself I probably slowed down a bit. But there was also great liberty because the first thing I had to check at the door with this character was my vanity, so I wasn't ever looking at the monitor thinking, "Oh God, that's not a good angle for me." Making sure I was attractive was removed from the equation, because *nothing* about this guy was attractive! [laughs]

HEMPHILL: It's a great performance, and I'm curious if you think the years you've spent directing have influenced or altered your acting in any way.

MCCARTHY: For the last five years I've barely been acting at all – I've only been directing – and I didn't really know how it would feel to return to it. It was actually a big relief, because now that I direct there's no burden on my acting – if I was only acting, I might not have even done this role. I'd have thought, "The guy's a pedophile, you don't want to be perceived in this way," but now I don't care. It's an interesting role, I haven't done it before, so my attitude is let's go for it – there's a great freedom in that way. I'm also certainly a more compliant actor for other directors now that I've been on the other side of it – I don't fight anything, partly because I'm so relieved when I don't have all that responsibility. The director has to throw the whole dinner party, and acting is just being the drunk uncle who shows up on the couch with a bag of Fritos. I understand the burdens of directing now, and I've learned that directors are absolutely unconcerned with a lot of the silly questions that I thought were really important when I was just acting. It's funny, because as a director who comes from being an actor, people invariably think I'm going to really get into it with the actors, but frankly I'd rather they just show up and nail it. If they want to talk about it I'm happy to – I understand and have experienced all the anxieties, and I can help work through them – but I'm much more into the visual aspect of telling the story than dealing with the actors. People are surprised that that isn't a priority for me at all.

HEMPHILL: You say that, but I've found that often the performances on episodes you direct have a slightly looser, more natural quality than episodes by other directors on the same series. So you must be doing something with the actors to facilitate that.

MCCARTHY: Don't get me wrong, I'm not going to let anything slide that isn't truthful or authentic – that's a given, of course we have to get that right. I try to be as encouraging as possible, because the worst thing you can hear as an actor is "Cut, one more." All that means is, "Cut you failed." That may not literally be what the director is saying, but if you're wide open and vulnerable as an actor that's what you hear, and it makes you tense up. All I ever tell actors is to go back to Acting 101: Why are you in the room? What do you want? What are you trying to get? When I say cut, I tell the actors, "That's great, but what about ...?" It seems like such an obvious thing, yet most directors don't do it. I guess I've been on the receiving end of it so often that I know how I behave, and I know that I'm more relaxed if it's not just, "Cut, go again." I want people to be engaged, and some of that comes from using props and the world around them – if you're in the kitchen, boil some water, or scrub the pot ... do something!

HEMPHILL: I think you just articulated what I'm getting at when I sense a more naturalistic tone in your work ... people are always doing something, they're not just standing around waiting for each other to speak.

MCCARTHY: Well, people rarely just stand there at the counter when they're in the kitchen. And what you're talking about, it all starts with

blocking – if you block well, everything falls into place. I always try to block truthfully; in other words, I'm not going to ask the actor to move somewhere that doesn't make sense just because it's a good shot. Every night before I shoot I walk around my living room with the script acting out all the parts; my wife walks in and says, "What are you doing?" and I tell her, "I'm blocking, leave me alone!" [laughs] I play Joan Allen's part, I play Alison Pill's part, so that when the actors walk in the next day I can tell them what I'm thinking and why. Whether or not they want to do it exactly the way I've planned, we're starting from an organic place where they can see that I've thought through how and why they would be placed in a certain way, and from there we can start working on behavior. It keeps the actors from falling back on melodramatic mood acting, which is just terrible.

HEMPHILL: Well, you see that kind of mood acting on a lot of series that have been on the air for a while, where the leads start to rely on certain default gestures and line readings that have become rote ... do you ever come across that, and how do you push those actors out of their comfort zones?

MCCARTHY: They have to want it, first of all. And if they don't that's fine, but usually people want to be engaged – yes, sometimes they'll just grind it out when they've been on a series for a long time, but when it comes down to it they really would rather do creative, rewarding work. If people start behaving badly and just want to get out of there, fine, but if you can tap back into why they're there in the first place, they're going to like that and be excited by that. And that goes for everyone from the prop guy to number one on the call sheet. If a prop guy walks up to me and asks, "Do you want the blue coffee cup or the red one," instead of just telling him the blue one, I say, "You've been on the show longer, what do you think?" Then the next time he comes back at me he might have an interesting suggestion of his own that comes from him feeling like he's in the game and empowered – he's not just punching a clock, I've called on him to bring some of his creativity to the show. If you can do that with everybody, suddenly everybody wants to be there, everyone's engaged, you go home earlier, and I get to take credit for everyone's great ideas.

With actors, if they just come in and do their usual shtick, I'll usually say, "Okay, that's great, but what if ...?" and they see that you're invested. You let them know that you're noticing details about their performance – just that alone, the fact that they realize you're actually watching, usually leads them to step it up a little. With someone like James Spader – I worked with him last week on *The Blacklist*, and he's a really fantastic actor who doesn't need much from the director – I can just say "hey, I noticed you're doing this," and he'll say "oh, okay," and that's all the conversation we need to have. I'm a believer in the idea that sometimes just bringing up the question provides its own answer, though some actors require heavier lifting. I very rarely encounter actors who don't want to do better, even if they may act that way at first. I was on

that show *Gossip Girl*, and by the end the kids were just like, "Whatever, where do you want me," but I would find that as soon as I engaged them it became contagious and they lost that attitude – I mean, people want to come off well.

HEMPHILL: As a big fan of *Less than Zero* and *Pretty in Pink*, I was so excited to see you working with Spader again, even if one of you was behind the camera and one was in front of it. How did that reunion come about?

MCCARTHY: I worked with a DP on another show who was close with the showrunner on *The Blacklist*, and he said, "I just worked with this director who's great," and the showrunner said, "Terrific, I need some new directors, who is he?" I met with producing director Michael Watkins and got the job, and then I walked on the set not having seen James in years, though we were quite close when we were kids. We picked up right where we left off; we were laughing about something and somebody on the set said, "So, you guys worked together in your twenties and now you're doing again, what's it like?" James said, "We're exactly the same, only more so," and that's how I feel about it. There's just no substitute for knowing somebody that well and that long – it makes working together a real pleasure, especially since James is so talented and so hard working. He works as hard as anybody in the business.

HEMPHILL: Thinking about *The Blacklist* leads me to a larger question, which is how you straddle the line between your own sensibility and that of any given series. On the one hand, you're being hired to direct shows with their own preexisting styles, but on the other they've presumably hired you because they want you to bring your point of view to the material. How do you reconcile those two things?

MCCARTHY: That's the hardest part of the job. They want you to make it fresh and make it different and make it interesting – but don't fuck with our show! [laughs] Again, I always start with blocking and trying to make it organic, which then dictates where you put the camera – and that doesn't mean the easiest place to put it, but the best place to put it. How much leeway you have to make it your own depends on the people. For instance, Jenji Kohan [creator of *Orange is the New Black*] just says, "Capture my dialogue and go make your movie" – she just wants to hear her actresses saying her lines. On a show like *The Blacklist* you can get as cinematic as you want to, while other shows do not lend themselves to that. The biggest challenge of episodic directing is getting the lay of the land politically – who has the power, who's really running the show, who's insecure, who's compensating, who's the devil in the room ... the actual work of being on the floor is something I've done for thirty-odd years, so it's relatively easy. It's the politics and the dynamics that are difficult. On *The Blacklist* they just say, "Go, bring it in," but on another show you might have the writer tapping you on the shoulder telling you you need a close-up. And that can be a challenge, particularly if they're someone who doesn't have a lot of experience on a set and they want to

assert themselves. Now, some of the most successful TV directors are just get-along guys who'll say, "Sure, great idea, let's do that close-up!" I'm not always so easygoing about it; I'll explain to the writer why I want to shoot it in a certain way, and try to make them see why I think that would work better. I'll usually offer to shoot the close-up as well so they have it. And then they always cut to the close-up. [laughs] Left to my own devices I prefer a certain formality with the camera – my own style doesn't lean toward hand-held verité – but having said that, *Orange is the New Black* is largely hand-held and I love it.

HEMPHILL: How much influence do you have over casting when you're directing episodic? Do you get to choose the actors who are guest starring or being introduced in your episodes? The reason I ask is that one of the things I loved about your "Of Puppies and Monsters" episode of *The Family* was the casting of Matthew Lawlor as the FBI agent and Zoe Perry as Jane … they were both fantastic and really kicked that show up to another level.

MCCARTHY: It all depends. On Jenji's show she likes to cast everybody, even day players – she has a great eye for casting and wants to pick her people. On other shows, maybe they'll have you pick your top two and send them to the producer and showrunner; if I feel particularly strongly, maybe I'll only send them one and not give them another choice unless they ask for it. In the case of Matthew Lawlor there were a couple other people being considered who were more on the nose – square-jawed blonde guys with stubble – and I saw Matthew and said, "What about this guy? He's quirky and human." God forbid we get some actual human beings on TV! What I loved about him was that he showed up for the audition and his hair was a mess. [laughs] He was a little befuddled, dropping his pages, and I thought, "I really like this guy." And they said great, though with a bigger part like that it has to go to the network to get approved and all that kind of stuff.

HEMPHILL: Does the fact that you're an actor who's in every episode of the series allow you to have a little more influence over the series as a whole than you would as a director on another show, where you might be more of a gun for hire?

MCCARTHY: Well, I directed three of the first five episodes, not counting the pilot, so right from the beginning I was pretty heavily involved because I was in prep from day one. I was always in the production office, whereas I don't think any of the other actors *ever* went to the production office. I was always shooting or in prep for the first ten weeks of work, so during that time I was very involved in every aspect of it – then when that was done I was like, "Thank God! Just call me on Tuesday when my scene is up."

13 Kimberly Peirce (*Dear White People, I Love Dick, Six*)

Before she started working in episodic television, Kimberly Peirce established herself as one of the most promising feature directors of her generation with *Boys Don't Cry*, her 1999 masterpiece that garnered Hilary Swank an Academy Award for her role as transgender murder victim Brandon Teena. For a variety of reasons that Peirce discusses in our interview below, the movie career she envisioned proved elusive, but she has now found a home as an in-demand director in the worlds of premium cable and streaming. Amazingly, she hasn't had to sacrifice her own voice on shows as varied as *Halt and Catch Fire*, *I Love Dick*, and *Dear White People*; through a combination of careful selection (she refuses to work on any show she doesn't feel a personal connection to) and deft application of the varied visual techniques she learned as a film student, Peirce has created a body of work that's astonishing in its consistency. To my surprise, she claims that working with showrunners who are themselves strong auteurs *helps* her retain her vision, not the opposite. We spoke about this and other topics at her home in Los Angeles the day before she began preparing for a new episode of *Dear White People*.

HEMPHILL: I want to start by asking about *The L Word* since that was the first episode of TV that you directed. How did the job come to you?

KIMBERLY PEIRCE: It might be politically incorrect to say, but dykes know dykes, you know what I mean? The truth is, if you're a talented, queer woman you probably know most of the other talented, queer women. So I knew Rose Troche, I knew some of the people involved early. When the project first went around, I was interested in the idea but I wasn't sure that it was the next thing I should do coming off of *Boys Don't Cry*. There was talk of me doing the pilot but I didn't; then they wanted me to do an episode and I didn't know if that's what I should do. It goes back to the fact that *Boys* was the perfect experience; it was autobiographical, and it pulled in all my classical training. I had been at the University of Chicago, I had been to Columbia, I had studied with Paul Schrader. I had studied with Kathy Bates. I had all these masters teach me and in *Boys* I could take classical cinema and combine it with a very unusual and very specific gender identity that I had and my friends had and that I found

in Brandon. Brandon was kind of the perfect calling for me. And *Boys* had been this amazing experience because I knew I wanted to do a movie that was empathetic and didn't recycle misogyny and pornographic violence, and as a miracle we pulled it off. It was crazy. So I came to Hollywood thinking I could just keep making movies as good as *Boys Don't Cry*. Well, that didn't happen. I didn't quite understand the obstacles I was up against as I was up against them; it took being a kind of historian to figure it out. So that took time.

Also, I'm a bit of a social anthropologist. Everything I do is kind of realistic. So eventually I thought, well fuck it. I should just do *The L Word* and not worry about impressing anybody. Because back then there was a concern that if you were a movie director and you did TV, you might get ghetto-ized. And nobody wants to ghetto-ize themselves, right? But, at the same time, I'm just a storyteller. I'm a racehorse that needs to race. I got to a point where I needed to get back to my roots; I just needed to work, I needed to tell stories, I needed to tell stories that were good, I needed to be supported and I needed to be able to dance. So I thought, you know, this might work. I looked at the show and it was essentially lesbians being lesbians, it was women being with women. There was a level of basic authenticity that the show had. The stories weren't always consistent, but the show always had that authenticity no matter what. And the girls were funny, they were sexy, and it was a world that I clearly knew. These were my buddies. So I said yes and I just had a blast. The cast was so much fun because they were hot and sexy and they were fun to be with. And I think there's something interesting about that. It was an unmanufactured show on some level simply because they were sexual. I got to do a sex scene that wasn't quite like anything I had seen before. Female masculinity like Brandon, handsome girl, pretty girl, having sex with a strap on. And the girls were like, "Thank you for bringing sex back to *The L Word* and thank you for doing female masculinity in a way that we had never done it." It was amazing that I got to chart that new territory.

HEMPHILL: Then you directed a couple movies, *Stop-Loss* and *Carrie*, and pretty much stayed away from television for several years before coming back to it – now you do a lot of it, and on the top tier shows. Why did you stay away, and why did you come back?

PEIRCE: I think I stayed out because I bought into the fantasy that you could do movie after movie after movie. That you could be an auteur director, and not even auteur in the fancy sense, but that you got to do stories that you love in a three-act form. It's not to put TV below film, but I'm trained in three acts. And, you know, the thing about three acts is, name any great movie, it's a protagonist who has a goal and overcomes obstacles to achieve that goal, usually a universal need. There's a beginning, there's a middle, and there's an end and there is no repetition. At all. That's what you're rooting out when you're writing it and you're

directing it and you're editing it; everything must move forward. Well, the interesting thing about TV is it's an infinitely exploitable problem. By necessity it has to repeat all the time. So, for me, while I love doing TV, and I feel that I get uniqueness in my episodes and a lot of creative freedom, I don't get the finality. The finiteness of a three act structure. The power of the performances in the story that are affected by that finiteness.

That's the reason I didn't immediately return to it. I held out the wrong assumption that you could actually sustain yourself in features. And you couldn't. Now every great director is doing television. Men and women. I wish I had gone back earlier. And then I did.

HEMPHILL: On that topic of being an auteur, when you directed *I Love Dick* you were working with showrunner Jill Soloway, who has a very strong voice in her own right. So how does that collaboration work?

PEIRCE: Well that's a really interesting question, because you're right, I'm working with a strong auteur, I'm working with somebody who has a strong voice. People have said to me, "You're a writer/director. You're a strong auteur. Why would you want to work with another auteur? Wouldn't you want to work with somebody who would be under you? Isn't there going to be an ego thing?" It's so important people realize that the more talented people are, the easier it is to collaborate with them. It is so pure. If somebody has a strong vision of what they want to do, then I can see where I come in and I can see where I duplicate them. But I also can see where there's an opportunity for me to have a voice that is an echo of what they want or an extension of what they want. It's not a conflict, it ends up becoming an embroidering and a deepening. If you notice, I work with really powerful auteurs, right? John Ridley, Jill Soloway, Bruce McKenna. I do the best when the people are the most powerful – there's no ego issue, I get to have fun.

With Jill, the visual style is a very interesting question because I don't think it's her focus. I think the focus is very much her living inside the characters and embroidering from within; it's a reflection of her and her interest in female sexuality, her interest in female desire, in neurosis. It's this kind of volcanic, constantly erupting creative furnace around that stuff. She's aware of visual language, she knows what she likes, but I don't think it's where she starts from. She likes things loose. She's very influenced by Andrea Arnold. So, *Fish Tank*. She had me watch the British show *Fleabag*, which is a brilliant show when it comes to female sexuality. It wasn't exactly what Jill was going to do, but I think she was telling me to break open the barrier so that you feel the intimacy and the reality and the authenticity and the humor. A little bit like what *The L Word* did, even though it's very different.

The DP, Jim Frohna, had shot everything that Jill had done, so the visual style was very much in keeping with what Jim did. Which is, he's hand-held, and he's brilliant at it. He's a character in the scene. So, the

cinematographer's going to be a character – what does that mean? How does one position him so that you're getting the shots that you want. Is the female gaze any different than the male gaze? Is storytelling storytelling? How does one actually get into that – is the female gaze from the female point of view? Or is it at the female? And the truth is, it's both. And it's complicated.

HEMPHILL: Well, again you have an episode with a great sex scene. How did you approach that, both visually and in terms of making the actors feel comfortable?

PEIRCE: With Jill, the visual language is definitely loose and naturalistic – she doesn't want you to be super high or super low or position the camera in a way that draws attention to itself. She doesn't want it to feel controlled. You know that going in, you don't want the shot to feel controlled. And yet, we have to control things. So there's that, right? You don't want the performances to feel controlled. And yet, you have to shape them. You don't want the script to feel controlled, and yet it's written. So those are all really interesting things and interesting challenges.

The truth is, the scene wasn't really written very much. There were only a few lines because it was about their desire with each other, it was about her desiring Dick and about her manufacturing the vision of Dick in the room. Fucking the husband while fucking Dick, and then Dick controlling the orgasm. The beauty is, Jill is smart enough to know what the ingredients are and the structure that you need as a jumping off point. But any more dialogue than that in such a physical scene, I believe, would have had to be thrown out anyway.

If you're doing a scene that's all about the dialogue, then you can pretty much stay to the dialogue. But if you're doing a scene which is about a married couple coming together resurrecting their sex life and a wife fantasizing about a guy who then comes into the room and then controls the sexuality, you can feel it in the physicality. Too much specific language isn't what it was ever going be about. It was the architecture of the scene where the brilliance was. And that was really interesting for me, learning what dialogue is inherently important to the creation of the scene and what dialogue is just there to get us going. It's about getting rid of artifice and getting inside the experience. If you and I have a hitting match right now that's really messy and ugly, you may not want to choreograph it too much. Capturing the messiness of human life, it's largely the art of getting out of the way. Okay, so that's one.

So two, creating the environment. Generally, for me, in movies and TV, I just like to get to know the actor for who they are. I want to get a vibe on them and I want to give them the freedom just to be themselves. So I generally just hang out with them and I ask them about themselves. And they almost always tell you their life story as if they were the character, so you begin to get inside the emotional machinery

of this person. I would do that with Kathryn Hahn, I would do that with Griffin Dunne for that scene, and then Kevin Bacon, I mean Kevin is great. Kevin is a straight man in that scene. So I have that basic looseness with them and then it's anything goes, because it's their show. And I have to give Jill a lot of credit in this, I want that to be reflected. It's somebody else's TV show, they have a huge rapport with these actors. So even if you have rapport with actors like I do and you love them and you've been able to get great performances, you also have to be very aware this is somebody else's house. You want to show respect and give them the space to have the control, while at the same time finding where you fit. It's back to that idea that I'm working with a brilliant person and I have really strong ideas, and it's about finding the place that the ideas can play with each other.

I want these actors to be loose and comfortable sexually, so I have to check in with Jill how that's done. At one point, I was told by a department that so-and-so wants to wear underwear. That scene would not work with underwear. So is it my place to go to the actor first? Not necessarily. If it was my movie, yes, but I went to Jill and said, "I understand so-and-so wants to wear underwear and you want them to wear underwear. I'm just concerned if we have a really loose style of shooting, unless we're willing to pay for visual effects, I don't know how we do it. If you had a fixed camera, maybe." And she was like, "Who said I wanted underwear?" She said, "Kim, I want it to be really sexy. Go talk to the actor and tell them they're not gonna wear underwear." So I go to the actor and I say, "Well, I heard about the underwear." "What are you talking about? My ass is out in the pilot, I don't want to wear underwear." Okay…

So those are important things as you encounter this kind of rigidity and then when you dial it back learn that there's not actually a rigidity. The writer/producer wants an openness, and so do the actors. So that's important, that you've already peeled away something that could have inhibited your ability to create a very fun environment. So, everybody's naked. Okay, well we need a closed set. We all agree on that. When I have a closed set and you have people naked and you've got cameras around, how do you loosen it back up? Well, you've gotta play music. You've gotta just play crazy music, you've gotta play sexy music. But everybody's idea of sexy is different, right? So we're all throwing in, "Well, this is sexy, that's not sexy, this is sexy, that's not sexy." You know. So it's me and it's Jill and it's the writer Sarah Gubbins and we're letting Jill run the lead because she has done this before with them. But it's very much the way I work, which is loosen it up, loosen it up, loosen it up. Let it roll, let it roll, let it roll.

Now, Kathryn Hahn is classically trained, she went to Yale. And she's a master of improv, a comic genius. Dunne is really hilarious and Kevin had to keep a straight face in the scene, which we didn't think he could

do. We specifically shot one take without him. We get the music play-
ing and then you just play. Dance, dance naked, run around, do this,
you're throwing them playful things. It's only a minute-and-a-half, two-
minute scene, but you roll a 22-minute tape. Why? Because there's no
way if you filmed a minute-and-a-half you would ever have the joy of
life and sex, the ease, the humor. So with the miracle of digital, you have
a 22-minute thing. And the miracle of brilliant actors who trust you and
who are having fun is that at some point they take control and it becomes
a reflection of your humor, their humor, and their essential humanity and
sexuality. They come in and they're dancing naked and you realize, that's
what it would take for this married couple to get hot again. It's so honest,
do you know what I mean?

So they're playing, playing, playing, playing, playing, then they get
onto the bed. Probably burned up, what, two minutes with the dancing?
That's okay, that's a fifth of your scene. You get into the bed, you watch
them do it one way, then you can gently run in and suggest, "Try it like
that, okay?" And then you run back out to the monitor, you're watching,
watching, watching. "Try it like that." The art is how to shape it, but
not interfere if it's got a magic and a fluidity of its own. And then we're
back by the monitors, us three girls, and we're biting our arms because it's
so good. Because the actors have taken the essence of it and they're not
thinking of the dialogue that was written, they're living in a scene that
they as performers know how to exploit.

And another part of the sex scene is Jim Frohna. It's a 22-minute take,
only two of them, Bacon is not in the first take. So when we bring Bacon
in, we know we have most of the coverage already on the couple. The
beautiful thing is, because it's 360, it's one camera operator. You can't
have two cameras, they'd shoot each other. When we're shooting Bacon,
he doesn't know how funny the scene is. So the beauty is, Kevin Bacon,
who's a great actor, is on the verge of busting out laughing the whole
time. And he's suppressing it, and that creates another dynamic in the
scene. And Jim Frohna being intuitive, he's laying on the bed. The sex
scene is happening around him, and he's following what's interesting to
him and also keeping in mind our question about how you get a female
point of view. Well, it's partly by looking at Hahn and looking as Hahn.
At Bacon.

HEMPHILL: You mentioned the writer Sarah Gubbins. What's your collabo-
ration like with her?

PEIRCE: I was amazed at how much the script changed. We had a script that
I thought was perfect and brilliant. We did a read through with Griffin
and Kevin and Kathryn for Amazon and I just thought it was amazing.
And then it started changing, and that was weird to me – but very inter-
esting. In a way that's where I came to my understanding of how to do
the sex scene and make it authentic; it was influenced by what I saw in the
process of having a perfect reading and then going in and opening it back

up. The stuff in the reading, while it was great dramaturgically, it wasn't going to have the strange, weird freshness. I don't think you would have gotten it off of that script. And that was a mind-blowing revelation to me about creating the kind of really electric and alive content that I think Jill does. A speech Kathryn has about being a woman director is a perfect example - that speech evolved over days and days and days. There was a germ of that speech in every draft and it kept changing.

We would improv it and it got thrown out a number of times and Hahn would come back in and do a ten-minute take and do it a bit differently every time. So, in fact, it was the same thing as the sex scene. There was a kernel of an idea that was great, the joke of a woman who's complaining about women directors when she's actually a woman artist. We knew that was funny, but we filmed that scene, threw it out, filmed it again … it was written the way Chaplin used to create, throwing things at the wall a number of times by really good writers, a really good actor, then editing it and shaping it.

HEMPHILL: It sounds closer to features in a way then I might have expected.

PEIRCE: It is. Most shows rely on a more conventional way of covering, because there's such a high page count you have to get through. You have your wides, you have your close-ups. I would have to say that almost every show that I've worked on is different from Jill's in terms of the looseness she encourages. If you're doing *Game of Throne*, there is no way you're improvising on the day. There's just no way, there's too massive of a structure around you. Even if you're doing *Halt and Catch Fire*, it demands a level of prep and follow through to get the story to look and feel the way it feels. And that is really important. You have to say, "What's the end result of this show. Oh, they need me to get 30 shots today because this show doesn't work if it doesn't match. This show needs the super-wide and the medium and the close." Jill's shows don't.

So then you have to say, "Okay, don't fight for the super-wide, don't fight for the medium and the close-up because it's not what the show wants." What does the show want? The show needs you to get that dialogue working in the right way and the humor to work and it doesn't really matter if you have to give up something, and you always do, you're giving up the mise en scene. And that's okay, because it's give and take, right?

I'm a director who prepares a ton. I watch every episode, I take screen shots of the pilot and of all the episodes, I begin to know the DNA of the show, what the show likes. "Oh, this show likes a high shot." On *Halt and Catch Fire* this show likes a Frazier, a particular lens that goes really low and when the characters look down you can see them and the background through them. Or, if I'm in a computer I can look inside the computer out at them. That's a very *Halt and Catch Fire* shot. I wouldn't do it on Jill's show. It requires a ton of time and it would be out of the vernacular of the show. Could it work? It might. Chances are it won't and I don't have the time.

You have to very quickly learn where the show likes to live. Then, I have my shot list and I do all my prep with my actors. I try to get in there and find out what they don't like, because I don't want them to tell me on the day that they don't like it, I don't have time. I come up with a shot structure for every scene, where I act out the scenes myself on the weekend. Blocking is really 50 percent of it. Because if I block it right, then the shots fall in order. I don't start with the shot. I start with the blocking.

So I have all that worked out. On a John Ridley show like *American Crime*, it's a very restricted way of shooting. He doesn't like that camera to move a lot. He doesn't like his actors to move a lot. So if the actors aren't going to move a lot and the camera's not going to move a lot, you have to be more clever in terms of the mise en scene. Because you're not going to find it on the day. Like, "Oh, they wanna walk here and they wanna walk here." Because he doesn't like that style. You have to work with what he does and think about how to shoot without a lot of movement.

So on a John Ridley show you're staring at the actors saying the dialogue. On *Halt and Catch Fire*, a lot of the dialogue is all technical and it's meant to be thrown away. Do you want to be staring at an actor delivering technical dialogue? No. You actually want to hear it as they're doing something. So that the geeks are getting all that stuff but you're watching the humans. You have to design that so that they're in motion. And you generally need those actors to come in, because what you don't want to do is pre-block – you never pre-block. When I was saying blocking is everything, you just want to get an impression. Or you want to get a hold of those actors and just say, "Hey, can I steal you on a lunch. Let's run through it. Where does your body want to go?" Just so I have a visual imprint of where it's going to go.

You over prepare for everything. And even on Justin Simen's show, *Dear White People*, I went in an extra five days in prep. I shadowed him and put in a lot of extra time and that's why I think the episodes are so good. You always want to super-prepare. On Jill's show, what's interesting is, the plan is not going last. Your familiarity with what shots could be working is all going to help, but it's not going to be what you think it's going to be.

HEMPHILL: Do you think having to work on these shows and learn their visual language has expanded your own toolkit as a filmmaker, being forced to think about shots outside of your own inclinations?

PEIRCE: A million percent. One of the reasons I only do shows that I love and that I care about is … look, you could write any number of things you don't like and be fine at it, but it's not going to expand your depth as a writer. But when John Ridley tells me, "I don't want the actors to move and I don't want the camera to move," when else do I get to have somebody super-brilliant challenge me and then I get to go back up and I

get to do it in another way? So now that's in my repertoire, to ask, "Hey Kim, do you think you always have to have it moving?" Maybe just the opposite. Maybe you don't move at all. That's really interesting.

Sex scene. What I got to do with Jill and Gubbins was create with two other women, two other directors, two other artists on a set – we got to share the space on actors that they had already broken in. I got to learn in an environment that I never would have gotten to otherwise. There's a misnomer that as the director you always have to be in charge, but you're in charge by being really loose and really smart. And by being able to let the better idea win. That's really what it's about. So I'm so profoundly thankful that I've done 12 episodes and, because I do extra prep, I'm proud of each one. I really think that they were able to be more authentic in some ways than the work I was doing on my last feature because I wasn't given the proper freedom to do what I'm good at. And weirdly enough, in television, it's somebody else's set, but I was given more freedom than I was given on my last movie. Now why is that? Because smart people know if they hire a good director, I'm in service of them, anyway. It's very interesting that the work is better, that some of the work is better.

HEMPHILL: And then there are the actors you get to work with. But it's different from features, right?

PEIRCE: The really big difference is on a feature you're birthing them. So you're finding them because they have qualities that you think are going to carry the beginning, middle, and end of that character. On *Boy's Don't Cry*, Peter Sarsgaard really wanted the role and I didn't think he was scary enough. But the truth was, the guys that scared me didn't have the need for love. Peter had the need for love, so I beefed up his scariness, I made him tougher. So on features I kind of invent them, you know what I mean? In television, I haven't invented them. I haven't found them, I haven't chosen them, I don't know their ins-and-outs.

Often when I get to a TV show, people will tell me the problems they're having with an actor, that he or she can't get to this place. Or the actor and I will meet and they'll say, "I can't get to this place." When Justin Simien hired me, he loved Antoinette Robertson, and he knew that I could take her to a new place in this episode. He said, "I want you to break her." But he meant it respectfully. "I want you to break her in the way you're good at." I had to be careful and I said, "Look, this is your actor. I don't want to take up too much space." But he was saying, "But I want you to take this space."

So once I had that acknowledgement, then I would meet with her privately, I would get inside what she wanted. She was saying, "I want to be more emotional, I want to be more flexible," because she's playing a beautiful, high-class woman who's putting off a little bit of a shallowness and ambition. Justin wanted to open up this emotionality, so with his permission, I then do a deep-dive into that, but only because they want

that. If he didn't ask for that, it would be inappropriate. I'm not going in to change something unless I'm asked to. And if I am asked to, I can.

You're a guest in somebody's house and if they're saying to you, "Just set the table," set the table. If they say, "I got a broken pipe and I know you're good at ..." that's something else.

HEMPHILL: One of my favorite pieces you directed was the episode you did of *Six* in its first season. What drew you to that show?

PEIRCE: I really chased that. Lesli Linka Glatter, a director I'm very good friends with, got me on it. What drew me to it was the auspices. It was a handsomely mounted cable show that was really going to look at these men at war and the effects at home. That was really interesting to me, and I like doing action. I'm good at action, and I got to do things on *Six* that I had never done. I had to choreograph those battle sequences on paper well ahead of time, thinking about what I need to see, when I need to see faces, what's the dynamic? Knowing that I'll have seven hours to shoot it, so what's important? What shots do I actually need?

Part of how I learned film directing was to take my favorite scenes in movies and literally draw every shot. I'd see, okay, they went from here to here to here and the camera went from here to here and then from here to here. With *Six* I reviewed *Platoon*, I reviewed Kubrick war films. I would just pull great clips of battle stuff to see how they did it.

HEMPHILL: That episode also has some great stuff that isn't action, like a montage where you show the dissolution of a marriage in a matter of a few minutes.

PEIRCE: That was a real challenge for all of us because we knew we had what's called a bottle episode, which was all about Walton Goggins' character. Those are the most fun, in a way, the most fun to do. You have less resources but sometimes you have a better story.

The entire marriage has to rise and fall in the flashes, which is difficult. You just keep thinking, "How do I shoot that?" Because if I shoot it in multiple angles and I cut it together, it's going to feel episodic. It just is. I thought, "Okay, if I don't shoot it in multiple angles, what if I shot it in a oner?" And what would that oner be like? Would the oner travel all over the place? No, that's gonna feel episodic. What if I could do a mise en scene where I created a basic scenario that held together in one glimpse and I had the action play out back-and-forth? The unity of that will differentiate itself from anything that preceded it.

HEMPHILL: At this point in your career, what do you see as the advantages of television over features and vice versa?

PEIRCE: We're living in a very strange time in terms of theatrical. I think cinema is fantastic. It's our cathedral. I really believe in sitting in the dark with a bunch of people you don't know and experiencing something. I think it's part of our humanity. I really want to protect that experience because I think a single protagonist who goes through a journey with a rise and fall, a beginning and an end, lives in you when you leave, in a

way that I don't know that television always does. At the same time, theatrical is very challenged right now. There are fewer studios and they're making fewer movies and they're making bigger movies, so the smaller films that have great characters and great stories, they're challenged. They can't make back their money because you have to have an advertising budget that's bigger than the movie. That's just the reality.

So film is dicier right now. The amazing thing about cable, and even more so about the streaming services like Netflix and Amazon and Hulu, is that they're not rated. That's crazy. We don't want to yell that too loud, but there's not the suppression of sexuality and identity, the moral suppression, that you get with the ratings system in theatrical. That is going to change, but for now it's quite extraordinary. It's a very explosive, open time because it's not rated and because there's a desperate need for more and more content. It's an exciting time to create, and what I love is that we're one of the most innovative, progressive businesses. Every time I get on a set I learn something new. I learn a new lens, I learn a new way of doing things. And we're an international business. So we're constantly cross-training, learning how to tell stories in new ways, we're learning new languages. I think you're going to keep hearing from what we would consider diverse voices because, whereas in theatrical film you have to hit four quadrants ultimately, what do you have to do on Netflix? You just have to hit an audience. Which is essentially where independent movies were born.

James Schamus, who used to run Focus, was one of my professors. He said with *Boys*, you just need to hit your audience, you just have to play to your audience. I asked, "What's my audience?" He said, "Gay people." I'm like, "What does that mean?" I didn't understand what it meant to satisfy gay people because I was queer. And he said, "You just better make sure that your friends love your movie, the people who were meant to love it. Because if they do, you'll succeed, not because you're four quadrants, but because any movie, if it satisfies its audience it can cross over." So I believe that we're living in a time where if I tell a good story I can get it made. And that's amazing.

Boys was such a perfect experience. You have to be careful when you've had such a perfect experience. I thought all experiences would be that rich. And I think that that stopped me from signing onto certain things because I didn't know how to do anything that wasn't that meaningful to me. And I think that's really important. I wanted everything to be that good and that meaningful. And nothing was going to be. Over time, I've learned how to find meaning in other things. I loved doing *Dear White People* and I loved doing *I Love Dick* and I loved doing *Six*. But that, to me, is a miracle, because I don't know coming right off the gate of *Boys* I would have had the appreciation to do those things the way I do now. Now I know the merit. And I think I was inhibited, because I was sold the bill of goods that you could have a feature career like the old guys.

I thought I could have, whether it was Spike Lee or Spielberg or Scorsese, I thought I could have that kind of career. You couldn't, at the time I came of age. Not as a man or a woman, but especially not as a woman. I had no idea that there was sexism, because I didn't experience it on my first movie. I experienced it on my second and my third, and that was crippling. I didn't understand until after all that that you had to venture out into TV. Now I'm so glad I did. I love my TV experience.

14 Mark Pellington
(*Blindspot, Cold Case*)

One of the most visually arresting pieces of filmmaking I've seen in recent years was the pilot episode of *Blindspot*, an NBC series that slyly reinvigorates the network procedural genre by fusing the raw materials of '70s conspiracy thrillers with an ingenious puzzle device. The puzzle comes in the form of a body covered with tattoos; the body belongs to "Jane Doe" (Jaimie Alexander), a woman who, in the opening scene of the pilot, is discovered zipped up in a duffel bag left unattended in Times Square. Jane has no memory of who she is or how she got in the bag, but she and the audience quickly learn that she has an unusual set of skills – when threatened, she instinctively springs into action and exhibits the training of a Navy SEAL. Over the course of the series, an FBI team led by Kurt Weller (Sullivan Stapleton) – whose name is tattooed on Jane Doe's back – tries to crack the mystery of Jane's background while decoding the clues left on her body in the form of her elaborate tattoos. The result is a show that in creator Martin Gero's hands becomes part visceral thriller and part philosophical inquiry, exploring issues of identity and moral responsibility in between some of the most kinetic action sequences ever put on television.

The style of those action sequences and the distinctive tone of the series are largely the creation of Mark Pellington, who directed the pilot and two additional episodes early on in *Blindspot*'s run. With its meticulously crafted visual design and precise calibration of performance and action, *Blindspot* is emblematic of Pellington's directorial signature; it synthesizes the narrative tautness of *Arlington Road* with the deft handling of character one finds in *Henry Poole is Here* and *I Melt With You*, and contains the depth and detail of Pellington's documentaries with the dynamic integration of light, color, and cutting one finds in his award-winning music video work. Pellington has long been one of our most diverse craftsmen as well as an artist of immense sensitivity; it's some kind of small miracle that he was able to express both sides of his sensibility in the realm of network television via *Blindspot*. I sat down with Pellington to find out how he did it on the eve of the Blu-ray release of the series' first season.

JIM HEMPHILL: When the script for *Blindspot* first came to you, what were your initial steps in terms of formulating your approach?

MARK PELLINGTON: I do the same thing with every piece that I get sent, whether it's a track for a music video or a script. I read it once just as a reader, and then if I'm sucked in I'll immediately read it again and let it speak to me in terms of theme and subtext and whatever else is going on. Then, I read it a third time and really start to underline things and make design connections – I make notes as the script starts to tell me what it should be.

In the case of *Blindspot*, I had done the pilot for *Cold Case* and some other work for Warner Brothers, so their executives called me and said "We're sending you this script. Greg Berlanti is producing it. Martin Gero created it. We're really into it." I read it that night and immediately knew that it was going to be a TV series – the hook was so strong that I could see the series unfolding, I could see the mythology. Sometimes you'll read pilots and think, "God, that's a brilliant 45-minute short film," but it's kind of a one-off. With this one, I read it the three times and wrote my impressions down within a 24-hour period. I met with Martin and Greg at the Soho House and said, "Okay, I really love it. Can I just read what I wrote and it will give you a sense of my take and my point of view?" I read this list of things I felt on the page, and they said, "We want you to do it." Five days later, I was in New York.

HEMPHILL: So you're responsible for formulating the look of the show, but you're also working with Martin Gero, who is the creator and has his own voice ... how does that collaboration work?

PELLINGTON: In one sense directing a pilot is similar to doing a movie – you're in charge of the design, you're very involved in the casting – but you also serve the creator. In this instance, Martin Gero had directed before, and he knew more about visual effects than I did. He was very, very open and I was very open to him, so in a way the two of us became a greater union than a traditional writer–director team.

On a pilot, your job as a director is really to set the template, to establish the shape and style – I try to help the ship leave the harbor, and then if a pilot is successful and gets picked up to series I always try to get involved and do two or three episodes to really train everyone. You have to make sure that what you establish in the pilot is replicable on a weekly basis. On *Blindspot*, for example, we shot in the old Pfizer medical building and the production designer worked with what existed to create these great interrogation rooms and other sets. We couldn't go back there for the series for fiscal reasons – as well as health issues, I think – so we had to replicate it on a slightly smaller scale. I wanted to maintain the aesthetic weirdness of that place, so there were some rooms that we literally just knocked off – I said, "Just do it exactly the way it was, with every weird offset piece of silver in the wall." It's hard to compete with something that's been there 50 years.

HEMPHILL: You get a lot of detail and character out of shooting on location. I remember watching the fight scene in the cramped building in

Chinatown and being struck by how much texture it had – but it also occurred to me that it must have been difficult to shoot.

PELLINGTON: I far prefer locations to sets. That Chinatown place you're talking about is a perfect example. It's so narrow and shitty, but I love the half-red, half-white walls and the fact that you don't know what floor you're on. It feels like a maze, which is what I saw in my head – it perfectly reflected Jane's mindset at that moment. In places that are tiny like that, you just take all the shit off the camera and strip it down and get it in there.

I had never done a really long fight sequence like that, and it taught me the power of the stunt coordinator. I would watch what the actors and Stephen Pope, our stunt coordinator, mapped out and then basically just shoot it – the hardest thing is convincing the operator to embrace the mistakes. You're collecting these aggressive pieces, and sometimes you want the operator to put the camera on his shoulder backwards so he can't even see what he's shooting while an actor chases after him, or sometimes I jostle the operator right before the take so he bounces a little as he's running before he settles in. It's a process of loosening people up – some guys have been trained for so many years to get everything perfectly that they'll say, "I've got to do it again" if they miss something and it isn't exactly right. I don't care, especially in an action sequence where someone's got a knife and someone else is screaming and they're chasing each other. Something I learned from Paul Greengrass is that you only need it to work for two seconds, or one second. You only need the piece. I was heavily influenced by the *Bourne* movies Greengrass directed, as well as this Korean film called *The Suspect* that Stephen Pope recommended to me – it was relentless, non-stop action. It out-Greengrassed Greengrass. I really wanted that pervasive sense of tension and chaos, and within the first hour of the first day of the shoot I was telling everybody to forget about the marks, cross the line.

HEMPHILL: What I like about *Blindspot* though, is that it alternates that kinetic, messy style with formal compositions that are almost Kubrickian in their symmetry and precision. I'm thinking of things like the psychiatrist scenes.

PELLINGTON: Yes, you let the crew cut loose one day and then the next there's a shift where you say, "Put the camera down – put an 18mm on and don't touch it." That shrink room signifies balance and control, and it's cold and antiseptic, so you don't move the camera – that's the rule. There are rules for other sets too, like Patterson's lab, where the walls are white. You either have to turn all the lights on or turn them all off, because the middle ground looks shitty – either go for all black and use the glass and neon tubes and screens, or make it all white and sterile and go full Kubrick. These things take shape after three episodes, five episodes ... my job as an executive producer for the first 13 episodes was to oversee the look of the show and do the color correction, and everybody was trained so that when I left the transition felt pretty seamless.

HEMPHILL: That gets back to something I was thinking about earlier when you mentioned that you had to replicate the location from the pilot on a new set for the series. As a pilot director, do you feel responsible to the directors who follow you who don't have your resources and time? I'm assuming the pilot gets a significantly bigger budget than any of the individual episodes that follow.

PELLINGTON: Right, you don't want to make something that's unattainable. That's why I did the second episode and the fifth episode, to make sure I could do the episodic version of something as well as the pilot version. A fight scene that you have two days to shoot in a pilot has to be done in one for an episode. In episode five we had a huge shoot-out in a cemetery in Queens that was scheduled for two days. The first breakdown with the AD was four. We lost some stuff, I collapsed some ideas and got it down to three days, and then we made a narrative jump – I figured out something we could get rid of that made sense to the writer – and then we had something we could shoot in two days with four cameras. That kind of problem solving makes you better as a filmmaker and it's a fun challenge.

HEMPHILL: And then there's another kind of challenge, which is that in between the action sequences a lot of the show involves people in rooms looking at monitors. Did you have any techniques for keeping that kind of material visually interesting?

PELLINGTON: Sure. In fact, I wrote up some brief rules before I left to give to other directors – some followed them better than others. One was what I called the one-second rule, which they later renamed the Pellington rule: you always do a take in SIOC [Strategic Information and Operations Center] (which is the place with all the screens) where the camera never stays on one person longer than a second. So if there are four people sitting there, you're constantly crossing over, pulling focus from one to the other, moving from one reaction to another so you always feel like the information is traveling. If the editor has that in their pocket along with the other coverage they can cross the line and constantly shift points of view so that you build energy.

HEMPHILL: And I assume casting is important in that regard as well.

PELLINGTON: Totally. It's so important – that's why people shoot pilots and then scrap them just to replace one person. On the *Cold Case* pilot, we ended up replacing a person and reshooting half the pilot. It's very important, and there's a lot of scrutiny and a lot of cooks in the kitchen.

HEMPHILL: How many?

PELLINGTON: Let's say you do an indie movie. Who has to approve the casting? You and the financier, right? On a network show, there are probably ten people from the studio and ten from the network. But they're very respectful – I really like shooting pilots. I've only done one episode of a show where I didn't direct the pilot, early on in my career, and it's different … it keeps you shooting, and you can put your stamp on it in a little way, but you're not an auteur. There's not a lot for you to do. You just

have to make sure things keep running and the actors keep their pace. But when you're doing the pilot, you're inventing it all.

HEMPHILL: I want to ask about the logistics of shooting the opening scene in Times Square. It contains the series' most iconic image, that of the bomb squad clearing the area out and then Jane Doe climbing out of the bag. Did you guys actually empty out Times Square, or was it CGI [Computer Generated Imagery]?

PELLINGTON: It was real. We were on the location scout, and I knew from living in New York for 18 years exactly where the best place to shoot that scene would be: the northeast corner of 44th Street. There's a place that's a little further north with some bleachers that's a little smaller. It's where you buy tickets for Broadway. The location scouts took me there because it's cheaper — it's $5000 to shoot there. Where I wanted to shoot was $50,000. I said, "Let's just go look at it." We went to shoot the pictures, and it was clearly the place — and it wasn't as hard as you might think to make it work. If you go to Times Square at four in the morning, there's nobody really there; the biggest thing was the construction cones because there's so much construction shit going on. For the moment when the cop walks up to the bag, we just shot it without worrying about closing anything off — we had some of our own extras going by, but a lot of people were real. We had four cameras and placed them far away and just shot it without telling people what to do — it's New York, let them react how they're going to react. Once the cop finds the bag and they think it could be a bomb, the key is selling the emptiness, which you can do in just a few shots. Looking in the direction of the SWAT [Special Weapons And Tactics] truck, we put in a big light — that's all of 7th Avenue you don't have to worry about, because we're never going to see it. We didn't really need to look toward Broadway, so there were basically three angles and we just kept shooting close-ups until there were the fewest people around — then we got the wider stuff.

HEMPHILL: A location that costs $50,000 vs. one that costs $5000 is a big jump. How do you decide when things like that are worth fighting for, and when you can make compromises without hurting the piece?

PELLINGTON: It's inherent in the film business, whether you're working on a no-budget video or a big pilot, that you're always trying to get 20 pounds of potatoes in a 15-pound bag — it's so much work in such a short amount of time. But on that Times Square thing, there was no fight — I looked at Martin and said, "You've got to do it to sell the pilot," and he knew it. It was clear on the page that that was a very, very important set piece.

HEMPHILL: You've done so many different types of filmmaking, from documentaries and commercials to music videos and features ... do the different disciplines inform each other?

PELLINGTON: At this point, whether it's a music video or a commercial, I don't really distinguish between them. I just shoot what I shoot. With narrative filmmaking, the script and the characters are my guide. I always

want to know what's going on emotionally and psychologically and visually, beyond what the dialogue is saying. If I can really know what the scene is about underneath and design something in the blocking and the art direction that feeds that part of my brain, then that feels good. When I don't feel myself in my work when I look back, that's my least successful stuff. The stuff that I think is my best comes from when I've really put myself into it and trusted my instincts and had fun doing it.

15 Karen Gaviola (*NYPD Blue, Lucifer, Magnum PI*)

With a career that has yielded well over a hundred hours of TV in virtually every possible genre, Karen Gaviola serves as an exemplary case study in the wide array of artistic opportunities available to episodic television directors with the talent and taste to take advantage of them. After starting out in the film and television industry as an assistant director, Gaviola was promoted from within on the classic series *NYPD Blue* and proceeded to make a name for herself as a filmmaker equally attentive to performance and kinetic action. Her credits include procedurals (*CSI: Miami*), family dramas (*Brothers and Sisters*), science fiction (*Terra Nova*), a Western (*Hell on Wheels*), and even a horror-fantasy-detective hybrid (*Grimm*), and that's just scratching the surface. In recent years Gaviola has taken greater control over the visual styles of her shows, serving as a producer-director on *Lucifer, Magnum P.I.*, and *Hawaii Five-0*. Although it might initially seem like the series she works on have little in common, her wide range coexists with a consistent attention to emotional authenticity that links episodes on shows as disparate as *Supergirl*, *Prison Break*, and *Empire*. For reasons explained in the interview below, Gaviola tends to get series-best work out of her actors, and her sensitivity to character perfectly complements the precision of her action choreography. I spoke with Gaviola by phone while she was in production in Hawaii to ask about the evolution of her career, her directorial approach, and what she looks for in other directors.

JIM HEMPHILL: I'd like to start by asking a little about how you got into the business. You began as an assistant director – was directing always your ultimate goal, or did that desire come later?

KAREN GAVIOLA: I majored in documentary filmmaking at Harvard, but I never actually thought you could make a living out of it. I'm from LA, so after graduation I came back and I was looking for a job. I heard about a test you could take to get into the Directors Guild; I didn't really know what it was but I was a good test taker, so I took the test. And I got in as a trainee. The great thing about that position is that they find you the work – you don't have to find your own jobs. I did that, and then I got into the Directors Guild as a second assistant director, which is sort of towards the bottom of the ladder, and I worked my way up.

HEMPHILL: How do you think that working as an AD prepared you for directing?

GAVIOLA: It was great preparation, especially for a woman director. You have to manage large groups of people, and you're in charge of organizing the whole shoot. It gives you a certain confidence in dealing with large groups of people that didn't come naturally to me. I know directors come from all sorts of disciplines, but for me as a shy, retiring person it was great. If you can run a set as the first AD, the chances that you can run the set as a director are pretty high.

HEMPHILL: When did you start thinking you wanted to become a director?

GAVIOLA: I decided pretty quickly that although I was really good as an AD, it wasn't something I wanted to do the rest of my life. The pathway for an assistant director is generally towards producing or directing, but it's much harder to become a director than it is to be a producer. A lot of producers started out as assistant directors because they know production so well. I decided I didn't like being a producer, and I didn't want to stay an AD.

I'd studied directing in college. I'm not going to say my footage was good, but I started out there. Then as an AD I watched different directors at work and it's a great way to learn, just by sitting right next to a director and seeing what choices that person makes. I decided when I first became a first AD that I would set my sights on being a director. And it was a tactical choice that meant I wouldn't be doing features because almost no assistant directors in features become directors. I can think of two people. That's it. So I decided to stay in television, and television just had more opportunities for getting me that first chance at being a director.

HEMPHILL: What was that first chance? What was the first show you directed?

GAVIOLA: I did a show called *NYPD Blue*. I was a first assistant director on that, and every year at the end of the season I'd go to my boss and say, "Can I have a directing shot?" The first two years he said no, and the third year he said sure. A lot of it is based on loyalty and whether they think that you can handle it. I guess he thought at that point I could do it. I had a good experience on my first episode, because everyone on the set knew and supported me. The hardest part was that I had a very emotional scene with a guest star. She had to cry, and I couldn't get her to cry. Mark Tinker, a producer-director on the show who was a big mentor or mine, happened to be on the set, and he really helped me through that scene. The rest of it came pretty naturally to me. I'm really good at logistics, and I'd studied acting, so I started to learn the language that actors use. And I had a great group of people to try it out on.

HEMPHILL: Since you brought up the subject of guest stars, I'm curious, how do you make the guest stars comfortable when they have so little time to become part of the team that has been working together for months, years, even decades?

GAVIOLA: I think the guest stars learn to trust me pretty quickly because I will give them notes. I'm not judging how other people do their jobs, but a lot of directors … their forte isn't giving notes to actors. It's about studying human behavior and learning what works in terms of how to get somebody to do something that you want them to do. A lot of it's just psychology. I think when I give guest stars notes I make it obvious that I'm watching what they're doing. I can get very detailed about it. And so they feel safe because they know somebody's watching and making sure they don't screw up.

I also try to establish with actors very quickly that I'm not there to judge them, I'm there to support them. The worst thing that can happen with them is they feel they're being judged by people because then they start doubting their decisions. You don't want that on the set. You want them to feel like they can do whatever they want. But I do it basically by letting them know very quickly that I'm watching them. I think that's the biggest thing. There's a lot to watch. A lot of people are watching the camera, they're watching the focus, they're watching the background players. But the director's main job, as far as I'm concerned, is to watch acting. I watch and I give notes, and whether the actor takes the notes or not, that's their problem. But I let them know there's a safety net. They know that they're not going to fail because I'm watching them. I think that enables them to succeed.

HEMPHILL: It sounds like on your first episode of *NYPD Blue*, there was already mutual trust between you and the cast and the crew. I'm wondering if it was difficult getting that next job that wasn't *NYPD Blue* and was it difficult coming in and quickly earning that trust that you had there?

GAVIOLA: It was really hard to get my first job out of *NYPD Blue*. I had directed three episodes. One was great, the other two were pretty darn good, but no one wanted to take a chance because they knew I was directing on my home show, and they knew that I had the support of the cast and the crew and the producers. Their inclination is to say, "Well, she had help. She's not gonna get help on my show." I got an opportunity on the show *Providence*, and it didn't go so well. I was used to my home turf. I was used to how they worked, and the challenge was working with a group of people who didn't know me, they knew I hadn't directed much, and for that reason they really didn't trust me. That was hard. I made mistakes, which is how you learn. It didn't go over quite as well as my *NYPD Blue* episodes, but I learned a lot from it. I learned that every show's different. You have to learn very quickly how to fit in and what they're expecting of you. And every show has different expectations.

HEMPHILL: How do you determine those expectations when you come on? What's your first step when you get a job on a new show?

GAVIOLA: What I do is, first I watch an episode or two or four or 20, then go on IMDB. I check to see if I know any directors on the show. Usually I'll

know somebody. I will reach out to them and say, "Do you mind talking to me about this show?" Not a lot of directors do that, and they should. We all do the same job, but we never meet each other. It's so helpful.

I've been blessed by knowing directors who are generous enough to tell me what to expect. I'll call them up ahead of time and say, "So what's the DP like? How's the star?" And then when I get to the show, if there's a producer-director, I will ask for a private meeting with that person and I will say, "I want to succeed. What do I need to know?" They might be guarded 'cause they may not know you, but they can tell you some things like, "Well, the script supervisor's not that good. Yeah, this star, he always wants to be covered last because he has to warm up and learn his lines." That kind of stuff.

Also, the AD is a great source of information. The script supervisor is a great person to ask about on set behavior because they see everything. You wander around and you listen. You listen to what people are saying. You're riding around in a van looking for locations and people get really relaxed in that environment. They start saying things that should not be said outside the confines of the van. And you learn a lot just by listening. My big favorite is calling the director and asking for tips. Not too many people call me, and I wish they would. Now, I'm going speak more frankly with somebody I know as opposed to someone I don't know, but still it's a good way to get a feeling for what the show's like.

HEMPHILL: Since you brought up the producer-director, I wanted to ask a few questions about your experience in that role. What was the first show you were a producing director on?

GAVIOLA: My first job was a show called *Lucifer*, which is now on Netflix, but it was on Fox at the time. It was about three years ago. I'd been wanting to move into that position for a long time, and just to speak frankly, the gender politics don't always favor that move. But my reps were very persistent, and I finally got an opportunity on *Lucifer*. The best part about being a producer-director is that you feel it's your own show and you can shape it creatively – within what the showrunner wants of course. It depends on who the showrunner is and how much they'll let you shape it. A lot of times you're just enabling their vision, which is fine. The downside is that I actually like doing different kinds of shows. I don't want to get pigeonholed. When I'm producing, I can't go do all these cool shows that are out there because I'm contracted to one show. I like exercising different muscles on different types of shows. When I started doing different types of shows, it was a conscious effort on my part because the show that finally made me a working director was *CSI: Miami*, which is a CBS procedural. It's a crime show. It was a good place to learn, but then I started getting other assignments, and they were all procedurals. After two years or three years, I realized this was a pattern. I said to my agents at the time, "I need to do other kinds of shows. I don't want to get pigeonholed as a procedural director." At one point a producer I met at

a function called me, "Oh, you're the queen of procedurals." I thought, well that's a bad title to have.

I really pushed my agents to look for other types of shows that I could do. A lot of them were cable, so they don't pay as well, but that's not the point. The point is to broaden your career. As you get known, people then start taking chances on you even if you haven't done something in that genre before because they know your reputation. It's a slow process. You build up more episodes, you get to know more people … it was a concerted effort on my part, and it got to the point where I would turn a lot of stuff down, which you have to do if you want to shape your career. You have to say no. And it's hard because as a freelancer, you always want to make sure you've got a job. At a certain point, saying no is better than saying yes.

HEMPHILL: You're known for some extremely complex action directing on shows like *The Blacklist* and *Magnum P.I.* How meticulously do you plan those out? And how often do you have to abandon the plan due to the vagaries of schedule, location, etc.?

GAVIOLA: One of the best pieces of advice I ever got when I was starting out was: always have a plan and be prepared to break it. That was from a director named Matthew Penn who used to be the producer-director on *Law & Order* and *Queen of the South*. That's what I do. I've always done shot lists on every single episode I've ever done. A lot of directors don't. I respect that. Everyone has their own way of working, but I am a big planner. I go through all the beats in the scene and figure out what I need and what the transition into the scene from the previous scene will be. I write it all down, that's how I process. But then, once I've shot listed it I've gotten to the point that I don't look at it on the day unless it's a massive action scene with lots of little pieces, because I've already thought through how I'm going to block it. My process for prep is to shot-list, and that's how I block the scene in my head. Then on the day I get to the scene, if the producer says, "Okay, the cars are too close. You gotta put them further apart," everyone can have input into the scene but because I know the pieces I want I'm more able to incorporate the suggestions into what I need.

HEMPHILL: On *Magnum* you staged an incredibly complicated fight scene between multiple people inside a car. How did you approach that?

GAVIOLA: First of all, I tried desperately to get it out of the car and the writer said no. I said, "Okay, fine. Four people in a car." Then I thought about it. "Okay, I want a really big car." We got a Suburban or something. The stunt coordinator was my partner in all this, because I don't know that much about hitting people, but he does. I sat down with him, we discussed the scene, we discussed the logistics, we discussed what, character-wise, I wanted out of Magnum and out of Higgins. The main character point for Higgins is that she is a fighting machine. She is never a helpless female. She may be in five-inch heels and a miniskirt, but she's

still a deadly weapon just with her own two hands. I wanted to make sure character-wise that that happened, and that of course Magnum is a Navy Seal. He's a trained fighter. And then we talked about where we were going to put people in the car. And then I said, "Okay, now you have my parameters. Can you work out a fight?" And he did. He would videotape it and I'd look at it. I'd give notes. My notes on fights are mostly character based. Once in a while I'll weigh in that a fight looks too staged and like a stuntman's doing it. We need to make it scrappy and messy.

Then he blocked out the fight with his doubles and he showed it to me. It was a lot of discussion. And then when we finally went to shoot it, the big discussion then was are we shooting this on a moving car, or are we going to do it on stage and use a green screen? The cheaper way to shoot it would have been in a moving car, but four people fighting in a moving car is very difficult to direct. We did it on stage and it was more expensive because we had to use green screen, but it came out a lot better. And then once we did a master, I quickly realized the master wouldn't work. Because if you're doing a master of four people in a car, you can't see anything – they're all fighting. I quickly said, "we're going to divide this fight up into sections and into quadrants because there are four people in a car." But that's something you don't know until you see it through a camera. Then you realize it's not going to work. But it's a pretty effective fight.

HEMPHILL: That episode of *Magnum* was only the second one in the series – the first after the pilot. Is it different directing actors on a show that's just starting out versus when you're on something like *Hawaii Five-0* where you've got people who've been playing those characters for something like ten years? Does it change your job or the way you interact with them at all?

GAVIOLA: It changes it a lot. With the *Magnum* cast, they'd only done one episode. So there were still things that the network and the writers wanted out of the characters that didn't happen in the pilot. They wanted to warm Higgins up, for example. She's always picking on Magnum for one thing or another and they said, "Warm her up so she doesn't come across too bitchy." Because she's a series regular, you want people to like her. As Magnum, Jay Hernandez was very earnest and sincere in the pilot. They wanted to warm him up too and make him a little more loose and easy going. I got those notes from the writers. And then on set, because they'd only done the character once, Jay and Perdie and Zach and Stephen, they were all really open to notes, and I gave them lots of notes. They were happy for the feedback.

Now on a show like *Five-0*, I am not going to presume to tell Alex O'Loughlin what his character's thinking because he's been doing it for nine years, and I've been doing it for six months. This happens all the time, by the way. The way I direct series regulars is, I ask questions. And I'll just suggest things, but mostly I ask questions that I think will inform

how they perform in a scene. On a long running series I think you have to admit to yourself that there's no way you can ever know a character better than the person playing it. All you have to do is demonstrate to them that you're watching out for them.

HEMPHILL: Getting back to your role as a producing director, how do you hire other directors? What factors make you choose someone, and what factors keep someone from being asked back?

GAVIOLA: First of all, I look at their footage, their sample or reel or whatever, even though in episodic, it's not really your style – your job is to conform to the style of a show. Having said that, you look at the shot selection. You look at the performances. That's the first thing I do in terms of hiring people. The second thing is to call around and ask about the person. I know enough people that I can call someone, usually a producer or director or an AD or a line producer, and I'll say, "How'd this person do? How'd were they on the set? Did they make their days?" Because in episodic it's all about time.

I could interview them, but I tend not to … I don't think meeting anybody tells you much, to be honest. It's more about asking other people about them. A lot of times the studio will say, "Hey this person's great. Just hire them." And then I don't have a choice.

As far as why they don't get asked back, some directors don't know how to behave on a set – they don't know how to handle a large group of people. You get a director, and the star starts asking him a bunch of questions and they get flustered, then they get defensive. You look at how they prep. I tend to respect directors who prep more than directors who don't. Having said that, a lot of people who don't are great directors. You see how they get along with your crew and your cast. I personally like people who are respectful and nice and not screaming and yelling. With all the great crew people out there, most directors have a hard time failing, because they have the support of a crew. But if a director alienates a crew, they're not gonna help him. Honestly, it's very much about just fitting in. Do they fit in?

Then you just look at the footage. You look at the show and some shows just stick out and some are pretty flat. Yes, you could blame the editor, you could blame the actors, you could blame lots of people, but ultimately it's up to the director.

16 Lea Thompson
(*The Goldbergs, Mom*)

To most audiences, Lea Thompson is probably best known for her iconic roles as an actress: Lorraine McFly in *Back to the Future*, or the title character on the hit sitcom *Caroline in the City*. In recent years, however, Thompson has become recognized in the industry for her excellent directing work across a wide variety of styles. Whereas most directors in TV tend to specialize in one format or another (hour-long episodic vs. half-hour sitcoms, for example), Thompson is equally comfortable behind the camera on an episodic drama such as *Switched at Birth* as she is calling the shots for *Mom*, a multi-camera sitcom in front of an audience, or *The Goldbergs*, a half-hour comedy with a more cinematic approach. Along with her TV work, Thompson also garnered critical acclaim for her 2018 feature *The Year of Spectacular Men*, a richly observed independent film filled with warmth, humor, and insight that boasted an expressive, vibrant palette and an elegant sense of blocking and composition. What all of Thompson's directorial efforts have in common is a mastery of tone, as she perfectly balances the comic and dramatic at whatever pitch each show requires; her determination to, as she puts it, remain vigilant during every phase of filmmaking, results in movies and TV episodes that are polished and lively in equal measures. I became friends with Lea when I directed her in *The Trouble with the Truth*, a movie where her expertise as both an actress and director came in handy, given our limited budget and schedule, and I've always been impressed by her combination of intelligence and enthusiasm – though she sees the industry exactly how it is and is under no illusions about it, she also has as much passion for her craft as a recent film school graduate or aspiring actor who just stepped off the bus. I spoke with Lea the day after she finished an episode of *The Goldbergs* to ask her about her work on that show and others.

JIM HEMPHILL: You started directing in the world of TV movies, on the *Jane Doe* series where you played the lead character. How did that come about?

LEA THOMPSON: I always wanted to direct, and I knew the only way someone would let me would be if they needed me to be there as an actress. So I had done a few of them, and I just asked. You know, that's one of

the first things to remember is just ask – you can't get something if you don't ask. So I asked, and for whatever reason – I'm not entirely sure why – they let me. And it was really difficult, far more difficult than episodic directing because it was more like a real movie – I had to pick all the locations, cast the whole thing, really hone the script, whereas on a normal episodic show you don't really have that much power. Most of the casting has been done without you, and the script is not yours to mess with. The locations are mostly established. I really enjoyed directing *Jane Doe* though; I had 24 days, and we shot on film – it was like a *Game of Thrones* schedule! But what's fun about episodic directing is that you've got this giant safety net that you can and should – must, really – use, which is the machine you're stepping into.

If you're going to do the job of episodic directing, especially if you're doing a show that people like that's been on for a long time, you need to come in with the attitude that it's their party and you're just there to bring new inspiration to it. Your job is to breathe new life into the show, because often times I think familiarity breeds contempt, and on a network series the actors aren't really looked at as actors – people stop respecting them as artists, and that starts a chain reaction that I try to break when I get there.

HEMPHILL: So one of the most important components of guest directing is just being a person who has enthusiasm for the show and shares that with the people who have been there for months, maybe even years?

THOMPSON: That's how I see it. I still have a great love for our business after all the time that I've been in it. I still love the crews and watching them work, especially when you see people who have been working together for years and are in a kind of ballet together. And I think that's why it's smart sometimes to have a director come from the outside with a new perspective. Even though you're not trying to reinvent the wheel, I think that you can encourage the crew and the actors to remind them that what they're doing is actually really cool.

HEMPHILL: What about on a show like *Switched at Birth*, where you were a regular actor on the show? So you're a guest director, but not really a guest ...

THOMPSON: I felt like I could breathe new life into *Switched at Birth* as a cheerleader for the work of my fellow actors and the crew, and by really encouraging the actors to go deeper or to follow their instincts. When you're an actor on a show, you have to know how to direct in a way as a matter as survival. You have to know how to direct yourself, because there are a lot of directors who don't help you out. They're thinking about other things. And after a while, you know if they didn't get something, and if you don't want to do that re-shoot you have to tell them, "You didn't get the close-up." But directing episodic as a guest is such an interesting position to be in, because you're essentially going to someone else's house and throwing them a dinner party. And you're supposed to

be the boss of a lot of people who know the show way better than you do, and each show has its own bizarre set of rules. It helps if you can find someone – hopefully your first AD – who can tell you what the rules are, and what you need to know about different actors, or different crew members. Because there are all kinds of things going on that can be completely overwhelming, and some of them, frankly, are better to not worry about – if someone is a grump in the morning, just stay away from them. Don't take it personally, just let it wash over you. But there's always a weird dance that you have to do that takes a lot of people skills.

HEMPHILL: What advice do you give people who want to direct?

THOMPSON: The thing I learned being in the business for so long was how crews work, and that's hugely important. So I always encourage anybody who wants to direct to do other jobs on the set, be a PA [Production Assistant], observe, observe, observe. And really observe! Don't just sit there on your frickin' phone. Watch how the hierarchy works and how important everyone's job is so that you don't dismiss someone and piss them off. When you get on a show, it's incredibly important to figure out which master you're serving – who has the power on the show? But it's also really important to figure out where the weak spots are on the crew. If they're not lighting the girls right, for example – things look cheap when the actors aren't lit right and look like crap, so you need to figure out what to do to help them look better right away. And that kind of thing can make the actors really like you, and trust you, and make them work a lot harder for you. They'll also work harder if you just let them know that they're doing a good job – everybody wants to feel valued and important.

HEMPHILL: With *Switched at Birth* and *Jane Doe* you were directing series you were already involved with as an actor, but how did you come to direct *The Goldbergs*?

THOMPSON: I think the fact that that show fetishizes the '80s worked in my favor, because my agent figured Adam Goldberg, the creator, would appreciate where I came from and that I understood the perspective of the show. I was really lucky because I went in for a meeting with Adam and it went well and he just gave me an episode – he has a lot of power and doesn't have to ask anyone's approval, which is lovely. And what's great about working for Adam is that he's very specific about what he wants; it's his world, and my job is to make that world as funny – and on budget – as possible. The time constraints are the hardest part of that show, because you only have four or five days, and sometimes … well, on the episode I just directed I had to create a traffic jam on a freeway. And we only had time to shoot it in a small parking lot! I think it looks good, but there's only so much you can do at a certain point, and you just hope the audience will go with you because the jokes are funny. Just make it funny, and no one will care. The most important thing for me, especially with comedy, is trying to keep the light on in people's eyes. Try to keep

them inspired, try to help them feel comfortable and taken care of and appreciated so that they can do their best work.

HEMPHILL: You've also directed *Mom*, which is a different format – a more traditional multi-cam sitcom in front of an audience, right?

THOMPSON: Yeah, four cameras and very different from something like *The Goldbergs* or *Switched at Birth*. Luckily, I have tons of experience in that style from when I starred on *Caroline in the City*, and several members of the crew on *Mom* were from that same crew. So they were super happy to see me and super helpful. Multi-camera sitcoms are exhausting though, because there are four cameras on your monitor and you're always trying to watch four shots at the same time. You're shooting one person on one side of the table and the other person on the other side of the table, and two other angles and it's hard to look at because those are four completely separate shots and you're trying to pay attention to whether or not each actor in each shot is giving you something good.

The other thing is, there's no prep on a show like that, which is why so often sitcoms use the same one or two directors the whole season. You go in for the table read the first day, then you rehearse a little bit and get a sense of what doesn't work. You take the scenes that *do* work and try to put them up on their feet a little bit. The next day, you get a new script, because they rewrote the first one. And you put the whole thing on its feet with actors carrying the script around and show it to the writers. The actors give notes to the writers, the writers give notes to the actors, and the next day you have yet another new script. Usually on that day – Wednesday if you're starting on Monday – you put it all on its fee and show it to the network and the studio. It's really nerve wracking for the actors, because a lot of the writing is new and there's no way to memorize it, but they have to land the jokes. So then the network gives *their* notes, and on Thursday you might shoot some of the show, because on *Mom* they shoot about half of the show without an audience. The writers and director have to figure out which scenes will work better in front of an audience and which ones won't, or maybe you're shooting stuff on the street or in a car wash or something that they can't build. So construction is going on during the night and they're building new sets, and on Thursday you do some pre-shooting and still show new scenes to the writers. On Friday you come in and do camera blocking – and still get new pages – and then you bring in the audience at 5:00 or 6:00pm and shoot until 11 or midnight. And once you shoot a scene, if it doesn't work, we'll keep working on it, writing jokes on the fly with the audience there, and if it's really a disaster they'll just let the audience go home and fix it after they're gone.

It's a very intense pace, and part of your job is just keeping people from panicking, including yourself. You can make a plan, and it's so much better when you do, but know that it's going to change. There's always some nightmare that comes up. When I was directing *Mom*, Allison Janney

got nominated for an Academy Award and we had to take time for all these people to interview her. So you have to be adaptable. What's really important is accepting the things you cannot change, and that applies to all forms of directing – episodic drama, multi-camera sitcom, independent features … and I think it helps me that as a dancer I did all kinds of styles from modern to ballet, and I sing all different kinds of styles, and I've been lucky as an actress to do every kind of style. Whether you're doing your own personal movie like *The Year of Spectacular Men*, which I directed last year, or a show working for someone else, you just try to make the areas you can better.

And you can never rest. You can never let your guard down, because the minute you let your guard down, that's when something slips between the cracks. You have to be constantly vigilant about what you're seeing on the monitor, and making sure that each line is correct – if you can, you want at least one take of each scene exactly as it was written. In some of my early stuff, like the first movies I directed for the Hallmark Channel, there were very sketchy parts of the crew … not a great script supervisor, and on one of the early things I directed I had a very difficult DP. That's why it's so important to identify the weaknesses in your crew, to make sure you're vigilant in those areas. And then when you have someone who's really strong, you can coast on that a little … but not really. I was working recently with a great script supervisor who's been doing it a long time, and he still didn't notice a couple shots I needed that were missing. So you must be vigilant. And get a good master, because then if something is missing at least you have it there. If you forgot to get someone getting up and leaving, you have it.

With the technology nowadays, there are more ways to cover yourself. With high-def you can reframe in post if the shot isn't exactly the right size, or if you didn't get the close-up. You can even split the screen and use one actor's performance from one take and another's from another, or you can digitally take out pauses and add or subtract syllables in post to make the joke pop better, some of which I hate as an actor but I love as a director. It's important as a director to be aware of all that technology so you know what's possible.

HEMPHILL: You seem so passionate about directing now, and I'm curious where you see it in relation to your acting career. Given your choice, which would you like to focus on?

THOMPSON: Well, if you said I could star in a $100 million movie or I could direct a $100 million movie, I would definitely pick directing. Aside from the fact that I feel like there's more of a future for me there, I just feel like I know how to do the job. It feels natural for my personality and the way my mind works.

17 Bryan Spicer (*Hawaii Five-0*, *The Man in the High Castle*)

I first became aware of director Bryan Spicer when I encountered his lively episodes of *Eerie, Indiana* back in the early '90s. In the 25 years since then, he's built up a résumé that would be the envy of any filmmaker, doing excellent work in both features and television in virtually every genre – his filmography includes teen comedies, Westerns, sci-fi, a musical, urban action, romance, procedurals, comic book superheroes, period pieces and more. In recent years Spicer has focused almost entirely on one show, *Hawaii Five-0*, but that doesn't mean he has left his breadth of style behind. To the contrary, thanks to showrunner Peter Lenkov's audacious blend of tones, *Hawaii Five-0* has given Spicer the perfect vehicle for his talents: from week to week it shifts emphasis between light comedy and tragedy and all the emotional notes in between, juggling increasingly complex ensemble relationships with action set pieces of astonishing ambition and scope. *Hawaii Five-0*'s success has freed Lenkov, Spicer, and their collaborators up to go in bold new directions without losing sight of the breezy appeal the show established early on, and the inventiveness of the staging has steadily increased with each passing season. As producing director, Spicer directs several episodes a year and supervises the rest; he's responsible for maintaining the visual consistency of the show while continuing to stretch its aesthetic boundaries. The scale of the episodes directed by Spicer is unlike anything else on network television; he's almost singlehandedly keeping a certain tradition of action filmmaking – that of Walter Hill, Richard Donner, John Badham, and other '80s auteurs – alive, but with a fraction of the resources those directors had to work with in their heyday. I wanted to find out how he achieves his effects, and how he juggles his duties on his own episodes with those overseeing other directors, so I spoke to Spicer by phone the day after he returned to work in Hawaii for season nine.

HEMPHILL: I'm always amazed by the epic sweep you and the other directors are able to achieve on *Hawaii Five-0* – the season eight finale, for example, is like a John McTiernan movie shot on a TV schedule and budget. How do you conceive of and execute something like the prologue to that episode, where you've got a Russian sub rising out of the water on a

beach and there are guys in the water, hundreds of extras on the beach, Alex O'Loughlin riding out to the sub in an inflatable boat ... it all looks totally real, but I've got to assume there's a good deal of visual effects work there. What kind of planning goes into a scene like that?

BRYAN SPICER: There are two or three episodes a year – usually the premiere and the finale, which I direct – that require storyboards. In this case I storyboarded the whole thing, because obviously we couldn't get a submarine. It was all CG, and we worked closely with our computer special effects guys and then I went out and shot the plates. We shot the water with a drone, and that's basically a reference plate for them to put the CG submarine into. And we also did some stuff in our parking lot. I built the top hull of the submarine so people could stand on it and I put McGarrett (O'Loughlin) in a Zodiac in the parking lot on wheels, put the camera behind him, and pushed him toward the guys standing up on this platform so that we could get the shot over McGarrett to the guys with guns on the submarine. When the guy throws the ladder down to McGarrett, it's an all CG ladder – we see McGarrett climbing up onto the sub and standing on it, but we never actually see him grabbing the ladder. It would have been too expensive – and boring – so I cut that out. You do that in the storyboards; you cut corners where you can so that you can afford to do what you want to do and make it look the best you can. Then when blocking everybody going in the door of the sub, I built the door and the rest of it was all green screen.

HEMPHILL: What about the kind of action that isn't so effects dependent? In that same episode, there's a climax at the Russian consulate where you've got multiple characters spreading through the building with guns looking for the bad guy, and ultimately McGarrett has a big fight scene with him. Do you storyboard something like that and stick to a precise plan, or is it more about responding to what the actors and stuntmen do on the day?

SPICER: We have meetings ahead of time to talk about the fights and specifically what I want the fights to achieve. In a scene like that, they all enter the house looking for one guy and I have to keep everybody alive as they split up in different directions. It ends with McGarrett going out the window, but I need to give everybody else a little piece of action on the way. Once I get a location I'll walk it with the DP and stunt coordinator and lay out the groundwork – where everybody's going to be, where they're going to go, and how the film's going to cut together. The place where we shot wasn't really what the script said it was, it was a big mansion, so I had to piece different parts of the mansion together to make it look like it all flowed together. Once we've walked the location, the stunt guys rehearse the stunts on the stage, videotape it for me, cut it together, and then I watch it. I make adjustments and changes if the fight is too brutal or not slick enough, and then when we shoot we know what we want. I place the camera angles on the day based on that choreography;

if I had more time I would do it all ahead of time, but it's just as easy to do it on the day once I can physically see the fight.

HEMPHILL: How many cameras are you working with?

SPICER: I have three cameras on the show, every day. I think it's one of the reasons we're able to do the show so quickly, not only because we get a lot of coverage but also because you can leapfrog. For instance, when I was shooting that fight in the house we actually had four cameras, and while I was downstairs shooting the actors with two of them I sent my stunt guy upstairs with doubles to shoot the fight in wide shots. Then when he had done all the wide shots with the doubles I came upstairs and put the actors into it and went in closer on the actors doing the same fight that he just did with the stuntmen. It makes it just a little bit more time efficient if everybody's doing double duty with two units shooting at the same time. It's essential, because we do 25 episodes a season, which is more than most people – most shows do 22. I give most of the kudos to our crew, which is the best I've ever worked with. I don't know how they do it – every week they turn out more action than any other show in less time.

HEMPHILL: Yeah, I'm constantly impressed by what you guys are able to achieve on a TV schedule and budget. And the location work is phenomenal.

SPICER: We definitely want to make the island a character. We shoot mostly daytime here – very few nights, aside from the Halloween episodes – and I ask the directors to embrace the visuals of the island.

HEMPHILL: How much control do you have when you're out on location? The show has a lot of big crowd scenes ... are those all extras, or are you only in control of a limited amount of space and at the mercy of the public for what's going on in the background?

SPICER: It depends on where you are. In that teaser sequence you mentioned, the reason I picked the spots where you saw Five-0 looking at the submarine was that they were down by the Hilton Hawaiian Village at the very end of Waikiki Beach and we could control that a lot easier – we can rope it off and keep people away. If we came further up into Waikiki we could never do that. We had a season opener a few years ago with a drone shooting at people and we chose to shoot that in an area where we couldn't control the beach as well, and it was a bit of a mistake. For this one I decided to go to a place we could control. I also shot all the material before Five-0 shows up ahead of time without the actors being there – I called them in three or four hours later after I'd done all the point of views of the ship and everybody's reactions to the ship so that I could get 200 extras on the beach and spend the time I needed without the pressure of the actors waiting on me.

HEMPHILL: One of my favorite things about that episode is the sense of claustrophobia once you get inside the sub. How did you approach that material visually to convey that cramped, suffocating feeling?

SPICER: We used the foregrounds to help fill the frame up – it's all about framing and where you put people. I brought a lot of people in to make it really sweaty and put faces all over to fill up all the little gaps. We actually shot all those scenes on the Missouri, so I had to make a big ship look like a small submarine. I blocked the guys talking really close, face to face, so you feel like there's just nowhere to move.

HEMPHILL: I feel like your eye for knowing where the camera should be to best capture the action in scenes like that is really unerring ... as producing director do you ever find yourself in a position where you're watching another director put the camera in a place that you know is not the most dynamic, and how do you deal with that situation?

SPICER: At that point I become a coach. I'll ask them, "What's that position doing for you? What story is it telling? How can you tell that story better? What if ...?" I just try to approach it in a teaching way instead of an overbearing way and suggest. Suggest strongly, sometimes. [laughs] I think with my history and reputation people tend to listen and respect what I have to say, so it's been a good collaborative effort with all the directors that have come through here.

I schedule the directors in a certain pattern. I direct five episodes a year: the first one, the last one, and three in the middle. And every year we have returning directors that have been here before that I can trust, and I put them in slots around mine because I won't normally be able to be around for other episodes while I'm shooting. Then when we have new directors, which we do every year, I'll schedule them in places where I can be there with them, because it's a difficult show. I prep them in what we're looking for and what we like and show them episodes and talk through the scripts, and then I'm on set with them to help them succeed. I watch their back and make sure they're getting what we want and what we need.

HEMPHILL: And a year or two ago you were in that guest director position yourself, on *Man in the High Castle*. What was that like?

SPICER: It was a blast. During my hiatus, Frank Spotnitz, who worked with me on *The X-Files*, called me up and said, "What are you doing this summer?" I said, "nothing," and he hired me to come work on the show. You know, I started my career as a freelance director, on a show called *Parker Lewis Can't Lose*. I was really young, in my early twenties, and produced and directed that for two years, directing every other episode. It was kind of a live action cartoon, and one day my phone rang and it was Steven Spielberg. He'd been watching the show, and the next thing I knew I was in his office taking a meeting and the next thing I knew after that I was in an office next to his and I was working for Steven Spielberg.

HEMPHILL: Wow. What kind of stuff were you directing for him?

SPICER: I was preparing a movie and working on a series he had called *SeaQuest*. I worked for him for a while and then did the Power Rangers movie, then I directed a movie with Tim Allen and a movie called

McHale's Navy that didn't do very well, and eventually I came back to television on *The X-Files*. Since then it's been a lot of different TV shows over the years and I've been very blessed to work with some good people and really blessed to land this job in Hawaii. I moved out here and bought a house and I live here now.

HEMPHILL: Do you prefer staying on one show as producing director to moving around as a journeyman from series to series?

SPICER: They both have their pros and cons. When I was freelance, I was lucky enough to get on new shows and was able to get in on the ground floor of series trying to find their style. I was able to create the look on shows and show the producers things they didn't expect and they would say, "Wow, we like that. That's what the show should look like." That's a great opportunity that you get when you're just going from show to show. But it's very hard on your home life because it's like being a rock star. You're traveling from city to city every two weeks and you don't get to be home very often. And that's the downside to it. But I loved it – I did it for 20 years. I was all over the world shooting and it wasn't until I finally landed on this show that I realized it's actually nice to be on one shoot. You have a place, you have a life, you can go home at the end of the day and not have to worry about where you're flying off to. I've been here for seven years now and this crew is like my family. We party together, we hang out together and the island is small. It's not like working in LA where there are hundreds of shows. Wherever we go to film, people are happy to see us. The fans show up, and we allow them to come as close as possible so that they can watch what we're doing and then the actors go and do pictures with them and stuff like that. We have a screening of the premiere every year projected on the beach, out in the open for whoever wants to come.

HEMPHILL: Well, it does feel like even after eight seasons you and your collaborators are still really engaged with the work. The last season was as fresh and energetic as any of the previous ones.

SPICER: That really starts with the scripts. Our showrunner, Peter Lenkov, is amazing at giving us great scripts every week – and different scripts. He's a fantastic writer, and he's really ahead of the game – we always get about five or six scripts before we even start the year, where most shows don't even get one. We just run with them and try to make them the best that we can with the money and time that we have. It's a really tough job to keep the quality up, you know? Sometimes I'm amazed that we get it all done.

18 Kevin Dowling (*The Son, Bosch, The Americans*)

Kevin Dowling was a well-established stage and film director before he made the jump to episodic television in the late 1990s, having won numerous awards for his feature debut *The Sum of Us*, starring Russell Crowe. Coming to television with a theater director's sensitivity to performance and a filmmaker's conceptual eye, he quickly became one of the true artists of the medium, elevating series as varied as *One Tree Hill*, *Law and Order: Criminal Intent*, and *Heroes* with his sophisticated sense of composition and camera movement. The shows Dowling has worked on as producing director, like *Necessary Roughness* and the AMC Western *The Son*, are among the most cinematic on television, with fully realized visual strategies that would make the most noted feature directors proud. *The Son* in particular is one of the most striking series of recent years, a Western that both honors the traditions of the genre and takes them in bold new directions. Dowling has also turned in impressive work on the FX series *The Americans* and made a name for himself in the world of streaming as producer-director on *Bosch* for Amazon and *13 Reasons Why* for Netflix, though he said his basic job doesn't change much whether he's working on network television, cable, or for a streaming platform. We sat down in LA to talk about his career and approach while he was in the final weeks of postproduction on the third season of *13 Reasons Why*.

JIM HEMPHILL: You began in film and theater, and I'm curious how you made the transition into episodic television. Was it something you had always wanted to do?

KEVIN DOWLING: No, when I first moved to LA after *The Sum of Us* opened, the idea was to do independent films. *Sum of Us* had gone much better than I could possibly have hoped – it went all over the world, won awards, and I thought, "Okay, that's the way it will always be." Then I did *Mojave Moon*, which was kind of a sophomore jinx. We had a wonderful cast – Angelina Jolie and Danny Aiello and Alfred Molina. But we rushed the script, and I made the mistake that I'd told people a million times not to make, which is don't go into production until your script is ready. I thought, "No, we'll fix it." We didn't fix it. There were some wonderful things in it that I'm proud of, but overall we didn't fix it.

After that I did *Last Rites*, which was originally going to be an independent film. Universal picked it up for the independent unit they were starting, but then they pushed us off on Starz because Starz wanted to make original films. It was very successful for Starz, but I was sitting at home with a stack of six film scripts, and they were all some variation on a man chasing a woman down an alley with a knife, and I kept putting them to the side. On the other side of my chair was a pilot script that my agent had sent me; he said, "Look, I know you don't want to do television. Just read this script, it's really good." So I finally thought okay, I'm sick of this crap, and I picked it up. It was Barbara Hall's pilot for *Judging Amy*, and I read it cover to cover. And I said, "Okay, these people writing the film scripts can't write, this is shit. This woman Barbara Hall can write, I'll at least meet her." And the next thing I know I'm directing a *Judging Amy*.

Now, initially when people were asking if I wanted to get into television, I was told that the networks wouldn't approve me, because they thought an independent filmmaker couldn't make eight page days. Of course, it's easier to direct television than independent films – you have a lot more money and a lot more toys. But that wasn't the attitude, and my nickname at the time was Dark Dowling, which didn't help. But Barbara Hall and Joe Stern stood up for me and said they wanted me. And actually before that, a guy named David Jacobs, who had created *Dallas* and *Knots Landing*, was doing a thing called *Four Corners* with Ann-Margret and Sonia Braga and Ray Barry, and he hired me. He had seen my film and CBS just said okay. So that was actually the first thing I shot. It was a great experience; I was shooting the third episode and they weren't happy with the pilot, so I re-shot five scenes from the pilot for them. The network loved it, so I became approved at CBS, and when *Judging Amy* came up CBS was fine with me doing it.

HEMPHILL: So even though you never planned on working in television, you had some pretty good initial experiences. How did you have to adjust your thinking, and what were the pros and cons for you having come from independent films?

DOWLING: Well, one pro was obviously making a lot more money. And I was surprised. I had to leave my snobbery at home. The scripts were good scripts, and they were about things that I believed in. Then when I moved on to direct things like *Early Edition* I had huge action pieces to do that allowed me to expand. So I started treating television like the theater. In the theater, the playwright is central; by contract and by tradition, you can't change a word without their permission. In film, *you're* central, nobody does anything without you as the director. And then at the time I started in television, what had been a producer's medium was becoming a writer's medium again.

So when I went to *Early Edition*, I treated the script as if it was a play. I definitely gave notes, and I found that the writers were really responsive

to notes that were thoughtful. To this day I still treat it the same. I just did *13 Reasons Why*, and the showrunner Brian Yorkey comes from the stage. It's his vision, I didn't think it up. It wasn't something that I shepherded, so when I arrive in the third season, I have to treat it like a play that exists. But by the same token, Brian's very open to notes and I can say, "I don't think this will work here, can we move it here?" And he'll do all these things. That's how I've thrived in television; I see it as a collaboration that you really have to devote yourself to, and if you don't like the vision of the person doing it, don't do the show.

HEMPHILL: You had a more active creative role on *Necessary Roughness* though, correct? What was that experience like?

DOWLING: Well, that was my baby because I found the origin story. Actually my wife found the story and brought it to me, and I said this should be a series. Donna Dannenfelser, who was the person on whom *Necessary Roughness* was based, was the sister of an actor I'd directed. And he said my sister has a great story, she was the first therapist for an NFL team.

So I was working for almost a year trying to put it together before I met Liz Kruger and Craig Shapiro, who were the writers who eventually put it together with me, and we did it. That's a very different thing, because I set the style, I set how it looked, I shot the pilot, and I oversaw every single episode, and it had a stricter visual style than a lot of things. We shot football like the NFL. I didn't want to see any hand-held cameras running down on the field. In my opinion, football was being shot best by the NFL, and we literally hired NFL cameramen to do it because it just made it more exciting. The therapy sessions, on the other hand, were hand-held and very personal. So for other directors there were certain strictures coming in, but I always approach being the producing director with the attitude that we're doing an epic story that's 16 pieces long, and you're doing a part of that, and we want it to be as unique as you can make it, but it does have to fall within the universe of the other 15.

I will bring a director in and I'll say, "Look, here's what you have to do. And here's what we've learned that we liked, and here's the third category, which is do whatever you want. Find new things." I find that's the best approach, and for me it was satisfying to be part of this ongoing epic thing. The crew was all hired by me, the DPs were all hired by me, so it was as close as you could get to being a feature director on television, and I found that really satisfying.

The same thing was true when we were in the early days of *Bosch*. I couldn't stay as long there, but I'd known showrunner Eric Overmyer since theater days back at Playwrights Horizons in New York. And I said, "Look, I can only come in to redo the parts of the pilot you want to redo, and then do the next two episodes. But why don't we do them as a block, and we'll set the style." Because his early problem with the style of *Bosch* was that the way Jim McKay shot it was not the film noir that he and Michael Connelly saw. There were some feuds during the original pilot,

and I said, "The problem was that you guys just had different approaches, different world views." Jim McKay's a really talented director, but he's on record saying that he hates artifice, and he wants to shoot things as close to a documentary as you can. And by the way, if you want film noir, that's kind of the ultimate artificial style. Light is coming from places that are unmotivated, and all kinds of things.

And I think we looked for something in between. I said, "Look, you can't do strict film noir. You're going to want to do some hand-held things in the chases like that, but let me talk to the DPs about creating a lighting scheme and a feel to LA that we haven't seen before." So again, I got to have what is essentially a feature director's input on a show that they're still shooting that way. We took the movie *Out of the Past*, and used it as a template. If you look at some of the early lighting, we did a lot of the sort of dramatic, overdone, shadowy things on people's faces that you saw in that movie.

HEMPHILL: You also found some really unique ways to shoot LA, which is no small trick given how extensively the city has been photographed over the years. What was your philosophy when it came to locations?

DOWLING: You always say, "Let's find the part of LA no one else has found," and then you find out that there is almost nowhere that exists like that. Then I said, "Look, we're going to want to be in East LA. We're going to want to be in Boyle Heights. There are places there that aren't shot as much, let's look for them, and I want to do two competing things. I want to find gritty, strange places, and then I want to shoot them with a kind of lush color and light." And I think we achieved that pretty well – even something like the prison, which was a real prison, we made more majestic and impressive by the way we shot it.

HEMPHILL: That prison material is pretty tough, and *The Son* is a heavy drama as well. Is the environment different on the set of one of those shows than a lighter show like *Necessary Roughness*?

DOWLING: It doesn't change that much for me. I always see part of my job as creating a safe environment for the actors, so I try to instill that in a crew. I don't rehearse unless there's absolute quiet. I will hear somebody whispering and say, "All right, we're stopping now. When it's quiet, we can all continue doing our work. Whoever's talking, you should just know that we're waiting for you." It sets a mood.

I try to have humor on set. There were things going down in the *Bosch* episodes that were so dark that if you took the whole episode too much to the serious side, then the dark things wouldn't have the power that they should. I'm always looking for the buoyancy underneath the dark side, and then what's the dark undercurrent when people are laughing? I think I tried to do that with *Bosch, Necessary Roughness* – *The Americans* for sure. For example, the plot line we had where Philip seduces the 15-year old girl; everybody was wondering if we were going to lose people who would say, "Yes, we've been rooting for these Russian murderers who

are killing Americans, but this is the end of it." Julia Garner, who played the young woman, really helped with that because she had both this kind of injured, unhappy quality of a kid of neglectful parents, but she also was fun. And Matthew [Rhys] embraced that. So there were scenes like them fighting with popcorn in the kitchen and smoking a joint outside and other humorous things, and then suddenly you're going, "Holy shit. He's about to have sex with a 15-year-old."

HEMPHILL: Well, since you brought up sex scenes, how do you approach those? *The Son* and *Bosch* and some of your other shows have had fairly intimate moments. How do you create an environment for the actors to make them feel safe?

DOWLING: On *The Americans*, there was an interesting challenge because Annet [Mahendru] had done a nude scene the season before, and her father wouldn't speak to her afterward. So I had dinner with her and her costar and I just said, "Look, I treat sex scenes like everything else we do. I understand your father has a hang-up about that, but it's part of human behavior. And we're willing to portray murdering, we're willing to portray all kinds of other emotional states. This is one of the joyous wonderful parts of life. That's how I'll treat it. I will protect you. If you feel shy or you feel anything else, we will have a closed set, we'll do all those things. But then I want to explore this as if it were any other kind of work." And that's how I feel like you make people comfortable. This is just another acting exercise. What is it like when I have sex, when I'm frightened, when I'm having an orgasm, when I take off my clothes for the first time, when someone sees me naked for the first time? It's all just another acting exercise.

I find that sometimes people make the mistake of treating it too preciously – "Oh my God, we're doing a nude scene." I had a first AD on a show who kept going over to the actress and saying, "Anytime you're uncomfortable we'll stop." And I finally had to take her aside and say, "I'm trying to make her feel comfortable, and you're reminding her that she might be uncomfortable, and that's undoing the work."

HEMPHILL: Let's shift from sex to violence. There's a shocking moment in the third episode of *The Son* where a violent act seems to come out of nowhere, throwing the viewer back in his or her seat. What was your thinking about how to approach that?

DOWLING: I basically said, "I think we have to shoot this as if it's a conversation between a family or friends, and not play up the underlying conflict of this asshole who's treating Pierce Brosnan's character with such disdain. So that when Pierce is upset and gets up, what we really think is he's going to go over and either say something mean, or pat him on the shoulder, and that way we have a complete surprise." That's how we approached it. If you look at the shots, they're traditional overs and all of that; I think you had to lull everybody to sleep to make that work.

HEMPHILL: Well, in general I feel like the violence and the action on that show has a real immediacy to it. I was wondering if you could talk a little bit about how you work with the stunt coordinator – on *The Son* you were working with one of the legends, Buddy Joe Hooker.

DOWLING: He's great, and I can be kind of a pain to stunt coordinators, because coming from the stage, I did most of my own fight choreography – and I'm a martial artist, so I know how to fight. So there are lots of things that drive me nuts. When Buddy Joe and I first sat down to talk about the season, I said, "I want the violence to feel as brutal and true as it is, and I don't want any embellishment. I want to do as little embellishment as is necessary." At one point a Comanche is chasing the young Eli and he whacks him with a rifle. Obviously that has to be choreographed because you're putting everybody in danger with a horse moving that fast, but I wanted it to feel like it wasn't choreographed. I wanted it to be brutal, but I didn't want hyper-violence like Tarantino. I wanted it to be what it was, and I think we achieved that.

HEMPHILL: Another thing I like about *The Son* is you strike a really interesting balance between the classical John Ford-style compositions way of shooting it and a more intensely subjective style where you're really putting the audience in Eli's shoes. How did you decide which scenes to direct the more traditional way, and which ones really needed to shove the audience into the perspective of the character?

DOWLING: Basically, I said 1915 should feel formal. Anamorphic lenses, beautiful compositions, but it should also feel less vibrant in a funny way. And when we get to the Comanche world of the past, that should feel hand-held and dangerous, but also just full of life. And yes, I want to portray the side of them that were warriors, but I also want to see what it's like in a teepee and how they make love, and how they back each other. And then when you came back to Pierce [Brosnan] in 1915, the idea was for it to be classic, exactly what you were saying.

HEMPHILL: One of the prospective audiences for this book is theoretically film students, or indie filmmakers who are looking to make transition into directing episodic TV. So I'm wondering if there are any common mistakes you've seen people make when they start directing TV. What are some of the pitfalls that people should try to avoid?

DOWLING: When I first started with *Judging Amy* and other things like that, they were pretty traditionally shot. I think they were well shot, but it was masters, overs, close-ups ... people would lean toward close-ups a lot. That has changed hugely; now with television, you're essentially shooting small features on sizable budgets. *The Strain*, I think, is six million dollars, *Jack Ryan* is eight or ten.

You're having to deal with huge things, and I think there are two mistakes, two very different mistakes. One is coming in underestimating just how big these shows are. But the second mistake's a more classical mistake, and I made that mistake a little bit coming over from independent

film. It's the mistake of thinking, "I'm going to change how this works." And that's a hard one, because you don't want to discourage somebody's creative impulse. On the other hand, if you walked into *Necessary Roughness* and said, "I'm gonna shoot long lenses and on a dolly in the therapy room," we're not going to let you do that. So you have to embrace what you're doing, and if you can't then you have to know that's not where you should go. That's a question a director coming into it should ask. Are there strictures on here? How much leeway? When I arrived at *The Strain*, I sat down with Miles Dale and Guillermo del Toro and they said other than the vampires and the basics, this is yours now. I asked a couple of questions, I wanted to change a few things, and Guillermo in Guillermo's style said, "Kevin, this is not my nightmare anymore. This is your nightmare."

I think there's more and more of that in television, where people are honoring the director that way when they can. But you have to go in there and recognize, Guillermo del Toro created this. He created the look. To a certain degree, you're going to live within that. But, he's going to give you as much freedom within that world as you can want. Now, there are other places that won't do that. You're not going to shoot *Law & Order* in any other way than how they shoot it. They're not going to change it for you, and if you don't like that style you shouldn't do the show. I think you just have to use some common sense. Occasionally I will watch people come in and try to change what's been there and is already working., and that's not a smart idea. If you want to do that, develop your own stuff.

19 Michael Katleman (*China Beach, Zoo, Quantum Leap*)

Michael Katleman didn't set out to become a filmmaker; his first love was music. When his music career didn't work out, he moved over to the film industry and quickly gave himself a crash course in nearly every aspect of production, working his way up from production assistant to AD to director to producing director (with a detour along the way to direct a very entertaining feature film, the killer crocodile movie *Primeval*). His background in music is not incidental; if there's one thing that distinguishes Katleman's work it's an exemplary sense of rhythm and tone. His episodes are consistently involving and seductive, drawing the audience in through their precisely calibrated transitions and camera moves. Although he's directed hundreds of hours of television in genres ranging from dark sci-fi (*The X-Files*) to light dramedy (*The Gilmore Girls*) and is as comfortable helming a modern-day Western such as *Justified* as he is going back into a 1970s police department for *Life on Mars*, Katleman's finest work to date (in my humble opinion) is as producer-director on *Zoo*. An adaptation of James Patterson's novel about animals of the world rising up to attack the human race, *Zoo* was, over the course of its three seasons, an extraordinarily ambitious and unique combination of suspense, humor, action, and tragedy that had an epic sweep (it was set in multiple cities and even countries) as well as an intimate attention to character and to the nuances of animal behavior. Katleman created a singularly eerie visual style for the series, in which the perspective of the animals was as important as that of the humans, and as sharply conveyed via lenses and camera placement. I sat down to talk with him about this show and his background while he was finishing up the first season of a new ABC series, *The Fix*.

JIM HEMPHILL: What was your first job on a film or television set?

MICHAEL KATLEMAN: You used to get "drive to" money, where everyone on a crew got paid the gas money that it would cost to drive from the studio to wherever the location was. My job was to deliver that money to set. I was allowed to be on set for about an hour; I'd give everyone their six dollars, and they loved me for it. Through that they ended up giving me a job working on a show as a production assistant, and I ended up doing every kind of job you can imagine. I was an apprentice editor,

I did locations for a bit, on one independent film, *Native Son*, I was the first AD, the animal wrangler, and transportation for a day until I fired myself because I did such a bad job. I was pretty scrappy and would do just about any job there was out there, and then I ended up getting into the Directors Guild as a second AD, and worked my way up from there.

HEMPHILL: When did you know you wanted to direct and how did you start preparing for that?

KATLEMAN: I started doing a lot of features as an AD, and then that's when I really got bit by the bug. So I took acting classes, and I would just soak up as much as I possibly could by working in every department I knew. Because I'm not a writer and couldn't get into directing that way, I knew I had to get back into television, because you couldn't make that move from AD to director in features. I got hired on *China Beach*, which was created by John Sacret Young. I was always his AD when he directed, and he was super supportive – he's the one that gave me my shot.

HEMPHILL: What do you remember about that first shot?

KATLEMAN: I was his AD on the set, and we had this big dinner table sequence with every cast member. He knew I wanted to direct – I wasn't shy about it – and he just turned to me and said, "That's yours." I said, "Wait, what?" He goes "That's yours," and he became the AD and said, "and you have 45 minutes to get it." And I said, "Okay." Obviously I had prepped it as an AD, I knew it inside and out, it wasn't like I was cold, but I certainly wasn't prepared for that. And he just stepped back and watched, it was amazing. Then they ended up replacing the director on another episode with three days left, and he let me direct those three days. And then he ended up giving me an episode.

He said, "I'm going to give you one episode, I'm not going to give you another one, you have to go out in the world and direct. Once you go out and direct, I'll give you another episode." Which I thought was amazing, rather than just get stuck in the camp, not that it was a bad camp to be stuck in.

So he gave me that talk and then I didn't work again for six months. But I knew that at that point I was 100 percent committed to being a director. I was married, didn't have kids, we ended up taking a second mortgage out on the house, my wife worked at Nordstrom's, and I just watched every movie that came out. By then, it had been years and years of going up from being a PA to second to a first, and so I just stuck it out, and the second show I got was *Quantum Leap*. And then it just went from there. John gave me another one, then all of a sudden the shows started flowing, which was amazing. But it was really tough getting that *Quantum Leap* job. I went to a million meetings and did all the leg work that you possibly could do, that I was able to do, and then it happened.

HEMPHILL: When you did that first *Quantum Leap* episode, how did that experience differ from the experience you had on *China Beach*, where everyone knew you and was supporting you?

KATLEMAN: Totally different. When you get on a new show, they're testing you. They've looked you up, looked at your credits … I don't care who it is, every crew member sizes you up and then they test you. The DP tests you, because the DP wants to direct or has. The crew doesn't want to be there all day. Their whole thing is, "Are you going to be someone who just can't make your mind up?" The actors want someone that's going to have their back. So that first rehearsal is the most important moment ever. How you come out and handle yourself, how you deal with the actors and the crew – do you have a plan? How do you present that plan? And then it takes a while to win the crew over, and if you do, then you're going to have a great experience, and if you don't, it's going to be hell the whole time.

HEMPHILL: It seems to me that once you started working as a producing director that became your preferred mode. Do you like that better than jumping from one show to another?

KATLEMAN: I like both. I do prefer the producer-director role, because there's a beginning, middle, and end, and you get to know the actor's backstory and what's going on, you really get to get deep into it, into all the casting and the postproduction. You're there for the long haul, the full experience, and I love that. But after I get off a show, I do like to go do a couple episodes on a show I'm *not* producing, and say, "Okay, I'm just going to direct, I'm not going to worry about the other stuff." I really enjoy directing, so I find really fun inspiring things on every show.

HEMPHILL: One of my favorite shows you've been on as producer-director is *Zoo*, which had a really unsettling, unique style. What was your philosophy about how to approach that series visually?

KATLEMAN: Well, we really wanted to capture the fear, and we really wanted to capture the animals as characters, as opposed to sitting back and looking at them. It was really their story. So how do we manipulate the situations to make sure that you're getting that point across? A lot of it had to do with the height of the lens; whatever the animal was, you didn't want to look down on them. You wanted to make them feel big, make them feel important, see how agile they are, and try and show the communication between them without making it silly. And really make it feel that they are heroic and strong in their own. That was really how we entered … we went through the gamut of animals. How do you make them scary? It was often about what's around the corner rather than showing everything.

HEMPHILL: The compositions and transitions are really precise. Do you storyboard everything?

KATLEMAN: On that show we had to storyboard because of all the animals. You need to do it for a couple reasons. One is that you want to make sure that your plan's going to work, so you board the whole thing out just to find out, "Can I get animals here? If I can't, do I need to have the art department build something that looks organic, that the animals aren't

going to escape? This is the ultimate story I want to tell." You have to be able to show the boards to the animal people, the visual effects people, every department, the art department, and just say "This is what we're trying to do, can we accomplish this?" Then once you get the feedback from everybody, especially animal wranglers, and they say, "We can only do x, y, and z," then you modify it. So with that, every single animal sequence that we did, for all three years, we storyboarded. Storyboarded like crazy. And then, you'd shoot the animals always first. Because the animals sometimes don't like the storyboards. [laughs] The story totally shifts. But at least you go in knowing "Okay, this is the concept." Then you have to be fluid and say, "Okay, the bear doesn't want to do this," or, "The lions aren't going to do this."

HEMPHILL: I'm presuming the storyboards help you figure out where to use real animals and where to use visual effects as well.

KATLEMAN: Right. When we got a script, the very first thing we would do is storyboard it. If there was an animal that we had to get from out of state or somewhere, we knew early enough to get it there. On day one or two of prep you would have a meeting with visual effects, special effects, the animal wrangler, everyone, and everyone would go, "This is what we're trying to achieve." The art department. From that point on, everyone is working together as a group, so the communication is really important. So the animal wrangler may go, "I can do this, this, this, but I can't do this." Visual effects, "I can get him to go from a to b for you, what do we need? Okay, so we need to do a plate" It's very complicated, because on a weekly basis we would look at every sequence like that. We were really good about identifying right in the beginning if we couldn't achieve something, and if we couldn't we'd talk to the writers and switch it. Then the storyboard would be refined the whole time, so in theory, by the time you shoot everyone has vetted everything, you know how much is going to be visual effects.

HEMPHILL: You had a lot of top directors on that show – David Barrett, Norman Buckley, Gary Fleder, among others. What would you tell them as far as guidelines for how to direct their episodes?

KATLEMAN: In a weird way, it's somewhat loose. All those directors that you named are professionals, they've done their homework. So when they get there they understand the show and the genre and they know exactly what we're doing. The reason I like working with directors like that is they bring stuff that's surprising. You want them to surprise you. Especially on *Zoo*. There weren't a lot of rules. You could do hand-held, you could not do hand-held, you could do long lens, there wasn't a rule like, "This is how we make the show." It was more, "Do you understand the genre? And you want it to be as scary as possible? And you want to be in the animals' heads? Go."

That's really what the conversation would be. And they work closely with the DP, and we look at things, and we help, we find the locations that support that. So you want it to be that kind of environment where

the directors come in, and they get to do their thing. There's nothing I like better than when I'm sitting at the monitor in the producing role, and just thinking, "God, that's amazing. I don't think I would've thought of that." It's the best to see how other people approach something and look at it. And it has to be what's natural to them. If someone is feeling the scene is frenetic, let them go for it. And if it doesn't work, it doesn't work, it's not the end of the world. But, you don't want them to be second guessing themselves. You want them to be really just going for it.

HEMPHILL: What would you say are the most important things you look for when you're hiring directors for a show?

KATLEMAN: You want them to be inspired, you want them to bring something to it. You don't want them to phone it in; you want the director to want it badly, no matter how long they've been doing it. It's the director's job to come in and be detail oriented about what the transitions are, how the scenes are cut together, the casting … their sole job is to be detail oriented and to tell that story the best they can.

Sometimes it means arguing with the writers who wrote it, sometimes it means arguing with me, arguing with the line producer – it's not a fun job all the time. You have to be driven in that you'll get what you want, but still understand the battles that are going on in the show. So if you want something and it can't happen, then the reason it didn't happen is because it just couldn't happen, so move on. So you need a combination of drive and then knowing when to go, "Okay, I'm not going to win this battle." In other words, if this is a story point the network is adamant about, you're just not going to win it. We've already had that fight for two months, I promise you. So you want them to know that it's an honest relationship, and know that if they're getting push back, and it's legit, then you have to understand. But keep pushing until that last second to make the best show.

And you want them to get along. It's a hard job, so if everyone can just get along and be cool with each other, that's really important to me. I want to make sure that everyone is treating everybody with the utmost respect. As far as looking at their film, if someone has a lot, then you want to just look at their footage and see if their style fits. If it's someone new who only has a couple shows under their belt, then it's more about the personality. That's the kind of person who will fight harder. As weird as it sounds, more than anything it's really just a vibe, an energy that you get with the person. Once you say, "Okay, this is the person," you just want to be there as a producer to support them. As a producer-director it's my job to support the director and make sure they have all the tools they need to deliver an amazing show.

HEMPHILL: Do you often work with directors who are new to TV, and what are some of the mistakes they make?

KATLEMAN: Yes, I've worked with a lot of directors that are new, and I guess some of the mistakes would be … you really have to come in with a plan,

and they usually do have a plan, but then you have to know when you've gotten that. It's a matter of knowing when to move on, knowing what's important to get, and having confidence. And giving feedback, not being afraid to go talk with number one on the call sheet. People think that just because they're number one on the call sheet that they know their character really well, but every one of those people want feedback in a respectful way. When I first started I would think, "Okay, they're number one on the call sheet, they must know the character perfectly." And that's not true. So I think it's making sure that you really know when it's there, when you have it, so you can move on. Because if you get stuck in that first scene, all the other scenes are going to suffer. So I think it's that confidence of knowing when to move on, and that communication – those are important.

HEMPHILL: How have the changes in the TV business, both artistically and in terms of technology, changed your job since you started?

KATLEMAN: When I started directing, we were shooting film and each take was precious – and rehearsal was precious. It was kind of a weird balance, because you'd probably rehearse a little too much, then you'd get beat up if you used too much film. They literally kept tabs on how much film you shot, and you'd get really thrashed, because that's how they saved their money, so your takes were precious. Now that it's digital, you can just shoot the first take, you can shoot the rehearsal. I love shooting the rehearsal, because amazing things happen before people start getting comfortable. And we couldn't have done *Zoo* if it was film. Because when we shot the animals, we would just let it run – you'd have a ridiculous amount of footage wasted on the animals just licking their paws or something, and then finally they'd get the right look, and you'd go, "Boom, got it."

So that's one of the things. The other thing is that there were fewer networks and they made more episodes. It was common to have 22 episode seasons, not 13 or something. So as a director you got more shots. Believe it or not, now, only doing ten episodes, people are really precious about those slots. It's like the tension of a pilot is still being brought into the whole thing. I might be wrong, but back when there were fewer shows but they would do more episodes, it felt like there were more shots because you tried people that you didn't know, and you had 22 immediately, and so people were bouncing all around, and there were just a lot more opportunities.

But overall the job doesn't change, and I still really love it and I'm really lucky – I still get excited driving onto a studio lot. And working as a producer-director it's fascinating to meet other directors and see all their prep and how they approach certain things, because as a director you wouldn't normally do that. You wouldn't normally see how other people work. I love that part about it. Because everybody does it a little differently, and there's no right or wrong way. The most important thing to me is shooting the best show you can, the best scenes you can. At the end of the day, the only thing that matters is what's on that TV at the end of the experience.

20 Mary Lou Belli
(NCIS: New Orleans, Famous in Love, Station 19)

As is probably evident from several earlier interviews in this book, I've long admired the filmmaking on *NCIS: New Orleans*, which under the guidance of James Hayman has assembled one of the best rotating companies of directors in episodic television: James Whitmore, Jr., Stacey K. Black, Rob Greenlea, and Bethany Rooney are just some of the superb helmers who have done fine work on the series over the course of its three seasons. I interviewed Rooney for this book as she was preparing the second edition of her book *Directors Tell the Story* for publication; that volume stands alongside Sidney Lumet's *Making Movies* and Alexander Mackendrick's *On Filmmaking* as one of the best books on directing written by a practitioner of the craft.

Directors Tell the Story was co-authored by Mary Lou Belli, a filmmaker of immense range and talent who never met a genre she didn't like and couldn't tackle. Her résumé includes everything from sitcoms and melodramas to detective series and teen shows, and she's another one of *NCIS: New Orleans'* go-to directors. The past few years have been incredibly productive ones for Belli: in addition to her excellent work on *NCIS: New Orleans* she's directed standout episodes of the deliriously enjoyable Hollywood saga *Famous in Love* and the groundbreaking female-driven baseball drama *Pitch*, and in between directing assignments she works as a teacher, mentor, and author. (In addition to *Directors Tell the Story* she has co-written books on acting and television comedy.) Her "Slay the Dragon" episode from *NCIS: New Orleans* showcases Belli's chops as a top-notch action filmmaker who's as adept at shaping performances as she is at ratcheting up suspense and bringing out the humor in her material in a breezy, unaffected manner. What follows is a wide-ranging conversation with Belli about her work on that episode and others.

JIM HEMPHILL: *NCIS: New Orleans* seems to me to be an unusually challenging show in that it's strongly dependent on both character-driven scenes and action sequences – you have to be equally adept at performance and visually oriented set pieces. When you get a script for the show, what are your first steps in terms of thinking about how you're going to approach it?

MARY LOU BELLI: The first thing I do with any script, including *NCIS: New Orleans*, is read it with fresh eyes and with a focus on being the

best audience I can be for that story. I take no notes, and I try to do it with no interruptions. The second read is more like a brainstorming session; I don't edit or second-guess myself. My notes to myself are just that – notes to myself, free of judgment from me or anyone else. To be honest, I toss away a lot of those ideas, but they come from the most creative part of me, the one who is free from responsibility, time constraints and budgets. It's when I start to digest it, take notes, think of the big picture – i.e. what is this story about, why is it important, are there any running or recurring themes. But I also jot down on post-its any smaller questions I may have for the episode's writer, any fun visuals that may pop into my mind – really, anything that I may want to revisit on the next read ... my dissecting read.

That next read is actually my favorite because while I do it I construct my "director's diagram." This is an invaluable tool taught to me by Bethany Rooney. She actually showed me her first one on the set of a show called *South Of Nowhere* where I was invited to shadow her by our mutual friend, writer/producer Nancylee Myatt. (Subsequently, Nancylee, Bethany and I have all worked on *NCIS New Orleans* ... never at the same time.) When I do the director's diagram, I am deconstructing the story into the A, B, and C (or more) stories. At that time, I'm considering whose story is this, what is the structure of this particular episode, what are my big scenes, are they highly dramatic and full of tension, full of action, or full of emotion. Within that diagram I examine act-in and act-outs and I'm already trying to think of interesting visuals for them, especially the signature "phoofs" (freeze frames with postproduction colorization). And since every episode revolves around a crime, I also do a timeline for myself of the clues that the audience knows and in what order they get these clues ... I think of it as a sort of partnership or agreement with my audience, that if they want to play the "whodunit" game, I've given them all the pieces they need to solve the crime along with the NCIS agents. I can only begin to think about the stunts, because so many of them are location-dependent.

HEMPHILL: What kinds of conversations do you have with the producing director in pre-production and throughout the shoot?

BELLI: On my first episode of *NCIS: New Orleans*, I remember Jim Hayman, the show's wonderfully supportive and funny director/producer, saying to me, "Go big or go home." And that's the essence of what producing directors do ... they instruct, guide, and guard the signature of the show while at the same time giving the individual directors the creative space to add on. It's so easy on *NCIS: New Orleans* to put your complete trust in Jim Hayman, because it is so clear that he has your back and will steer you through any and all relationships effortlessly. He's very active during prep and present but never imposing during shooting. He is also very collaborative when giving script notes, which we discuss together.

Before I arrive in New Orleans, Jim, production designer Victoria Paul, and location managers Evan Eastham and David Thornsberry and their team have pre-scouted and/or looked at photos of possible locations. This is ridiculously helpful since this team knows New Orleans (and whether a location is film production friendly) better than I could with any amount of research. Also, Joseph Zolfo, the producer, and Eric Hays, the UPM, are invaluable at this stage. I love to be in a room with them all when they are pitching a place they have filmed before, or scouted before, or is next to where they have scouted before, or passed in the van on the way to where they may have eaten when they scouted before ... the visual clues are so anecdotal and specific, it could be a front door, a person on the street, the owner of the establishment, a reminder that parking was impossible ... the last always leads to us not even visiting that location.

During production, Jim shows up to "open the set." So he is there for the first rehearsal of the day and there for any other questions I have having to do with the day's work. If he's scouting or in meetings for the next show, he will not stick around, but normally, if we are at the studio, and he is upstairs, he'll come down for any and all blocking rehearsals. He has his finger on the pulse and will always feel free to suggest - he has a million great ideas – but I never feel dictated to.

HEMPHILL: Do you find that the collaboration with the producing director is similar on other shows, or does it vary from series to series?

BELLI: I've been on other shows where the producing director is equally helpful in different ways. Some are fantastic forecasters of what to expect on set from your crew and cast, others encourage you to interact with the writers personally and put your mark on that particular episode. Others are less hands-on but may be involved with post production and overseeing the cuts after your director's cut is completed. And then there are shows like *Famous in Love* or *American Woman*, neither of which has a producing director but both have a show runner who is also a director, I. Marlene King, and a Co-Exec (line) producer, Lisa Cochran-Neilan, both of whom are so savvy and director-friendly that having a producing director would seem redundant. There are consistencies among the wonderful producing directors with whom I have worked ... they are there to make your life easier, support you, and guide you. One for whom I worked even prepped me for my meeting with the studio and network to make sure I hit the right talking points before I even had the job – talk about good looking out!

HEMPHILL: How do you acclimate yourself to the visual style of each individual show, especially when there isn't a producing director as thorough as Hayman to introduce you to it?

BELLI: It's about homework, and it differs with established shows versus shows that are not yet on the air. With established shows, my handiest trick is to watch as many previous episodes as you can – with the sound off. Also, I always ask the producing director or show runner what episodes they

like. On *NCIS New Orleans*, Jim Hayman has a visual tone meeting and links to particular scenes and episodes that you will discuss together to make sure you deliver the show the network is expecting.

HEMPHILL: Do you ever feel constrained by those parameters?

BELLI: No, I love it. I think of myself as a person who is given this complicated puzzle, and I love the challenge of assembling it. It's like I'm asked to make a pizza and deliver it – and I get to choose the toppings as long as I deliver a pizza and not hot wings.

HEMPHILL: Are there certain visual principles that *NCIS: New Orleans* adheres to in terms of when and how to move the camera, when to use hand-held, how much to rely on close-ups, emphasizing wide vs. long lenses, etc.? Do you ever find, here or on other shows, that your own instincts for a scene are at odds with the "rules" of the show?

BELLI: I've had the good fortune to have not felt at odds with the look of any show ... I always think if I do, I haven't done my homework, which is to ask myself, "If they want it to look this way, why do they want it to look this way?" *NCIS: New Orleans* swirls with Steadicam masters and then is augmented by hand-held coverage from the operators on rolling stools, and occasionally we use a dolly. The shooting style and speed at which a director can get everything she needs is facilitated by the brilliant and collaborative cinematographer, Gordon Lonsdale, who's also one of the recurring directors on the show. He lights to facilitate the signature 360-degree shots and then the subsequent coverage needs little or no tweaking. So once you block a scene and he lights it, you move like lightning through the shooting process, often cross-shooting and getting as many as three pieces of coverage at the same time. And I'm always looking for every time a piece of coverage can become another piece of coverage, i.e., a close-up with a character crossing behind or standing next to the next character who is speaking so that a simple pan can have one close-up fall into the next one. Of course, you have to think ahead and make sure the blocking supports these choices and that the characters' objectives place them next to each other.

HEMPHILL: You began in 30-minute comedies like *Charles in Charge* and *The Hughleys*, which seem like things that would require a very different skill set from a procedural like *NCIS: New Orleans*. Was it challenging – both from a creative point of view and from a professional one (in terms of overcoming people's assumptions about you) – to transition from one style of filmmaking to another?

BELLI: Working with actors and knowing their language is similar in both arenas, but so many of the other skills are vastly different. I facilitated the transition from multi-camera sitcom, which is more like staging a play that is seen by an audience, in two ways. I studied and I shadowed generous, established TV directors and learned by observing. I would haul my butt to the AFI library and read a book (often suggested by the

librarian) about something I didn't know well enough. Or I hired a script supervisor with tons of experience to fill in my gaps.

I often say doing hour-long episodic is ten times harder and 100 percent more rewarding. The challenging part was getting folks in the industry to think of me as something other than a sitcom director. I tried to make that easier for them by going back to my roots and directing some plays; I always feel when a credible source (outside of your agent who benefits when you get work) says you're good – i.e. a good play review in *Variety* – it's easier for a person to hire you. I've also had actors who requested me and directors vouch for my skill set. Those endorsements are priceless – thank you, Scott Bakula and Jim Hayman!

HEMPHILL: Take me through the casting process of guest stars. On *NCIS: New Orleans*, for example, are you able to audition actors in a room, or is it done largely online these days?

BELLI: Although I prefer to do all casting in the room in order to give the actors adjustments and interact with them personally, geography gets in the way So, on *NCIS: New Orleans*, I cast the Los Angeles actors online. I do call casting before I leave Los Angeles and offer to come to any session they might be having ... but that's usually too far ahead for Susan Bluestein and Jason Kennedy, our wonderful, actor-friendly casting directors, so that has never yet worked out. But they send me amazing choices once I reach New Orleans, and Jim Hayman and I do attend local casting in New Orleans in person.

HEMPHILL: How does your work as an actor inform your approach as a director?

BELLI: The simple answer is empathy. I was an actor. I know how hard it is to be one and to do the work. I also think they are incredibly brave because the characters they play are through their personal lens, so they are choosing to share their innermost thoughts, fears, attributes, and flaws with strangers. So my job is to, first, know their process, then, protect them and their process. Luckily, my training covered many different schools of acting (Sandy Meisner, Stella Adler, Uta Hagen, Richard Boleslavsky, Actors Studio), so I have an extensive acting vocabulary. If a director hasn't studied acting, I strongly urge them to.

The most common mistake a director can make with actors is talking too much. Once I suggest something to an actor, I watch for that spark that says to me that they know what they want to try next. Let them do that ASAP. Any further explanation after they say, "OK" or "Got it," will dissipate that actor's creative spark. I also try to give them as much information as possible. Before we block a scene in the squad room on *NCIS: New Orleans*, I show the actors the computer graphics or videos generated during prep so that they know how specifically their dialogue will tie into what's on the computer screens. Also, on any show, a director should trust that an actor knows more about his or her character than she does ... and relish that insight.

HEMPHILL: In terms of planning your shots, do you come to set with a strong idea of how you're going to block a scene and then try to convey that to the actors, or do you let them do what comes naturally and then conform your shots to that blocking?

BELLI: I always come into a scene with a plan of how to block it, and that plan is hopefully well informed (i.e., whose desk is whose?). And I never ask for a move that is not motivated. My experience has been that if you know the five Ws – Who is this character?, What does he want?, Why does he want it?, and When and Where is he? (as that relates to the scene) – an actor will move if he or she agrees with the given circumstances. And if they don't you better be able to defend your rationale, and more important, seize that wonderful opportunity to figure out what specifically you disagree about, because that will only lead to more clarity about the character and the story going forward. And it is always give and take … directors are not dictators. They should be collaborative leaders who have done their homework and are willing to listen.

HEMPHILL: Virtually all of the episodes of *NCIS: New Orleans* are shot by Gordon Lonsdale. Talk a little bit more about your collaboration with him. Have you worked on other shows that had alternating DPs? If so, what are the advantages and disadvantages of each way of doing things?

BELLI: It is always easier to shoot with alternating DPs, especially on a show that spends more time out (on location) than in (standing sets at the sound stage), because he or she is with you for your whole prep including location scouting. But Gordon Lonsdale makes it all work. He's always available while I'm prepping for a specific question, he knows the standing sets inside and out, he's been there since the show began, and he comes on the tech scout. When Gordon is directing or gone for the next episode's tech scout the gaffer, Paul Olinde, moves up to DP.

HEMPHILL: What are the differences between coming on to a show like *NCIS: New Orleans*, which is part of a popular franchise with a clearly defined style, and working on a show like *Famous in Love* or *Pitch*, where it's the show's first season and you may not have even gotten a chance to see any episodes?

BELLI: *Famous in Love* and *Pitch* as well as *The Quad* were three new shows that I began in their first season. Luckily, all of them had their own iconic look due in no small part to their pilot directors. And I did study all of the pilots before I directed. From the first continuous shot of Ginny's walk from her hotel room to her car in *Pitch*, director Paris Barclay set the look of the show. And since Major League Baseball was also part of the show, Paris augmented the standard MLB shooting positions for games with the inside shots on the field where the viewers get inside Ginny and Mike's perspective. He communicated his vision both verbally and visually and then, very supportively and with his witty sense of humor, told me to "Make him look good!"

On *Famous in Love,* I watched the pilot, read Rebecca Serle's novels, and figured out from director Miguel Arteta's glamorous vision of Hollywood that they were selling the fantasy. And Larry Reibman, the DP who shot the pilot, was also my DP on the episode I directed. On *The Quad,* I not only watched the pilot, but I watched director Rob Hardy's film *Stomp the Yard,* since the episode I got involved a "battle of the bands." I got the feel of the show before starting and then during prep I had a visual tone meeting with Rob, who was very specific about the look and rhythm of the show. Also Felicia D. Henderson, who created the show with Rob, was very specific in how she wanted the scenes to begin ... she wanted very small but key visuals teasing the audience before the viewers would know where they were and what the scene was about.

As for working with the actors in the first season of a show – it could be my favorite thing about directing episodic TV. It's here that I feel I can make a difference in the genesis of a character, and every decision the actor makes can help define their character arc over the future seasons. It is when I can instill great working habits and help build confidence with the less experienced actors, and hopefully contribute to the complexity of the character for seasoned performers. For example, one of my happiest moments on *Pitch* was when Kylie Bunbury disagreed with me on a direction I gave her. Now, it was evident that Kylie was a star of immense talent when I saw the pilot. And she was collaborative, and prepared, and fun every moment on set. But that happy moment for me was when I knew she had taken complete ownership of who her character was and where and how she wanted that character to behave and grow. It reminded me of one of my teachers who always said to me, "my job is to make you independent of me."

HEMPHILL: Recently you worked on a new show, *Station 19,* for Shonda Rhimes' company. Were you able to see the pilot before you directed your episode?

BELLI: Yes, I was able see the pilot for *Station 19* before I directed my episode. Sometimes, especially when the show has not yet aired, there are limitations on when and where you get to view it. But my experience has been that it is very helpful and the producers go out of their way to show you the pilot so you can see the actors' performances and the visual tone. In the case of *Station 19,* Paris Barclay, who directed the pilot, had established the world of the series. It inspired me to maintain the excitement he found in this dangerous world of firefighting and also expand the relationships, camaraderie, and sexy banter that we both knew would attract the *Grey's Anatomy* audience! And especially in the standing sets, as the second director on the series, I wanted to keep exploring the space and see how it lent itself to the storytelling.

HEMPHILL: Was directing for Shondaland different in any way from your other experiences?

BELLI: With *Station 19*, I knew I was coming into an established brand. Luckily, I knew that brand inside out and backwards because I have been an avid *Grey's Anatomy* watcher since I first saw and LOVED that series. The season finale of *Grey's* prior to *Station 19* spinning off had involved a fire and a wonderful nuanced performance by Jerrika Hinton, who plays Dr. Stephanie Edwards. I took my cue from both that specific episode and employed the guidance of Jason George who was the crossover character, and an actor with whom I had worked multiple years on a series, to guide me. I also ended up with a very supportive and collaborative writer of that episode, Wendy Calhoun. We were both new to Shondaland, so we navigated our way together trying to fulfill creator Stacy McKee's vision. I also had Paris Barclay championing me from the very first meeting at Shondaland through delivering my cut. I had first worked with Paris on *Pitch*, and he helped me with everything from prepping for that meeting to empowering me to suggest anything I thought would add value to this new series.

HEMPHILL: Do you feel that shows on which women are in charge have strengths that other series don't?

BELLI: I think that in this series and others where I have worked with a lot of women in charge, my experience has been that we tend to cooperate really well with each other. I don't know if that comes from an unsaid sisterhood, or the knowledge that we have gotten where we are by not only hard work but also facing some common roadblocks. It does put us in a club and most of us are proud to be in that club. And then to know that you are now in a world, Shondaland, where there is this talented visionary – Shonda Rhimes – who has changed the face of television with both the stories she tells and the way she empowers women in the industry to find their voice and vision, I will tell you, for me it was pretty heady stuff and I was so proud to be there, and grateful that Shonda's executives, Betsy Beers, Ghazal Mosfegh, and Allison Eakle invited me to come play.

HEMPHILL: I know that you are active with the DGA and that you mentor young directors. What kind of programs do you participate in, and do you feel that this kind of work makes you a better director? How much of directing do you feel can actually be taught and how much comes down to taste and instinct?

BELLI: Right now, I serve as the co-chair of the Women's Steering Committee at the DGA. Also there, I have helped with instruction on the First Time Directors workshop and the Director Development Initiative. I have also taught workshops at AFI's Directing Workshop for Women, the Alliance of Women Directors, and I help Bethany Rooney with the fantastic curriculum she designed for the Warner Bros. Directing Workshop. I do panels whenever time allows and I'm also on the faculty of USC's School of Cinematic Arts. Teaching and particularly co-authoring both editions of Directors Tell the Story has definitely made me a better

director. I was told early on, if you can teach it, you know how to do it better. That is so true. Also I just love breaking down the skill sets needed to direct into manageable exercises that build sequentially on each other. So to answer this last question, I think you can be taught to be a better director. But the secret ingredient to being a leader is something that you have to feel and take responsibility for ... and if you are missing that, you'll never succeed. And as far as taste and instinct, I think that comes from being well read, studying TV and films, and living a full life ... and that's the perk of being a director. Every moment you are awake can contribute to your success.

Index